Rubens's Great Landscape
with a Tempest

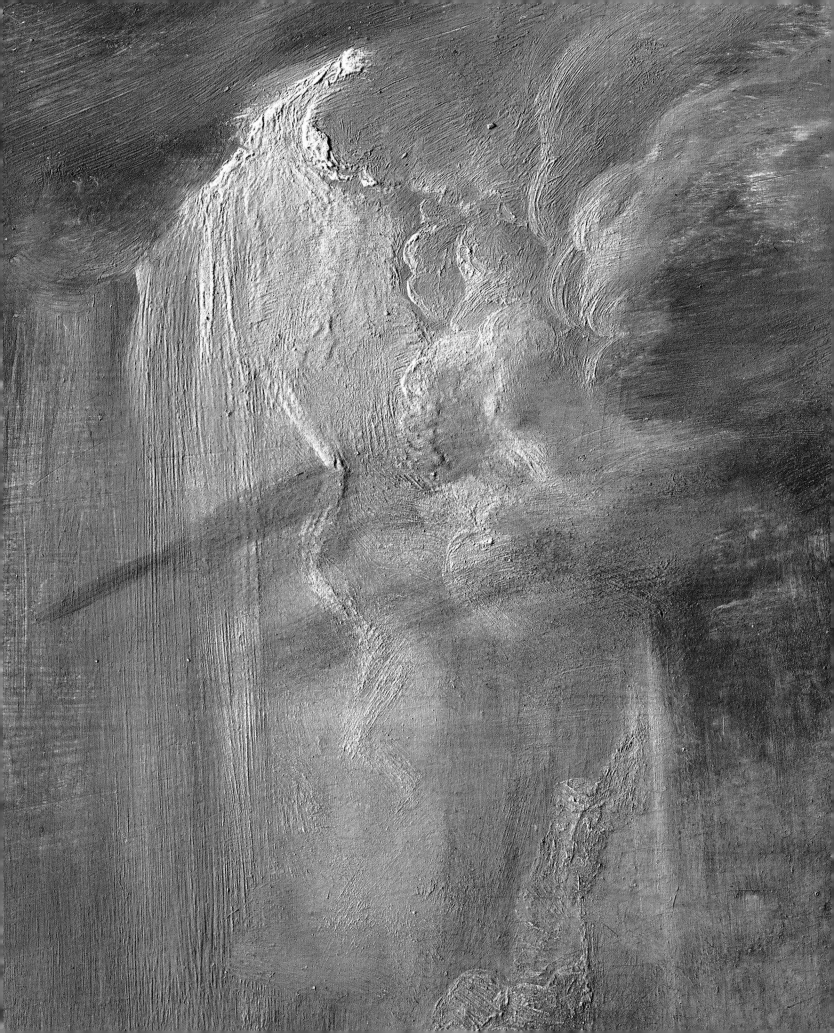

KUNST
HISTORISCHES
MUSEUM
WIEN

Rubens's Great Landscape with a Tempest

ANATOMY OF A MASTERPIECE

EDITED BY GERLINDE GRUBER AND ELKE OBERTHALER

SCHRIFTEN DES KUNSTHISTORISCHEN MUSEUMS, VOLUME 21
EDITED BY SABINE HAAG

HIRMER

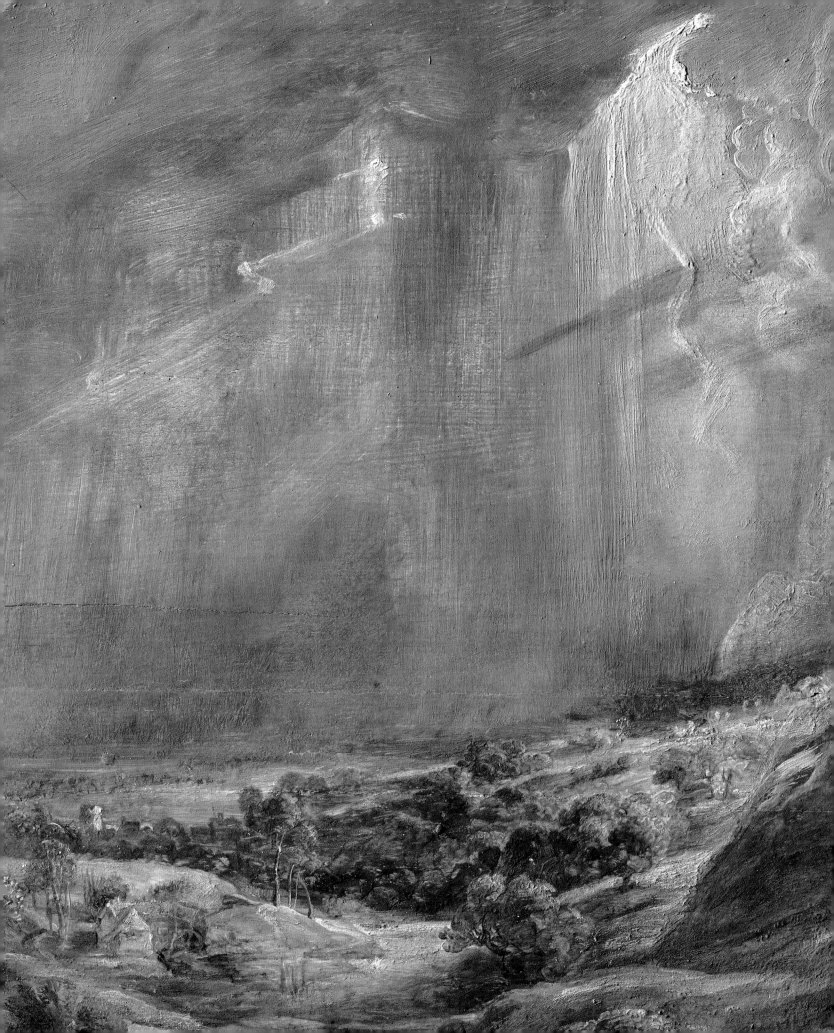

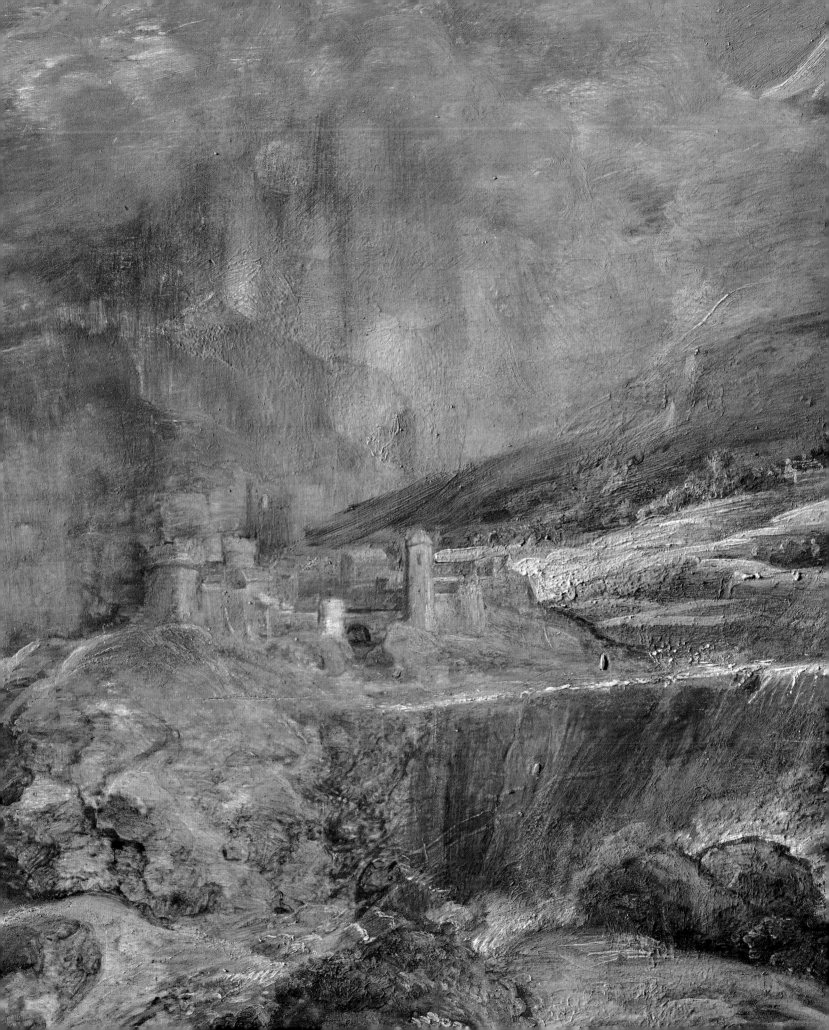

Content

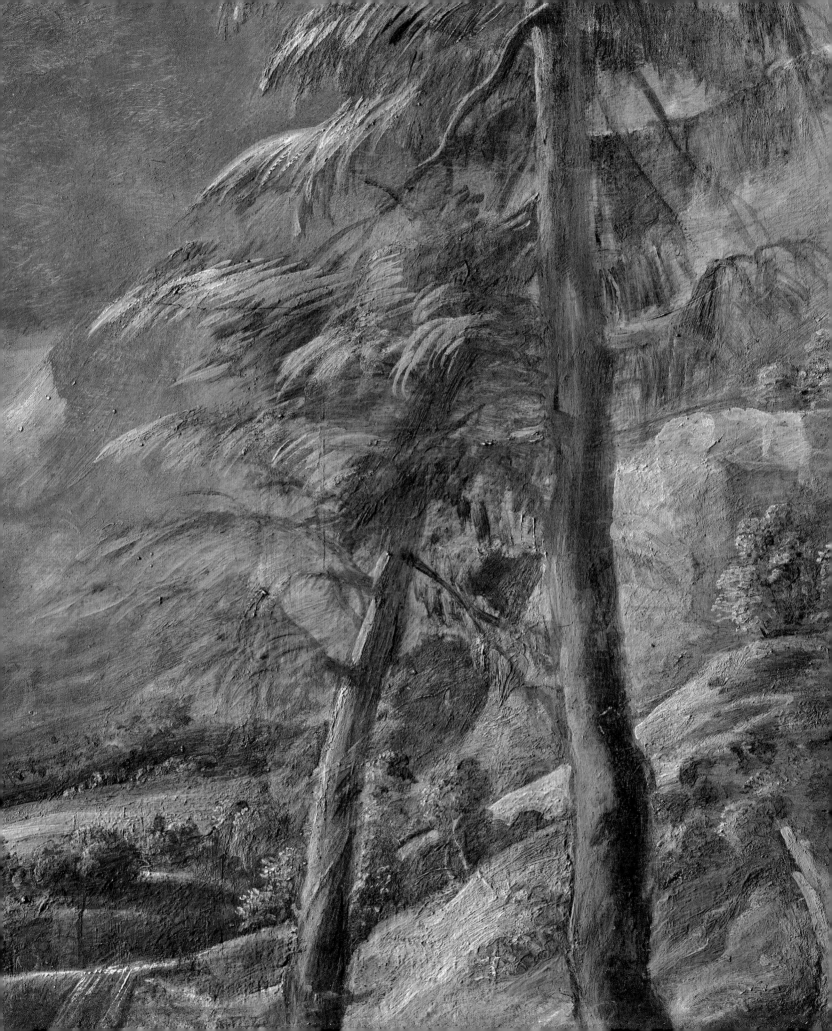

Introduction

GERLINDE GRUBER &
ELKE OBERTHALER

"A great Landschap with a Tempest beinge the Historie of Baucis and Philemon"[1] is how Peter Paul Rubens's *Stormy Landscape* (*fig. 1*) is described in the *Specification*, the inventory compiled in 1640 after his death, where it is mentioned for the first time. The description focuses on the landscape and the storm (the two mythological figures appear almost as an afterthought), clearly identifying the composition as a landscape.

As part of the comprehensive restoration of this oak panel undertaken between 2014 and 2017, which was generously supported by the Getty Panel Paintings Initiative, *The Stormy Landscape* was thoroughly examined for the first time, its condition prior to the restoration analyzed using a variety of methods and carefully documented. An old cradling was causing tensions and had to be removed, revealing the entire obverse of the panel, which provided new insights into the work's complex genesis – until then scholars had believed it had only been enlarged once.[2] In addition, we were able to carry out a dendrological analysis of the different boards of the panel before they disappeared again behind the newly constructed support.

In 2017 the recently restored *Stormy Landscape* was displayed for the first time in the exhibition *Rubens. Power of Transformation*.[3] It was, however, not possible to include a detailed account of the complicated restoration and its findings in the exhibition catalogue: hence this publication.

The essays focus on the complex genesis of the composition, on which Rubens worked for several years (Ina Slama, Gerlinde Gruber) and which went hand in hand with repeated enlargements of the panel (George Bisacca), the history of the work's restoration interventions (Elke Oberthaler), and its most recent restoration undertaken as part of the necessary stabilization of the support (Ina Slama).[4] All these findings were carefully documented and mapped (Georg Prast).

There is also an essay that explores the various sources that Rubens presumably drew on (Gerlinde Gruber), and another that presents the dendrological analysis of the work's temporarily exposed planks (Pascale Fraiture).

The odd one out, so to speak, in this monograph is the essay discussing a group of drawings tentatively attributed to Lucas Van Uden (Carina Fryklund). One of them is closely connected with our *Stormy Landscape* because it documents an intermediate state in the composition's genesis – one of the reasons why we thought it important to include it here. The drawing shows that Rubens allowed Van Uden to copy the painting when it was still unfinished – although Rubens may have felt it was completed but later changed his mind.

We would not have been able to realise this complicated conservation and restoration project without the generous financial and scholarly support of the Getty Panel Paintings Initiative, which is why we would like to express our deepest gratitude to the Getty Foundation and to Antoine Wilmering, the coordinator of the project, whose support and impressively unbureaucratic and highly constructive attitude proved invaluable. On the panel we worked with leading experts: George Bisacca (Metropolitan Museum New York) and José de la Fuente (Museo del Prado Madrid); Georg Prast (Kunsthistorisches Museum Vienna), who provided all necessary tools and materials and ensured that everything ran smoothly, and a number of mid-career trainees from the Getty Panel Paintings Initiative: Aleksandra Hola (Jan Matejko Academy of Fine Arts, Cracow), Adam Pokorný (Národní Galerie, Prague) and Johannes Schäfer (Altenburg/Dresden). Ina Slama restored the painting's surface. A preliminary report on the painting's damage dynamics compiled by Sara Mateu during a year-long internship also financed by the Getty Panel Paintings Initiative proved helpful in the run-up to the project.

We would also like to thank our colleagues at the Kunsthistorisches Museum Vienna, who contributed in various ways to this project: in the Conservation Studio Sonja Kocian was in charge of organisation, Ingrid Hopfner and Georg Prast measured the thickness of the panel, and our framers, Markus Geyer and Rudolf Hlava, helped in manifold ways; Andreas Uldrich, Michael Eder, Tom Ritter, Sanela Antic and Michael Aumüller provided excellent photographs and expert picture editing; Stefan Zeisler, head of the Dept. of Visual Media, generously allowed us to make use of his department's many resources; and the Conservation Science Department carried out numerous complex analyses, for which we are very grateful to Martina Griesser, its head, and Sabine Stanek, Katharina Uhlir and Václav Pitthard for their commitment and support, and Anneliese Földes for her assistance.

Tina Maria Seyfried was in charge of illustrations; Karin Zeleny was our trusted proofreader and editor; Clemens Wihlidal created the elegant layout; the texts were translated from the German and the English by Matthew Hayes, Agnes Stillfried, Ute Tüchler and Robert Wald; we would like to thank them all for their excellent work. We are also very grateful to Franz Pichorner, head of the Publications Dept., Benjamin Mayr and Rafael Kopper for helping along this publication in their usual judicious and calm manner. And we would like to thank Michael Roth and Christien Melzer and their team for the sympathetic and quick help provided by the Kupferstichkabinett in Berlin.

Eva Götz, Sabine Stanek, Robert Wald and Ingo Zechner offered helpful comments on the text. Stimulating conversations with a number of colleagues proved extremely useful, for which we would like to thank Arnout Balis, Christopher Brown, Nils Büttner, Lucy Davis, Stephen Gritt, Nico Van Hout, David Jaffé, Catherine Lusheck, Elizabeth McGrath, Britta New, Sabine Pénot, Ron Spronk, Francesca del Torre-Scheuch and Alejandro Vergara.

And, last but not least, we would like to thank David Maenaut, the representative of the Flemish Government in Vienna, who enthusiastically chaperoned this project through all its stages and generously supported this publication.

This book is dedicated to Stefan Weppelmann, the former director of the Picture Gallery, for his unflagging support of this project.

1 Muller 1989, 119–120, no. 137; Duverger 1984–2009, IV, 296 (137. Een groote Diluvie of zondvloed met de Historie van Philemon en Baucis), 312, 304 (137. Vn grand deluge auecq l'histoire de Philaemon et Baucis); exhib. cat. Antwerp 2004, 330.

2 See exhib. cat. Vienna 1977, cat. no. 41; Vergara 1982, 179–183; Adler 1982, cat. no. 29; exhib. cat. Essen & Vienna 2003/2004, cat. no. 124; exhib. cat. Vienna 2004, cat. no. 70; Kleinert 2014, 96–99.

3 Exhib. cat. Vienna & Frankfurt 2017.

4 For more on philosophical, literary, cultural-historical and other classifications see the publications by Raupp and Kleinert, which also include excellent summaries of the various interpretations suggested over the years: Kleinert 2014; Raupp 1994; Raupp 2001.

Gerlinde Gruber

Provenance and Sources of Inspiration

Landscape plays a pivotal role in many of the history paintings that Rubens produced mainly in the 1630s. However, he painted only a few autonomous landscapes, and they have a special place in his oeuvre:[1] contemporaries instinctively noted their intimate, private character, connecting it with Rubens's decision to retire to the country[2] – he owned two estates, one of which, *Het Steen,* acquired in 1635, he even depicted in a landscape (*fig. 1*; today London, National Gallery).[3]

Edward Norgate, the English miniaturist often quoted in this context, visited Rubens in 1640 during his sojourn in Antwerp to buy paintings for Charles I; he later wrote that "Sr. Peter Paul Rubens of Antwerp was soe delighted in his later time, as hee [sic] quitted all his other practice in Picture and Story, whereby he got a vast estate, to studie this, whereof he hath left the world the best that are to bee seene [...]."[4]

Rubens was generally very fond of landscapes: in the inventory compiled after his death (*Specification*)[5] the Vienna *Stormy Landscape with Philemon and Baucis* brings up the rear of a group of seven autograph landscapes,[6] but the inventory also lists additional landscapes by him as well as landscapes by Jan Wildens, Pieter Bruegel the Elder and Jan Brueghel the Elder, Pieter Snayers and Adriaen Brouwer, and by Dutch artists including Cornelis van Poelenburgh and Herman Saftleven.[7]

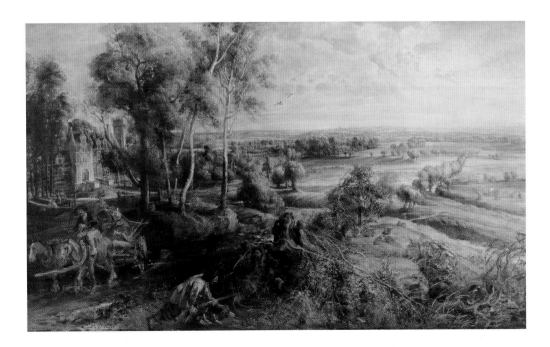

Fig. 1: Rubens, *A View of Het Steen in the Early Morning,* c. 1636, canvas, 131.2 x 229.2 cm. London, National Gallery

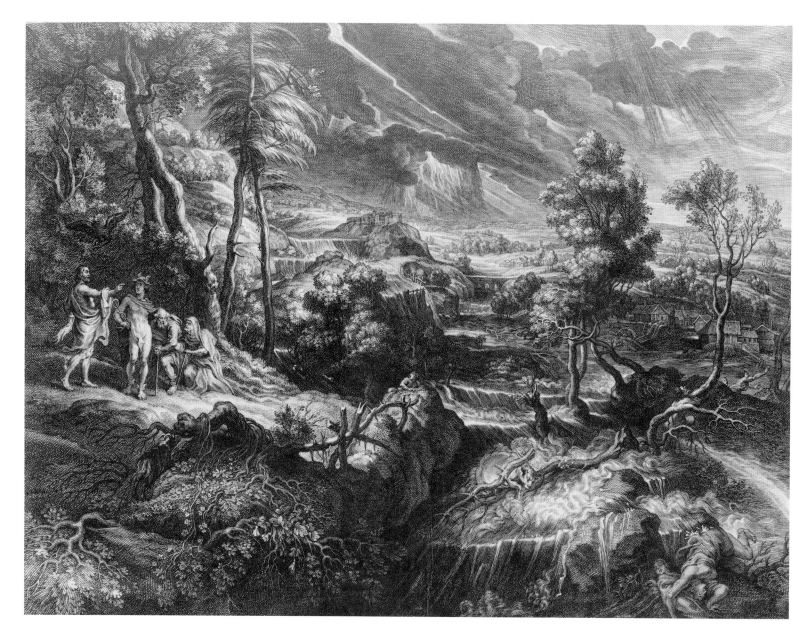

Fig. 2: Schelte Adamsz. Bolswert after Rubens, *The Stormy Landscape,* engraving, 305 x 433 mm. Vienna, Albertina

The fact that at the time of his death his collection included so many of his own land-scapes suggests they were never destined for sale.[8] Nonetheless, Rubens seems to have been keen to raise their profile: he asked Lucas Van Uden to make smaller copies and even had some of them reproduced as prints, as well as commissioning a series of *Small Landscapes*[9] from Schelte A. Bolswert, thus continuing a Flemish tradition of patronising landscape en-gravers. Scholars still disagree whether the series *Large Landscapes* dates from before or after his death.[10] The *Large Landscapes* include an engraved copy of the painting now in Vienna (*fig. 2*).

The Stormy Landscape has a special place among Rubens's views because it is one of the few featuring mythological figures – the others being *Odysseus and Nausicaa,* after Homer, *Odyssey* VI, 100-144 (*fig. 3*), and *Meleager and Atalante* (*fig. 4*).[11]

An annotation in the English manuscript of the *Specification* shows that Charles I want-ed to buy *The Stormy Landscape,* but the deteriorating political situation in England pre-vented him from concluding the deal.[12] Archduke Leopold William subsequently managed to acquire it – appointed Regent of the Spanish Netherlands in 1647, he moved to Brussels and employed David Teniers the Younger from 1650.[13]

The Archduke probably bought *The Stormy Landscape* before 1651/52 because by that

Fig. 3: Rubens, *Odysseus and Nausicaa*, panel, 127 x 205 cm. Florence, Pitti Palace

Fig. 4: Rubens, *Meleager and Atalante*, canvas, 162 x 264 cm. Madrid, Prado

date Teniers had already produced copies after selected paintings in the archducal collection for Johann Adolf, Prince of Schwarzenberg (1615–1683), the regent's Keeper of the Privy Purse, including one of *The Stormy Landscape*.[14] An inventory compiled in 1656 lists "1 painting with a deluge, is a copy after Rubens by the painter Teniers" ("1 billdt mit einer Sündtfluet, ist eine Copey nach Rubens durch den Mahler Tennirs gemacht").[15]

After Archduke Leopold William's return to Vienna in 1656, his collection was installed at Stallburg Palace: on the second floor above the stables, on the ground floor and in the armory on the first floor. *The Stormy Landscape* is listed as no. 147 in the inventory of his collection compiled in 1659 and described as "a large landscape in oil on panel, the deluge, with a number of people trying to flee from the advancing waters, and on the right lies a woman with a dead child, also a cow wedged between two large branches, and on the left stand Jupiter and Mercury. In a black frame, 8 span 4 fingers high and 11 span 5 fingers wide, original by P.P. Rubens" ("Ein grosse Landschafft von Öhlfarb auf Holcz, das Diluuium, warin ettliche Leüth das Wasser suechen zue entfliehen, vnden auf der rechten Seithen ligt ein Fraw mitt einem Khindt todter, wie auch ein Khue zwischen zwey Assten, vnndt auf der linckhen Jupiter vnd Mercurius stehen. In einer schwartzen Ramen, hoch 8 Span 4 Finger vnd 11 Spann 5 Finger brait, Original von P.P. Rubens").[16]

Presumably the painting remained at Stallburg Palace until the major new installation of the imperial gallery under Emperor Charles VI, although it is not mentioned in any extant description of a visit to Stallburg Palace.[17] After 1720 there is no trace of the panel in the imperial gallery: it may have been sent to Bratislava in the 1760s in connection with the enlargement and redecoration of the city's royal Hungarian castle as the new residence of Albert, Duke of Saxony-Teschen, and his wife, Archduchess Marie Christine. In 1781 *The Stormy Landscape* appears in the inventory of Bratislava Castle, but we may assume it returned to Vienna shortly afterwards because its supplementary entry in the 1772 inventory of the imperial collection in Vienna is annotated with the remark "from Bratislava" ("aus Pressburg").[18] Mechel included it in his new installation of the imperial picture collection at Belvedere Palace,[19] and from this time onwards *The Stormy Landscape* was always on show in the permanent gallery; because of the precarious condition of its support it was never loaned.[20]

The group comprising Jupiter on the far right of *The Stormy Landscape* depicts a scene from Ovid's *Metamorphoses* (VII, 689-697): accompanied by Mercury, the messenger of the gods, Jupiter visited Phrygia but the only ones to welcome the disguised gods were a poor married couple, Philemon and Baucis. As punishment he decided to turn Phrygia into a deadly muddy morass, though he saved his aged hosts – in Rubens's painting we see them struggling up a hill to safety. Mercury has laid a protective arm around old Philemon while

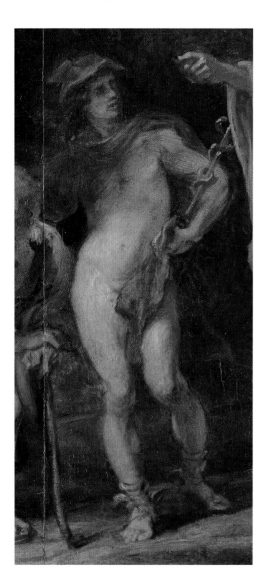

Fig. 5: Rubens, detail: Mercury

listening to Jupiter, whose head is unexpectedly set off from the darker background by a halo. His screeching eagle has just alighted on the tree behind the group. Clutching his thunderbolt in his right hand, Jupiter is pointing with his left towards the fast-rising waters, which have already inundated everything up to the middle ground, uprooting trees and even carrying away a cow. A few desperate figures are trying to save themselves.

Most of the floods are concentrated in the left half of the composition, though they are not included in Ovid's story of Philemon and Baucis. Such a deluge is more reminiscent of the flood at the time of Deucalion recounted in the first book of the *Metamorphoses* (I, 260-312). A relevant quote from this (either erroneous or taken from a faulty edition) explaining the reason for Jupiter's decision to bring on the deluge was also added to the engraving by Schelte A. Bolswert after the painting now in Vienna (*fig. 2*).[21] This description of a flood also includes both uprooted trees and drowning people and animals and a description of Iris: "Juno's messenger, clad in the brightest colours, rises from the waters to offer sustenance to the clouds" (270). Iris is the goddess of the rainbow[22] which Rubens depicts bottom left, connected with blowing spray, which may be informed by Seneca's *Naturales Quaestiones* (III,1),[23] or Aristotle's *Meteorology*, which, starting with col. 687, is included in the complete Latin edition that Rubens also owned.[24] It is unlikely that this rainbow symbolises either God's covenant with the earth and man, or divine harmony or hope: in the frequently quoted *Book of Genesis* (9, 11-15) the rainbow appears in the sky,[25] but here Rubens positioned it bottom left, next to the presumably dead mother who had desperately tried to save her infant. In 1604 Karel van Mander had already opined on various aspects of depicting rainbows, a discourse Rubens was surely familiar with.[26] In his account of the end of the world (III, 27, 4 et seq.),[27] Seneca described excessive rains, a deluge rushing down from the mountains carrying away anything and everything; Posidonios' world view, too, has been suggested as a key to understanding *The Stormy Landscape*:[28] as a symbol of the cosmos, the powerful order of Nature. While the left half of the painting is inundated by the devastating floods, the gods are saving the hospitable old couple on the right. Note the goat below this group near an uprooted willow. Attempts to connect it with Jupiter remain unconvincing[29] – because Amaltheia allegedly fed the infant deity goatmilk? This seems a little farfetched in this context: unlike, for example, the eagle whose shape Jupiter assumes to abduct Ganymede, the goat is not one of his typical attributes. And in this composition it is not placed directly below the father of the gods but below Baucis.

Here, Rubens combined two stories from the *Metamorphoses* while simultaneously illustrating a rarely-depicted moment from the story of Philemon and Baucis, their rescue – most artists, following illustrated editions of Ovid's *Metamorphoses*,[30] show either *Jupiter and Mercury in the House of Philemon and Baucis,* or *Philemon and Baucis Turned into Trees* at the end of their lives.[31] In the painting in Vienna, however, Rubens began with a flooded landscape, and this subject remains a dominant aspect of the composition – as late as 1940 Burckhardt called it "Deluge in Phrygia".[32] By eventually[33] adding the rescued old couple from Ovid's story Rubens ensures a happy ending.

Rubens used classical sculptures as models for the two gods. His Mercury (*fig. 5*) is actually informed by two celebrated ancient works: Scopas' *Meleager* (*fig. 6*),[34] which Rubens may have known from a Roman copy in the Pighini Collection (formerly Fusconi Collection) and which features a very similar pose. The *Mercury* executed by Rubens's workshop in 1636/37 for the Torre de la Parada series (*fig. 7*, Madrid, Prado, inv. P 1677), for which statues of Meleager have already been identified as models,[35] is even closer to the classical model. It seems that during the 1630s Rubens studied and repeatedly used this statue of Meleager in his compositions – the *Mercury* in Vienna probably dates from after 1635 too.[36] On the other hand, the way the deity is holding his caduceus (which seems to rest on his lower arm) has much in common with the *Hermes/Mercury* (*fig. 8*) in the Farnese Collection:[37] a Roman copy after Praxiteles that Rubens knew from his Roman sojourn.[38]

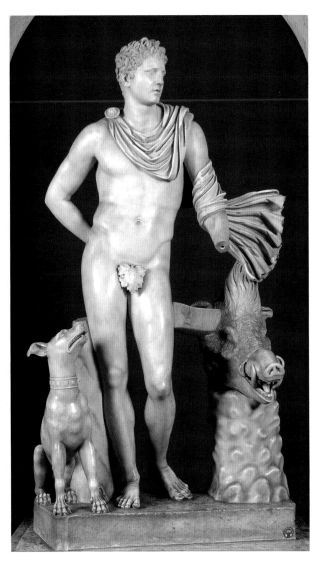

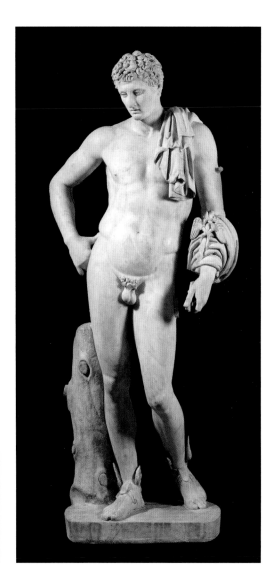

Fig. 6: Roman, after a Greek original, *Meleager*, marble, 210 cm. Rome, Musei Vaticani

Fig. 7: Rubens workshop, Mercury (from the Torre de la Parada series), canvas, 180 x 69 cm. Madrid, Prado

Fig. 8: Roman, after a Greek original, *The Farnese Hermes*, marble, 201 cm. London, British Museum

His Jupiter (*fig. 9*) quotes the celebrated statue of *Apollo Belvedere* (*fig. 10*),[39] which Rubens used as the starting point for very different subject matters.[40] In the composition in Vienna, Jupiter is pointing towards the deluge (though when all is said and done he is pointing at the rainbow too), which is why it has been read as a reference to the ancient statue's stance – i.e. that the artist had transferred Apollo's pose denoting his role as *alexicacus* (averter of evil) to Jupiter.[41] Rubens offers us an unusual view of Apollo's elegant pose – we see Jupiter from the side and from behind – which may have been inspired by a bronze reduction of the celebrated classical work. We know, for example, that Pier Jacopo Alari Bonacolsi called Antico had already produced such a statuette (Frankfurt, Liebieghaus Museum) as early as 1497/98.[42]

A lime tree and an oak are mentioned at the beginning of the story of Philemon and Baucis in the *Metamorphoses* (VIII, 621). The crossed-over trees just behind/above the old married couple (*fig. 11*) have been read as a reference to the latter's transformation into trees at the end of their lives,[43] but Rubens does not clearly identify the plants and the two stems appear to grow from a single badly twisted trunk. The motif seems like a paraphrase of a tree from Titian's tree-repertoire: in the woodcut *St. Jerome in the Wilderness* (*fig. 12*) we find a trifurcate tree with its dead third stem broken off in a way that is very similar to Rubens's. The fact that Lucas Van Uden produced a drawing of this tree constellation (Kupferstichkabinett, Berlin, KdZ 3132[44] – and see also p. 112, *fig. 6*) bears eloquent witness to the motif's popularity. Van Mander had already advised landscape specialists to use Titian's

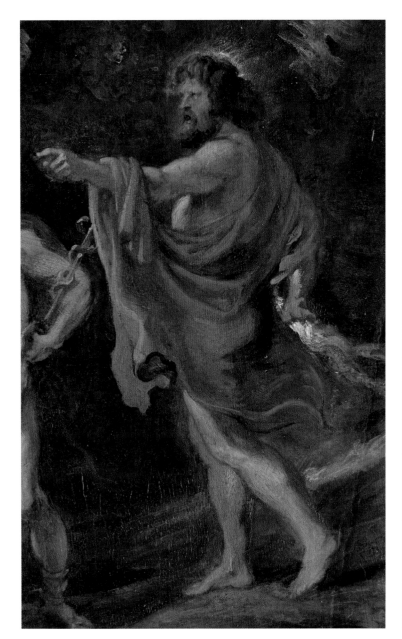

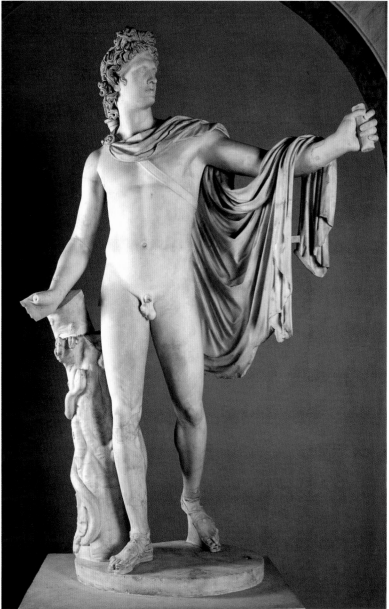

Fig. 9: Rubens, detail: Jupiter

Fig. 10: Roman, after a Greek original, *Apollo Belvedere*, marble, 2.24 m. Rome, Musei Vaticani

woodcuts as inspirations (*The Foundation of the Noble Liberal Art of Painting*, VIII, 24).[45] Crossed-over tree trunks also enjoyed a certain popularity as a forest-motif after their introduction by Titian: we find them, for example, bottom right both in Grimaldi's print after Titian depicting a *Landscape with Lute Player*[46] (*fig. 13*), and in a drawing of *St Eustace* by Girolamo Muziano that was reworked by Rubens.[47] We also encounter them in the centre of Pieter Bruegel the Elder's drawing *Wooded Landscape with Bear* (*fig. 14*) – transformed in Hieronymus Cock's engraving into a *Landscape with the Temptation of Christ* – and in the print after Johannes Stradanus's *Duck Shoot* (Bibliothèque Nationale, Paris – here the crossed-over tree trunks appear on the left).[48]

The uprooted tree in the centre bottom right (*fig. 15*) that seems to function as a fence is informed by Aegidius Sadeler's print after Roeland Savary, *Hare Hunting in a Forest* (*fig. 16*). Note also the brambles in the foreground on the left – in the painting in Vienna Rubens places them in the foreground in the right (*fig. 44* in the essay by Slama & Gruber). Bernard van Orley had used brambles as a foreground motif in a landscape in the tapestries depicting, respectively, August and October from the series *Hunts of Maximilian* (1531/33, Louvre, Paris),[49] and we know that Rubens was also familiar with Leonardo's drawings of this plant.[50]

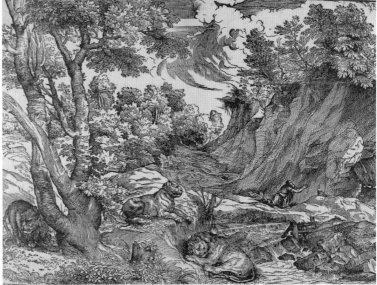

12

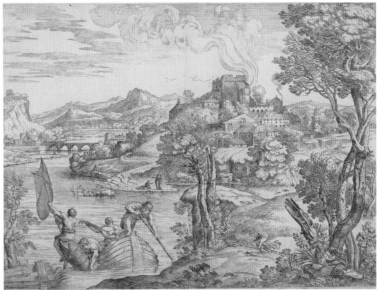

13

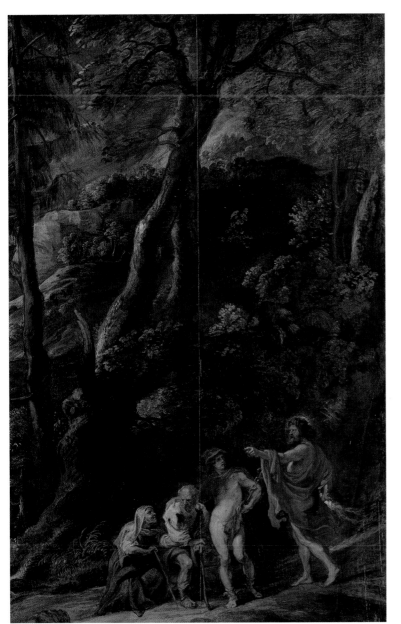

11

14

Fig. 11: Rubens, detail: Philemon and Baucis with Mercury and the trees

Fig. 12: Niccolò Boldrini (attributed) after Titian, *St. Jerome in the Wilderness*, 38.8 x 54.1 cm. New York, Metropolitan Museum of Art, Rogers Fund, 1922

Fig. 13: Giovanni Francesco Grimaldi after Titian, *Landscape with Lute Player*, engraving, 340 x 474 mm. Amsterdam, Rijksmuseum

Fig. 14: Pieter Bruegel the Elder., *Wooded Landscape with Bear*, brown pen, 273 x 410 mm. Prague, National Gallery

Fig. 15: Rubens, detail: fallen tree

Fig. 16: Aegidius Sadeler II after Roelant Savery, *Hare Hunting in a Forest*, engraving, 21 x 27.6 cm. New York, Metropolitan Museum, Harris Brisbane Dick Fund, 1953

Rubens probably never saw either Pieter Bruegel the Elder's autograph *Christ Carrying the Cross* or his *Hunters in the Snow* (*fig. 17*), both of which also feature brambles: the young painter may have had access to the court in Brussels through his teacher, Otto van Veen, who presumably facilitated Archduke Ernest's acquisition of the paintings by Pieter Bruegel the Elder,[51] but the Habsburg prince had died in 1595 and we do not know the whereabouts of Bruegel's *Seasons* following his death. But we may assume the existence of copies in Brussels,[52] and, as mentioned before, Rubens also owned other original works by Pieter Bruegel the Elder.

Prints probably functioned as a source of inspiration but we also know of a number of nature studies connected with Rubens's landscapes, e.g. *Landscape with Fallen Tree*, Louvre, c. 1618 (*fig. 18*), or *Fallen Tree with Brambles* at Chatsworth (*fig. 19*), though art historians are still debating whether the latter is by Rubens or Van Dyck.[53] But we do know that Rubens produced nature studies that he occasionally annotated, such as, for example, the drawing in the British Museum London (inv. Gg,2-229) that examines and studies reflections in an almost scientific-analytical way.[54] It has, however, often been noted that despite producing such drawings Rubens always subordinates light effects and nature in general to the composition. In keeping with contemporary ideas about imitating Nature in history paintings,[55] he clearly does not aim for radical verisimilitude.[56]

Rubens painted most of his landscapes for his own enjoyment, in a process accompanied by major changes, as we hope to show in more detail. But the wide dissemination of his landscape compositions through popular prints helped burnish his reputation in this genre too.

17a

17b

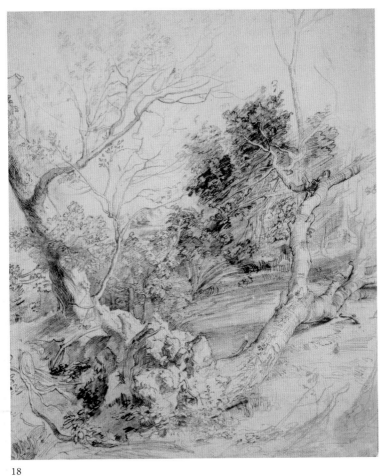

18

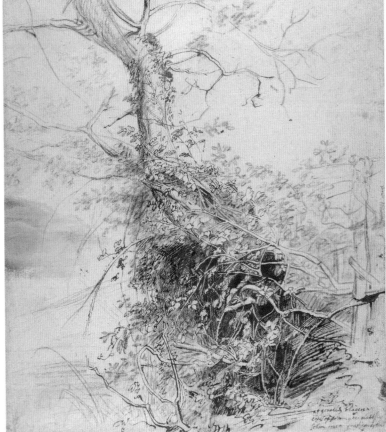

19

Fig. 17a: Pieter Bruegel the Elder, *Christ Carrying the Cross*, detail: brambles, oak panel, 124,3 x 170,6 x 1 cm. Vienna, Kunsthistorisches Museum, Picture Gallery

Fig. 17b: Pieter Bruegel the Elder, *Hunters in the Snow*, detail: brambles, oak panel, 116.5 x 162 x 2.4 cm. Vienna, Kunsthistorisches Museum, Picture Gallery

Fig. 18: Rubens (Van Dyck?), study of a tree, brown ink, black chalk, 583 x 490 mm. Paris, Louvre, Collection of Prints and Drawings

Fig. 19: Rubens, *Fallen Tree with Brambles,* brown ink with red and black chalk, watercolour, 352 x 298 mm. Chatsworth, Duke of Devonshire Collection

1 Art historians have long been aware of this; Ruelens 1883, 167: for example, his nephew, Philippe Rubens, wrote to Roger de Piles: "Les paysages qu'il [Rubens] a peints surpassent encore en estime les figures, aussi sont-ils en moindre nombre. Ayant acheté la seigneurie du Steen entre Bruxelles et Malines [...] il y prenoit grand plaisir de vivre dans la solitude, pour tant plus vivement pouvoir dépeindre au naturel les montagnes, plaines, vallées et prairies d'alentour, au lever et coucher du soleil, avec leurs orizons."

2 Adler 1985, 319-320; Brown 1996, 11; Renger 2003, 331-337, esp. 331.

3 For more on Rubens's country estates see Büttner 2006, 97-99. For the painting in London see Martin 1970, 137-142; Brown 1996, 59-79. Davis 2020.

4 "[...], that are to bee seene, some where off, were lately at York howse, but now unhappilie transplanted. The principall where of was an Aurora, indeed a rare peece and done by the Life as he him selfe told me un poco aiutato" (Ms. 1654, Oxford, Bodleian Library), Muller 1989, 18; Norgate 1997, 84, note 169.

5 Specification des peintvres trovvees a la maison mortvaire dv fev messire Pierre Pavl Rvbens, Chevalier, & c / An Inventory of Pictures found in the howse of the late Sr Peter Paul Rubens Knt: after his death: Inprimis pieces of Italian Mrs. See Muller 1989, 94-155; exhib. cat. Antwerp 2004, 328-335.

6 Muller 1989, 119; exhib. cat. Antwerp 2004, 330, cats. 131-137.

7 "Pure" landscapes became popular both in Antwerp and in other Dutch/Flemish cities around 1640. Muller 2004, 67.

8 The few landscapes in other collections during Rubens's lifetime were owned by his brother-in-law, Arnold Lunden, and some of Rubens's elite patrons, e.g. the Duke of Buckingham or Evrad (or Everhard) Jabach (Brown 1996, 11, 110, notes 5 and 6).

9 See Kleinert 2014, 61-112.

10 Exhib. cat. Brunswick 2004, cat. 58 (U. Heinen; from Rubens's final year as still with privilege); Kleinert 2014, 111 (after his death, with a reference to an inscription on Shipwreck after another print from this series after the painting in Berlin that identifies Gervaerts as imperial historiographer, a position to which he was only promoted in 1644).

11 The painting in Berlin has been identified both as *Shipwreck of St Paul near Malta* and as *Landscape with Aeneas' Shipwreck and Landfall in Carthage,* because the engraving by Schelte Adamsz. Bolswert after the painting quotes a line from Vergil's *Aeneid* (Verg. Aen. 3). However, below his engraving after the Viennese painting Bolswert added verses from the *Metamorphoses* not taken from the story of Philemon and Baucis but from the introduction to the flood of Deucalion (Ovid Met. 1, 240-243). Exhib. cat. Brunswick 2004, 261-264, cat. 59 (U. Heinen).

12 Muller 1989, 119; exhib. cat. Antwerp 2004, 330.

13 Vlieghe 2011, 34.

14 In his documentation on the painting in the Burchard-Archive of the Rubenianum in Antwerp, Ludwig Burchard mentions the existence of relevant archival material in the Schwarzenberg Central Archive (Český Krumlov): the correspondence between Schwarzenberg and his Master of the Household from 1651/52, as well as various inventories of Schwarzenberg holdings (1656), Zentral Archiv Falz. 594 a F Ph/2a Bilder. I would like to thank Gerrit Schulz-Bennewitz, Kateřina Hlavničková and Jindřich Hospaska for allowing me access to the Schwarzenberg inventories.

15 Note by Burchard (Burchard-Archive, Rubenianum, Antwerp) recording this copy at Schwarzenberg Palace in Vienna: "ca. 1686 (jedenfalls aber vor dem Jahre 1698 aufgenommen) Inventar des Wiener Stadtpalais Schwarzenberg. Nr. 40: Ein gross Bild von Sindtfluess mit einer schwarzen und ziervergulden Ram, 3 Ellen und fast ½ Viertel breit und 2 ¼ Ellen hoch, copie von Teniers" ("c. 1686 (at least before the 1698) inventory of the Schwarzenberg winter palace in Vienna, no. 40: a large painting showing a deluge with a black gilt frame, 3 ells and almost a ¼ wide and 2 ¼ ells high, copy by Teniers;" i.e. c. 156 x 93.6 cm). Mareš 1887, 350, too, records such a copy after Rubens. Today, however, this painting seems to be lost. *The Stormy Landscape* was repeatedly copied. In addition to the copies listed by Adler 1982, 109: London, Vente Philippe Panné, 26 March 1819, cat. 98, canvas, 145 x 173 cm; oak, 41.5 x 62 cm (erroneously identified as an autograph bozzetto for the painting in Vienna by Didier Bodart, exhib. cat. San Martino al Cimino 1999, cat. 87); Sotheby's New York 13 March 1985, lot 189, by a follower of Rubens, panel, 44.5 x 59 cm; Bredgade, Bruun Rasmussen Auction 739, 1-11 March 2005, lot 1550, 18th century copy, 144 x 214 cm (support not recorded); Rouen, Musée des Beaux-Arts, 18th century copy?, canvas, 154 x 212 cm, inv. 1953.26; in 1912 a canvas version was in the Baumains (Baumainy) Collection in Vernon (Rubenianum Archive, letter from Rooses dated 28 Jan. 1912); Josef Anton Koch, 1814, watercolor, 42.5 x 60.5 cm (Vienna, Kinsky Auction House, 24 June 2014, no. 516), see fig. 4a in the essay by Ina Slama, and Gerhard Frankl's free interpretation from 1923 in the Courtauld Gallery in London, canvas, 100 x 140 cm. The version now in the Philadelphia Museum of Art differs from these copies by unexpectedly ending at the bottom edge of the first addition of the central panel, thus showing a version that never existed because it would have meant cropping the vertical planks on both left and right (they are not cropped). Ludwig Burchard was the first to notice this, which is why he suggested this might depict an intermediate state before the final plank was added (annotation regarding the picture in Burchard's copy of Roose's Oeuvre, no. 1186, Rubenianum Antwerp).

16 In the 1659 inventory the descriptions (left and right) assume a viewpoint inside the composition, i.e. they are inverted from the viewer's point of view. Berger 1883, CXXIII (i.e. 174.72 x 332.8 cm, incl. frame). For more on the left-right problem see: Weigel 2001.

17 Reiffenstuell 1702. Haag & Swoboda (eds.) 2010, 12-13.

18 Bratislava inventory of 1781, "Nr. 293, ein Landschaft mit Figuren, Rubens". ("no. 293, a landscape with figures, Rubens"), Vienna inventory 1772 (addendum after 1781, below no. 1143, in pencil: "Pressburg. Eine Landschaft mit Paucis und Philemont, nach der Sintflut, Rubens, Gallerie 4. Zimmer links" / "Bratislava. A landscape with Baucis and Philemon, after the deluge, Rubens, gallery, 4th room on the left.) See also Gruber 2006/2007, 360-361,

395-396.

19 Mechel 1783, 118-119, no. 7.

20 Rosa 1796, 87, no. 8; Engerth 1884, no. 1171; catalogue raisonné 1892, no. 869; catalogue raisonné 1928, no. 869; catalogue raisonné 1938, no. 869; exhib. cat. Vienna 1977, cat. 41 (Demus); inventory 1991, 104, pl. 405; during WWII the painting was first removed to the former Carthusian monastery at Gaming (on 1 September 1939), then evacuated to Klosterneuburg in October 1944, and eventually returned to the museum in the autumn of 1945. I would like to thank Susanne Hehenberger for information on the details of the salvage operations.

21 Inscribed: "Pet. Paul Rubbens pinxit / S. à Bolswert sculpsit / Gillis Hendricx excudit / Antuerpiae // Occidit Vna domus: Sed non domus Vna perire / Digna fuit: qua terra paret fera regna Erijnnis: / In Facinus Jurasse putes dent ocius omne: / Quas meruere pati (sic stat sententia) poenas. Ovidii Metamorph. L. I." dedication: "D.o ac Magist.o PHILIPPO VAN VALKENIS I.V.Q.L. Secretario Antverpiensi. D.C.Q. AEgidius Henrici." See also, for example: exhib. cat. Brunswick 2004, cat. 58 (U. Heinen). The dedication to Van Valkenis was read as an indication that he had owned the painting before Archduke Leopold William: exhib. cat. Vienna 2004, cat. 70. I would like to thank Karin Zeleny for our stimulating discussions on the Metamorphoses.

22 Rubens included rainbows in a number of his compositions, and in very different ways. Van Hout lists seven paintings with rainbows (Van Hout in exhib. cat. Dresden 2016, 52); Lisa Vergara even speaks of rainbows as a "signature" of Rubens (Vergara 1982, 183).

23 Seneca 1990, 56. Rubens owned an annotated edition of Seneca's works; Arents 2001, 111, 203.

24 *Aristotelis Stagiritae Opera, post omnes quae in hunc vsque diem prodierunt editiones, summo studio emaculata, & ad Graecum exemplar diligenter recognita. Quibus accessit index locupletissimus, recens collectus,* Lyon 1561 (Arents 2001, 284). I would like to thank Karin Zeleny for drawing my attention to Aristotle.

25 Vergara 1982, 186-188 et al. on the different interpretations already suggested by Van Mander.

26 Van Mander 1604, *Den grondt der edel vry schilder-const*, VII, 9-24. Kern 2012, 106-107 on Rubens.

27 Raupp 2001, 174; exhib. cat. Brunswick 2004, cat. 58 (U. Heinen)

28 Dittmann 2001, 218-219, with reference to the classical scholar, Karl Reinhardt.

29 Adler 1982, 110.

30 See also, for example, Huber-Rebenich 2001, 141-162.

31 Stechow 1941, 103-113.

32 Burckhardt 1940, 16.

33 For more on this, see the essay by Slama & Gruber in this publication.

34 Today Rome, Musei Vaticani, Museo Pio-Clementino, inv. 490. Haskell & Penny 1982, 263, cat. 60.

35 Kieser 1933, 133, fig. 22; Alpers 1971, 233-235, no. 39, fig. 143. However, Van Der Meulen 1994, vol. 2, 49, note 8 states that there is no extant drawing by Rubens of this Meleager; and at the time the statue was identified as Adonis.

36 See the essay by Slama & Gruber in this publication.

37 Burchard had already suggested this Hermes as the model of the Mercury in the Torre de la Parada series, although not for the Mercury in Vienna. Alpers 1971, 233.

38 Van Der Meulen 1994, vol. I, 54-55. The *Hermes Belvedere* that Rubens copied (documented through a drawing by Cantoor, see ibid. vol. 2, no. 25, vol. 3, figs. 53-55) references the same model as the version in the Farnese Collection, but during Rubens's lifetime the god in the Belvedere did not hold a caduceus.

39 Today Rome, Musei Vaticani, inv. 1015, marble, H: 2.17 m.

40 Filipczak 2010, 124-149, on p. 139 she discusses variations of the *Apollo Belvedere*, though not in connection with the painting in Vienna.

41 Scribner 1989, 92.

42 For more on the use of bronze reductions, see Jaffé 2017, 51-59.

43 Vergara 1982, 179; Dittmann 2001, 217. Kleinert 2014, 97, 155, note 668.

44 Dreyer 1985, 762, 766-767.

45 Van Mander, Den Grondt der Edel vry Schilder-const: Waer in haer ghestalt, aerdt ende wesen, de leer-lustige Jeught in verschieyden Deelen in Rijm-dich wort voor ghedraghen, chapter VIII, fol. 36r, 24 https://www.dbnl.nl/tekst/mand001schi01_01/mand001schi01_01_0010.php?q=landouwen#hl1 (accessed on 10 August 2020)

46 Exhib. cat. Rome 1976, 65, cat. 174.

47 Wood 2011, no. 226, fig. 177.

48 Hazlehurst 1987, 588-590.

49 Balis et al. 1993, fig. 19. I would like to thank Sabine van Sprang for drawing my attention to this. See also exhib. cat. Brussels 2019, 194-219, figs. 5, 6.

50 Lusheck 2019, 128, 150-167, fig. 6.2.

51 Bertini 1998, 119-120.

52 Hoppe-Harnoncourt 2018, 434, note 11. Sellink, ibid., does not believe there were any copies; e-book 2018, 376. For Rubens and the Archdukes see Paolini 2018 and Orlando 2020.

53 Exhib. cat. Antwerp & London 1999, cats. 1 (Chatsworth) and 2 (Louvre) as Van Dyck; Logan 2001 (as Rubens); Logan 2005, 31-32 (as Rubens?); Van Hout 2016, 52 (as Van Dyck).

54 On this he noted "de boomen wederschyn (en) In het Waeter bruynder ende veel perfecter In het Waeter als de boomen selvde" ("In the water the reflection of the trees is darker and clearer than the trees themselves") – he was clearly interested in optical phenomena. See also: Held 1979, 257-264; Logan 2005.

55 Bartilla 2016, 244.

56 Most recently Kleinert 2014, 33.

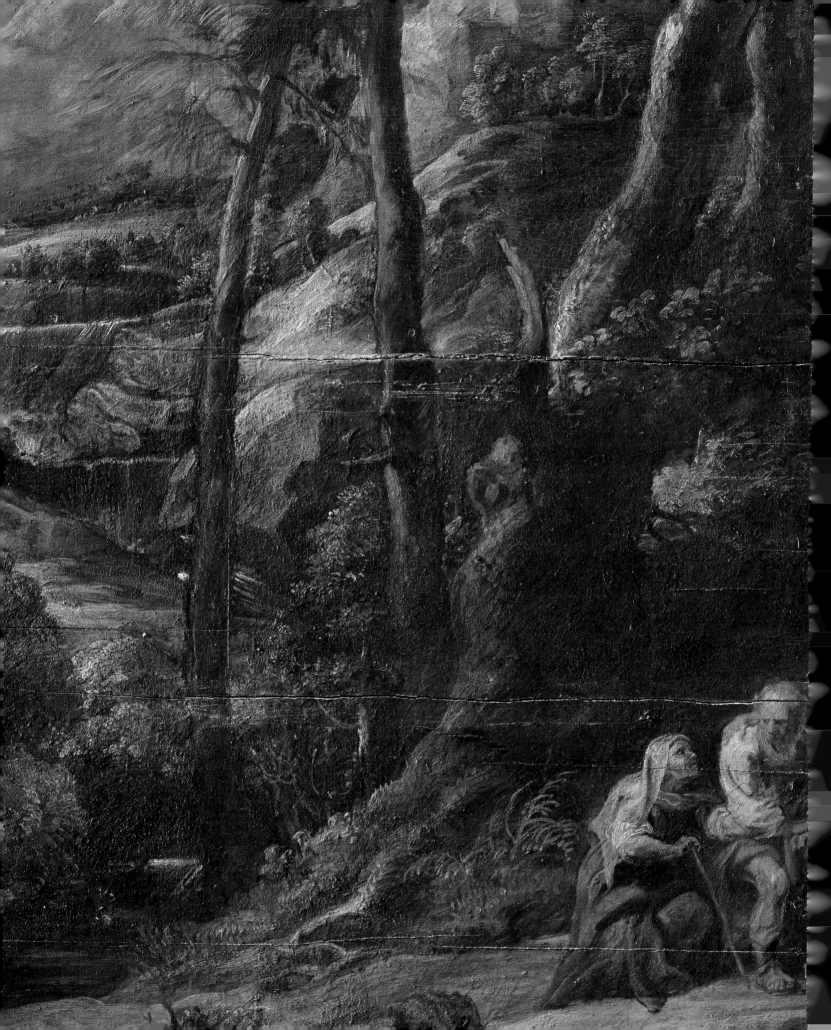

Elke Oberthaler

Reflections on Conservation History

One fascinating feature of *The Stormy Landscape with Jupiter, Mercury, Philemon and Baucis*, which is documented among Rubens's possessions until his death, is that it displays his creative process in an extremely immediate way.[1] The construction of the support was also subordinated to that process, for the artist had the panel enlarged in multiple stages. In so doing, planks were joined perpendicular to one other – against the rules of sound panel construction.[2]

The condition of *The Stormy Landscape,* visibly worsening over time, can be ascribed to the unorthodox construction of the panel, which clearly displays a long history of damages; these occasioned interventions, which sometimes led to new injuries (*fig. 1*). These can be broadly divided between those emerging before and those occurring after the attachment of the cradle in the early nineteenth century.

Rubens's oeuvre contains several paintings successively enlarged by the artist, especially for landscape compositions, and it has long been known that all of them represent particularly sensitive assemblages.[3] The Vienna landscape appears to have developed a comparatively greater number of problems with its support than other works that are more complicated and composed of more parts, grounds enough to pursue the question of how this came to be.

The fundamental parameters for the stability of wooden painting supports are the quality of the wood employed and the quality of the workmanship. Because wood, regardless of its age, reacts to changes in its environment – that is, absorbs and gives off humidity and thus continually changes its volume, swelling and shrinking – a stable climate is fundamental. The volume change occurs in the wood differentially, however: while it hardly alters in the axial direction (seen from the trunk), movements are increasingly greater in the radial and tangential directions.

The history of the painting in Vienna begins only sixteen years after the death of its creator with the gallery in the Stallburg, where the collection of Archduke Leopold Wilhelm was housed after his return from Brussels in 1656.[4] The painting was not included in the reinstallation of the collection under Charles VI from 1720: it was either in storage or located in private rooms.[5] Around 1765, it was probably transferred to Pressburg (today Bratislava) castle, but was already returned to Vienna in 1781 for the new installation in the Upper Belvedere.[6]

Around this time, the gallery directors began to note negative effects of climate: cold and humidity were identified as factors harmful to paintings.[7] It was Joseph Rosa, director of the gallery from 1772 until 1805, who already in 1776 commissioned a series of necessary measures in preparation for the new installation in the Upper Belvedere: '1st that eight stoves must be heated in the most high picture gallery (4 on the first and 4 on the second floor) for the conservation of its pictures. 2nd that by highest order, for heating, two workrooms (where the repair of its pictures is done) receive two loads of wood daily in winter,' so that the

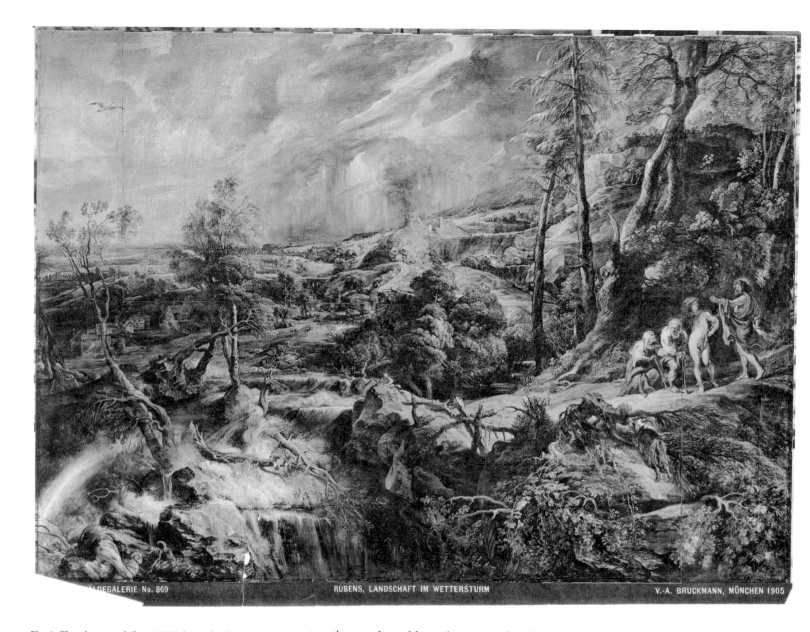

DEGALERIE No. 869 RUBENS, LANDSCHAFT IM WETTERSTURM V.-A. BRUCKMANN, MÜNCHEN 1905

Fig. 1: The photograph from 1905 shows the damage already clearly: the crack through the middle of the panel; the separation of the vertical planks at the sides from the horizontally oriented panel centre; and the cradle crossbars protruding beyond the panel's upper edge due to wood shrinkage.

restoration work could continue over the winter.[8]

In the newly installed Picture Gallery in the Upper Belvedere, *The Stormy Landscape* hung on the first floor in the fifth Netherlandish room and bore the number seven. The measures performed on it are summarily documented: 'whereas in the fifth Netherlandish room nos. 4, 5, 6, 7, 9, 10 were cleaned and repaired.'[9]

We can only speculate what the 'repairs' to *The Stormy Landscape* were. They may have been the non-original, large wood insert and compensation at the right edge – the 'repair' of a damage attributable to mechanical injury, perhaps a fall; or the sawing in two of the left vertical plank in the upper third of the picture, in order to glue the crack in the middle, horizontal plank; or they were the nails driven through the picture surface and panel along two cracks, which presumably sought to hinder their further opening with a reinforcing strip on the reverse.[10]

One can assume that the painting appeared visually 'in order' at the start of the hanging in the Upper Belvedere. But the climatic situation – the cold and particularly the damp walls, as well as the increased drafts and thus greater entry of dust – offered anything but ideal conditions for the paintings.[11] The Upper Belvedere was conceived and built as a summer palace and hence in no way winterproof, not least because its staircase and vestibule were open on both sides to the garden.

The Napoleonic Wars, which lasted until 1815, represented a dramatic threat for the

Picture Gallery. To protect it from the enemy troops, five evacuations took place between 1797 and 1813 during which the paintings, packed together in crates, were loaded aboard ships and transported down the Danube, away from the hostile forces and Napoleon's art commissars.[12] *The Stormy Landscape* was evacuated at least three times, in 1805, 1809, and 1813.[13] The paintings remained in crates for months, during the 1805 evacuation for around a year. Thus, however, *The Stormy Landscape* is documented as evading the French.[14]

At the same time, basic renovations of the palace building were carried out from 1800.[15] From 1810, damage to the pictures and frames caused by the evacuations were repaired,[16] but extensive and fundamental measures to both the building and the paintings came only in 1824, under the direction of Joseph Rebell and, following his death, under his successor Peter Krafft, whose impressively broad systematic campaign amounted to a general refurbishment.[17]

Rebell was likewise convinced that cold caused damage to paintings, and for this reason effected the installation of the so-called Meißner heating in the Upper Belvedere.[18] Air was warmed by eight cast iron stoves in the basement of the palace, which – partly using the existing chimneys and partly through newly installed pipes – was directed into the gallery rooms to guarantee 'the right amount of warmth'.[19] Rebell even had the palace heated during the summer to combat the humidity.[20]

The treatment of the paintings proceeded room by room. In 1829, after work on the Italian pictures was concluded, the German and Netherlandish paintings were addressed, in order to protect these before the start of winter and the heating season through the affixing of cradles.[21] Cradling was viewed as a protective measure – the opposite was the case, as was only recognized much later.

In 1830, the carpenter Michael Friedle, who had already been employed under Rebell and had won the trust of Krafft, was given the position of house servant.[22] It was probably Friedle who carried out the rather clever cradling of *The Stormy Landscape*. Work on the supports was then considered subordinate and performed by 'assistants'; treatment of the painting surfaces was reserved for the painter-restorers.

Friedle had obviously already recognized that this was a highly unorthodox and problematic panel construction, and he confronted the combination of central horizontal planks and two vertical planks at the sides with a special cradle assembly that sought to account for the movement directions of the different areas: the fixed horizontal members in the middle functioned in the vertical side planks as moveable crossbars for the members attached there following the grain direction (*fig. 2*).[23] The two lateral joints between the horizontal and vertical areas were probably not glued, but the planks instead only held together by the cradle. The spaces left for the crossbars in the fixed cradle members also show that (calculated) play was foreseen for the expected movements of the panel or its individual parts. Nonetheless, at the start of the project in 2015 these spaces were totally blocked such that the cradle exerted tension on the panel, a fact that made new intervention urgent.

The negative effects on the paintings of the new heating system by Meißner and the resulting extreme dryness was apparently visible within a few years: From 1832, Krafft sought to maintain the temperatures in winter below 10°C to prevent further damage to the panel paintings.[24] In 1859–1860, his successor Erasmus Engert had protective screens and metal pans constructed, the latter filled with water and positioned at the openings of the air shafts to humidify the air flowing past. In 1866, Engert determined that in its forty years of existence, the Meißner heating had caused major damage to the paintings.[25]

No interventions to *The Stormy Landscape* are documented in connection with the transfer of the collections to the 'Imperial and Royal Court Museum' on the Ringstraße.[26] The principle of heating with warmed air was retained, and quickly also showed negative effects in the new building.[27] The installation under Eduard von Engerth was soon followed by amendments, among them the extensive glazing of the paintings.[28] This was vehemently attacked by art historians, however. In 1902, August Schäffer von Wienwald, director of the museum's

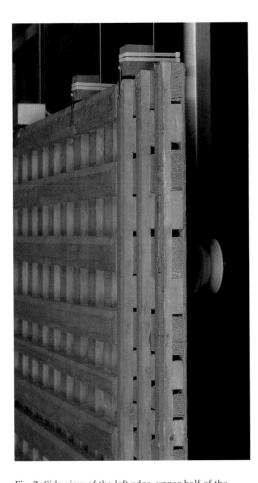

Fig. 2: Side view of the left edge, upper half of the painting: in the cradle affixed in ca. 1830, spaces were left to allow for the expected movements of the panel. Through shrinkage perpendicular to the grain, the middle of the panel has decreased in height while the vertical planks remain unchanged. In the upper half of the picture, the crossbars were shifted downwards toward the centre, and the spaces were blocked as a result.

Fig. 3: Detail of the upper left of the picture, before conservation treatment. The condition has clearly deteriorated compared with the photograph from 1905.

Picture Gallery from 1892–1910, explained the motivations for the glazing in the gallery: a 'positive effect of glazing,' Schäffer wrote, was that 'cracked planks in other pictures always changing in width, as e.g. in the large landscape by Rubens, have, without any action of the restorer's hand, closed so far that they now no longer appear disturbing, indeed are only noticeable to a slight degree.'[29]

The glazing was probably already removed under Gustav Glück (1911–1930), as the reflections when viewing the pictures were generally perceived as too disturbing.[30] The climatic conditions remained unchanged. They dramatically worsened again during the extremely cold winter of 1928–1929, after which loose paint on numerous paintings had to be secured. Only then were additional humidifiers added.[31]

Like other fragile paintings, *The Stormy Landscape* was evacuated close to Vienna during the Second World War: in 1939 it was brought to the Carthusian monastery of Gaming and in 1944 to Klosterneuburg, from which it returned in autumn 1945.[32] Its problematic condition continued to concern the gallery directors, as a 1950 letter from Friederike Klauner indicates: 'the conservation department of the Picture Gallery is currently occupied with the restoration of particularly precious pictures. The *Return of the Hunters* by Bruegel must be completely, the *Assumption of the Virgin* and *Thunderstorm* by Rubens partly transferred to new supports. The work can no longer be postponed, as the condition of the paintings will otherwise be extraordinarily endangered.'[33]

This partial transfer of the right, vertically oriented planks of the *Assumption of the Virgin* was in fact performed; the Bruegel and Rubens's *Stormy Landscape* were not transferred, however, as the advisory council spoke against it – the correct decision from our current perspective.[34]

In closing, it can be observed that the increased heating of the gallery rooms during the nineteenth and twentieth centuries was responsible for the greatest loss of volume: this is clearly recognisable through the crossbars of the cradle, which protrude by 1 cm. The cradle was completely blocked by this change in volume and would have caused further opening of the cracks in the original panel. The panel's visibly worsening condition thus demanded renewed engagement with the dynamics of damage (*fig. 3*).[35] Through its collaboration with leading panel experts, particularly those experienced with Rubens's panel constructions, the recent treatment is based on decades-long experience in wood technology and scientific research. To conserve the current condition, however, a stable environment is the most important factor. *The Stormy Landscape* was hence placed behind glass and in a microclimate enclosure for added protection.

1 The entry in the estate inventory is cited in the introduction of this volume; on Rubens's creative process, see the essays by Gerlinde Gruber and Ina Slama.
2 See plates IX–XI as well as the essay by George Bisacca in this volume.
3 See Brown & Reeve 1996, 28; Davis & Bobak & Bobak & Straub 2020.
4 See the essay by Gerlinde Gruber in this volume.

5 It does not appear in the installation documented by Ferdinand à Storffer. See Haag & Swoboda (eds.) 2010.

6 Mechel 1783, 118, no. 7; Engerth 1884, 394–395; Gruber 2006/2007, 360–361, 395-396.

7 Hoppe-Harnoncourt 2001, 146, 170, 171, 180–181, 201: talk was of mouldered pictures, 'vermoderten Bildern' (OkäA-B, Z. 631/182).

8 '1mo daß acht öfen in allerhöchstdero bildergalerie (4 in der ersten und 4 in der zweiten etage) wegen conservation deren bildern geheizet werden müßen. 2do dass er zur heizung zweier arbeitszimmer (wo die reparation derer bilder gemacht wird) auf allerhöchsten befehl im winter täglich zwei tragn holz erhalten', Rosa to the Keeper of the Privy Purse Count Rosenberg, cited in Hoppe-Harnoncourt 2001, 146. Rosa also installed shades in the Stallburg and heating so that work could be done in winter (see *ibid.*, 139–145).

9 'Hingegen im fünften Niederl. Zimmer N. 4. 5. 6. 7. 9. 10. gebuzt und repariert worden' in a 'List of those paintings of the Royal and Imperial Picture Gallery which, on the occasion of their new installation in the years 1780 and 1781, from necessity due to their poor condition, were cleaned and repaired, also in part due to earlier mutilation and trimming were augmented or brought to their true size, to also be able to use some of these as overdoors' ['Verzeichnis jener Gemälde der K. K. Bildergalerie, / welche bey Anlaß ihrer neuen Einrichtung in den Jahren 1780. & 1781. / aus Nothwendigkeit wegen ihrem üblem Zustand / sind gebuzt und repariert, / auch zum Theil wegen vorher geschehener Verstümmelung / und Wegschneidung sind ergänzt, / oder in ihre wahre Größe gebracht worden, / desgleichen auch um einige als Supra-porten / gebrauchen zu können']. See Swoboda 2013, vol. 1, 286–291, esp. 289.

10 Considered in greater detail in the essay by George Bisacca in this volume.

11 Hoppe-Harnoncourt 2001, 180.

12 On the evacuations, see Hoppe Harnoncourt 2001, 156-157.

13 Documented in lists of crates from 1805 and 1809: HHStA, OkäA-B, Z. 248/1813 Evacuation 1805–1806: 'In crate no. 13 P.P. Rubens "a large landscape"' ['In Kiste Nr. 13 P.P. Rubens "Eine große Landschaft"']. Evacuation 1809–1810: 'In crate no. 16 Rubens "a large landscape with a thunderstorm"' ['In Kiste Nr. 16 Rubens "Eine große Landschafft mit Gewitter"']. The entire gallery was evacuated again in 1813, but no inventory was made. I thank Alice Hoppe-Harnoncourt for the precise references.

14 *The Stormy Landscape* is not listed in the *Inventaire Napoleon*. Thanks to Sabine Pénot for this information.

15 Hoppe Harnoncourt 2001, 158, 180: Renewal of the roofs from 1800; replacement of the rotted beam ceilings above the Rubens room and the connecting rooms; in 1806, renewal of the roof on the Netherlandish side; in 1826, the open staircase was closed with glass doors and the Meißner heating installed; in 1828, Rebell was already obliged to request winter doors and new winter windows, as the glass doors were not adequate for the winter and the windows on the windward side had already decayed, but these were rejected on budgetary grounds.

16 These proceeded only sluggishly due to personnel problems (from 1822 when Rosa Jr. died until 1824, there was only one custodian (*Custos*) for the collection). Oberthaler 1996, 29; Hoppe Harnoncourt 2001, 200, and see OkäA-B, Z. 1370/1824.

17 Oberthaler 1999; Oberthaler 1998, 45–46.

18 Meißner 1823; Hoppe-Harnoncourt 2001, 158.

19 'das gehörige Maß an Wärme,' Hoppe-Harnoncourt 2001, 181.

20 This is documented for summer 1827. Hoppe-Harnoncourt 2001, 181.

21 Hoppe-Harnoncourt 2012, 12.

22 Hoppe-Harnoncourt 2012, 13. She suspected that Friedle carried out the cradlings under Krafft, without mentioning *The Stormy Landscape*.

23 See the essay by George Bisacca in this volume.

24 Hoppe-Harnoncourt 2012, 13: 'He was able to achieve this by closing the openings through which the warm air heated the gallery rooms.'

25 Oberthaler 1996, 30. Erasmus Engert was director from 1856 to 1871; he was followed by Eduard von Engerth from 1871 to 1892.

26 Engerth 1884, no. 1171; Cat. 1892, no. 1163 (in gallery with skylights XIX).

27 Schäffer 1902: 'also in the Kunsthistorisches Court Museum was soon evident [...] that excessive dryness of air prevailed. Spraying machines were thus set up in the basement that were to direct the humidity into the gallery through ventilation tubes, which went hand in hand with the proven tactic of opening the windows.' ['auch im Kunsthistorische Hofmuseum zeigte sich bald [...], daß zu große Trockenheit der Luft herrschte. Es wurden demnach im Keller Sprühapparate aufgestellt, welche die Feuchtigkeit durch Ventilationsschläuche in die Galerie zu führen hatten, womit eine wohlerprobte Taktik durch Fensteröffnen Hand in Hand ging']. Thermometers and hygrometers were set up; the air pollution in Vienna and its consequences were also recognized.

28 Schäffer 1902.

29 'günstigen Folge der Verglasung. . . Stets in ihrer Breite wechselnde Brettsprünge an anderen Bildern, wie z.B. an der großen Landschaft von Rubens, haben sich, ohne dass irgendwie die Hand des Restaurators dabei beteiligt war, so weit geschlossen, dass sie nun nicht mehr störend wirken, ja überhaupt in geringem Maße bemerkbar sind.' Schäffer 1902.

30 Gustav Glück was director of the gallery from 1911 until 1931. On Glück, see Deiters 2016.

31 Oberthaler 1998, 52; Gallery file Zl.9/Gal/1929.

32 See the contribution by Gerlinde Gruber in this volume. Rubens's *The Fur* was also evacuated close to Vienna: see Gruber & Oberthaler 2015, 14, 16.

33 Gallery file ZL.13/Gal/1950: letter from Friederike Klauner to the general director *Ministerialrat* Dr. Karl Wisoko-Meytsky from 3.2.1950. Friederike Klauner was active at the museum from 1945, and director of the Picture Gallery from 1967–1981.

34 Gallery file ZL.13/Gal/1950.

35 Preliminary 2013 report by Sara Mateu in the context of an internship supported by the Getty Panel Painting Initiative, in the preparatory phase of the project in Vienna.

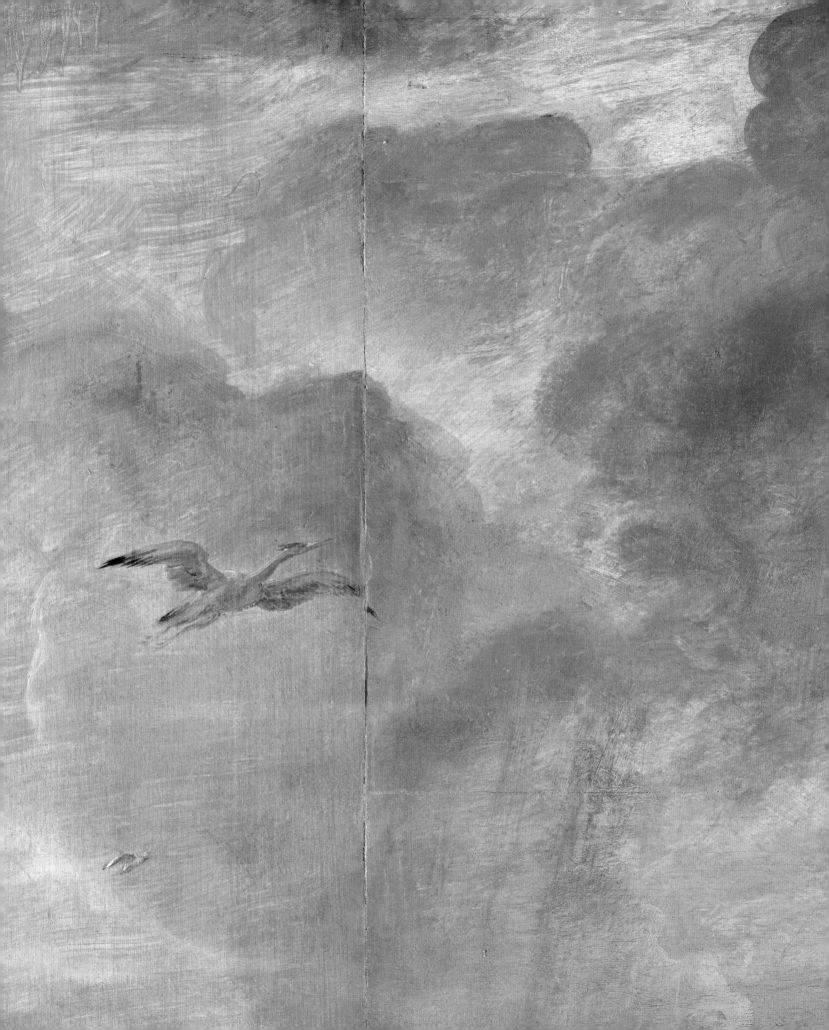

Plates

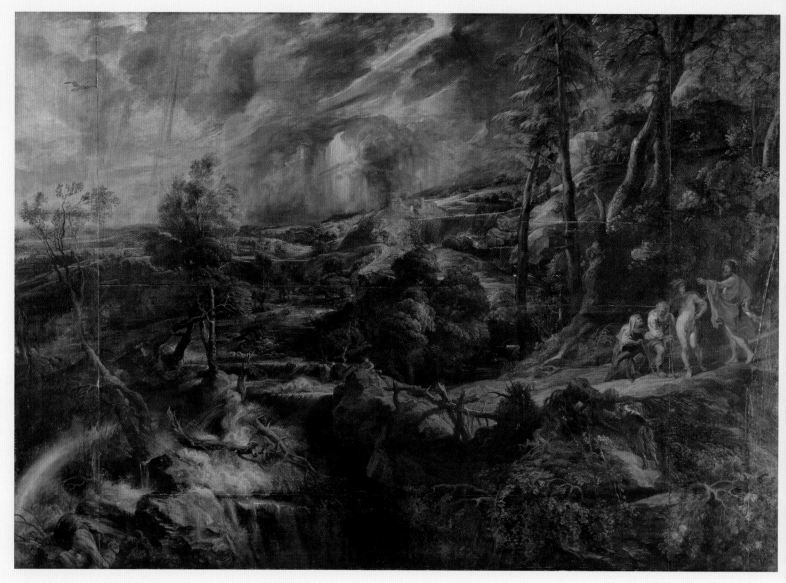

I Before conservation

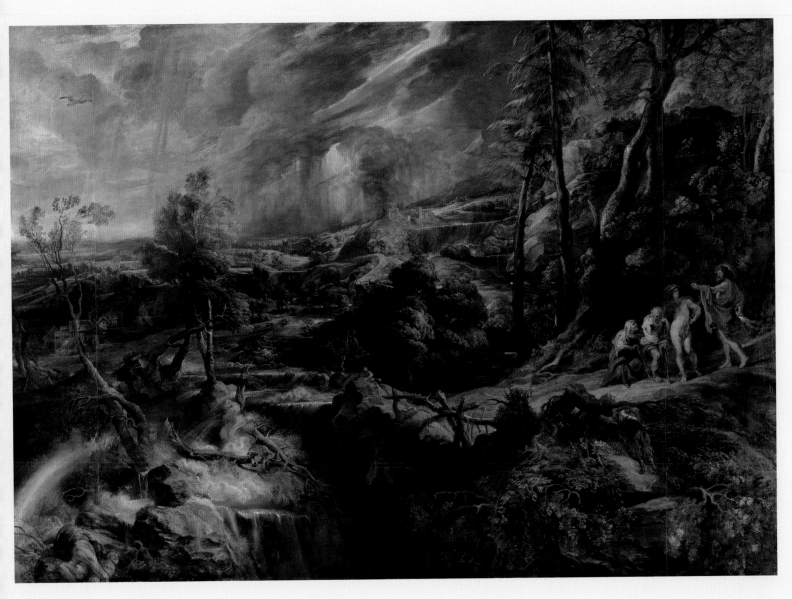

II After conservation

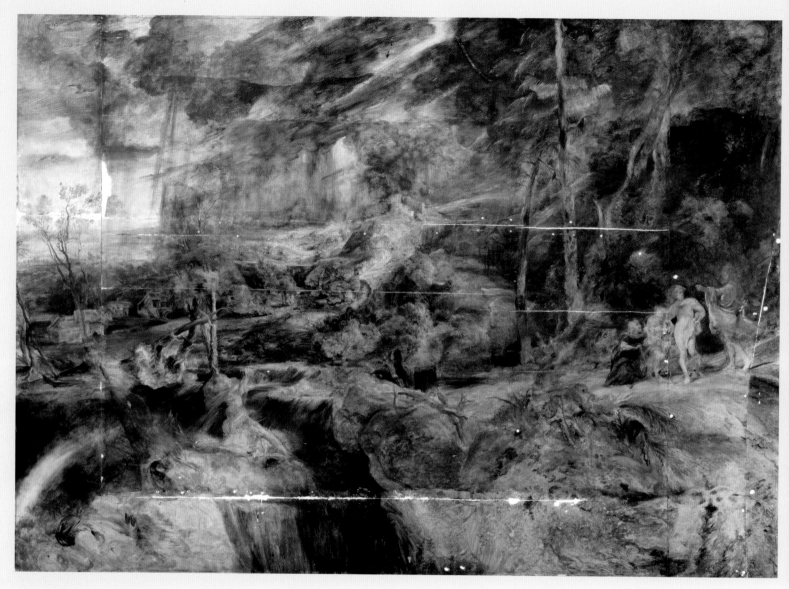
III Infrared reflectogram after cleaning and filling

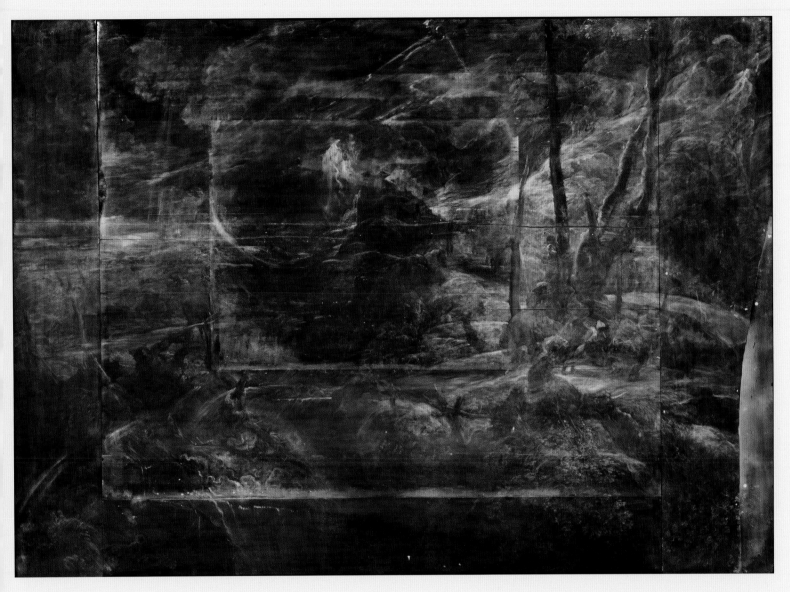

IV X-radiograph

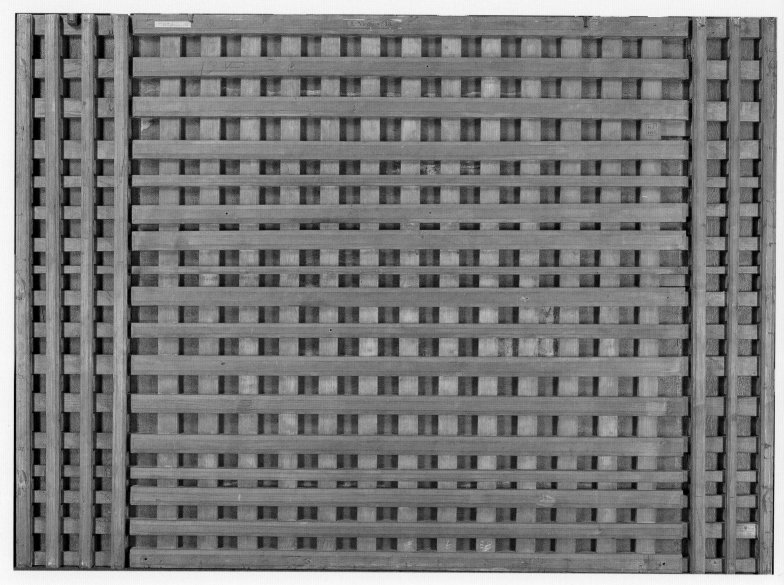

V The cradled reverse before conservation

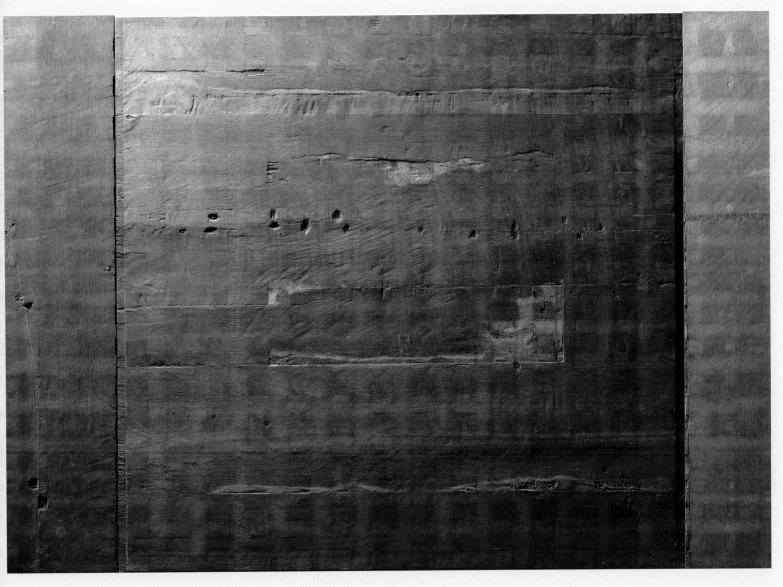

VI The reverse seen in raking light, after removal of the cradle and consolidation of the cracks

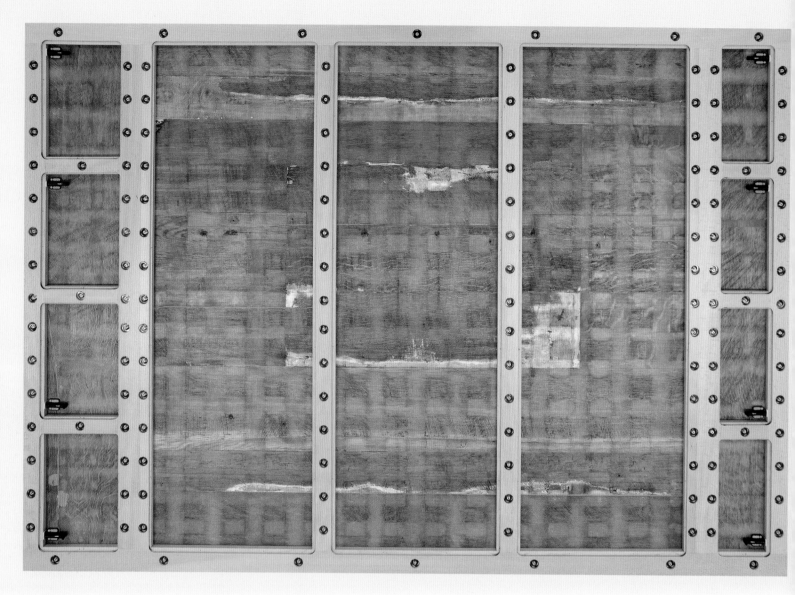

VII The strainer, constructed as a single element with 140 adjustable spring mechanisms. Two of the vertical members are double-width, to connect the central and vertical parts of the panel.

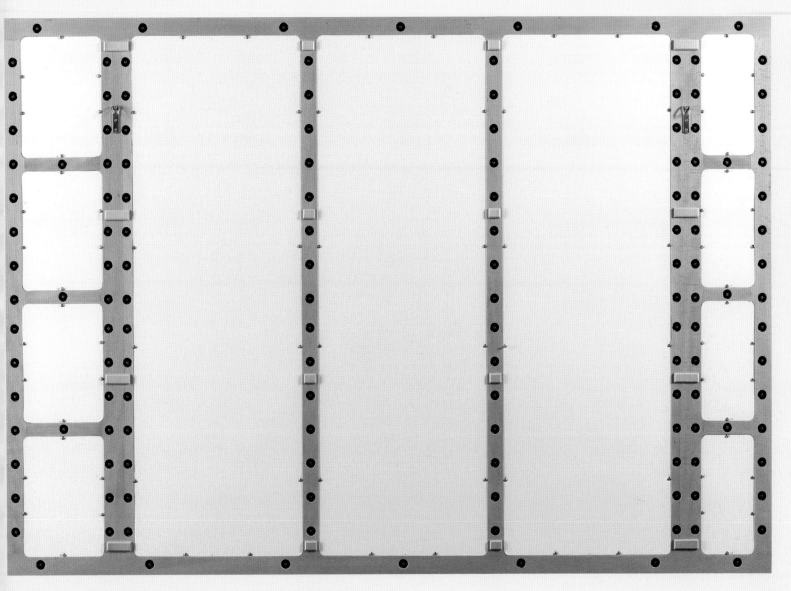

VIII The reverse with the strainer and backing made of thin sandwich board (KAPA® plast)

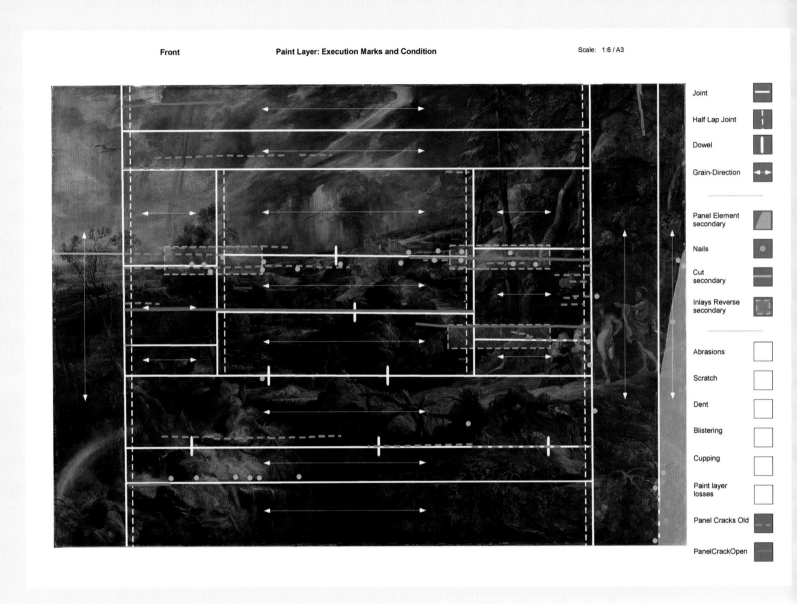

Legend:

- Joint
- Half Lap Joint
- Dowel
- Grain-Direction
- Panel Element secondary
- Nails
- Cut secondary
- Inlays Reverse secondary
- Abrasions
- Scratch
- Dent
- Blistering
- Cupping
- Paint layer losses
- Panel Cracks Old
- PanelCrackOpen

IX Documentation of the support: diagram showing the assembly of the planks, grain direction, joints, and later changes: wood inserts, cracks, and nails

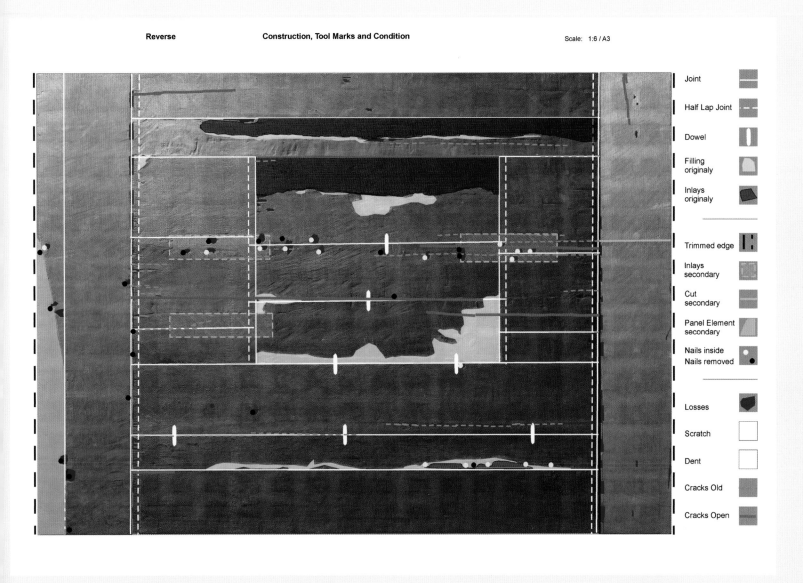

Joint

Half Lap Joint

Dowel

Filling
originaly

Inlays
originaly

Trimmed edge

Inlays
secondary

Cut
secondary

Panel Element
secondary

Nails inside
Nails removed

Losses

Scratch

Dent

Cracks Old

Cracks Open

X Documentation of the support: diagram of the reverse showing plank assembly (white), narrow, original wood inserts (dark blue), remains of the original gesso ground (yellow). Later changes: inserts (light blue) and losses (red)

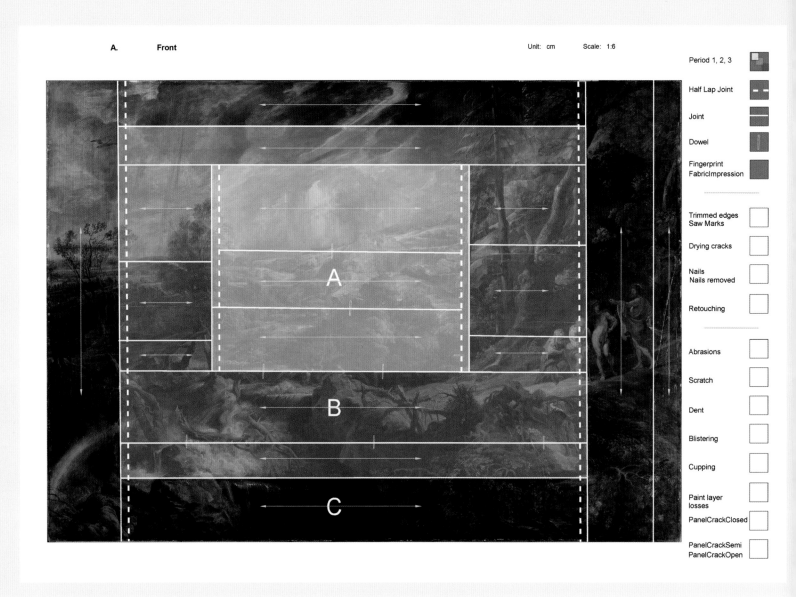

A. **Front**

Unit: cm Scale: 1:6

Period 1, 2, 3

Half Lap Joint

Joint

Dowel

Fingerprint
FabricImpression

Trimmed edges
Saw Marks

Drying cracks

Nails
Nails removed

Retouching

Abrasions

Scratch

Dent

Blistering

Cupping

Paint layer
losses

PanelCrackClosed

PanelCrackSemi
PanelCrackOpen

XI Diagram showing the three stages of enlarging the panel A, B, and C, with plank assembly and grain direction

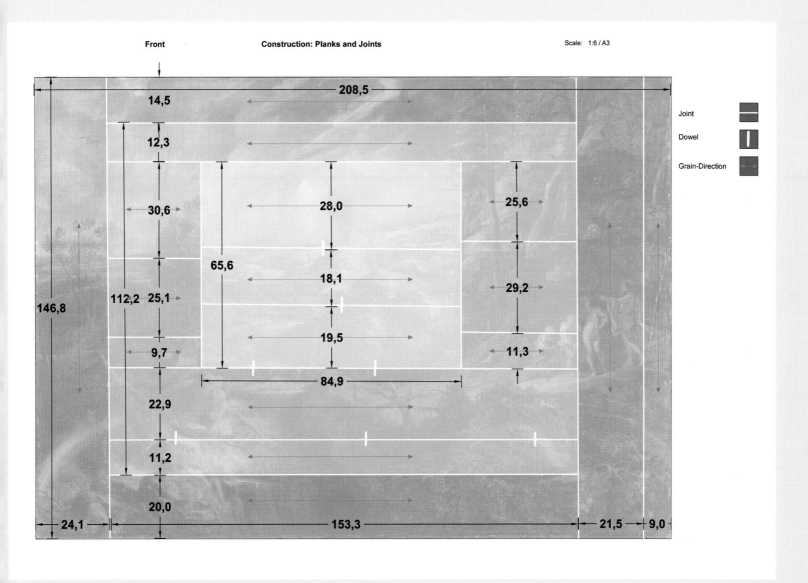

Joint

Dowel

Grain-Direction

XII Diagram of the three stages of enlarging the panel A, B, and C: dimensions of the planks (cm), assembly, and grain directions

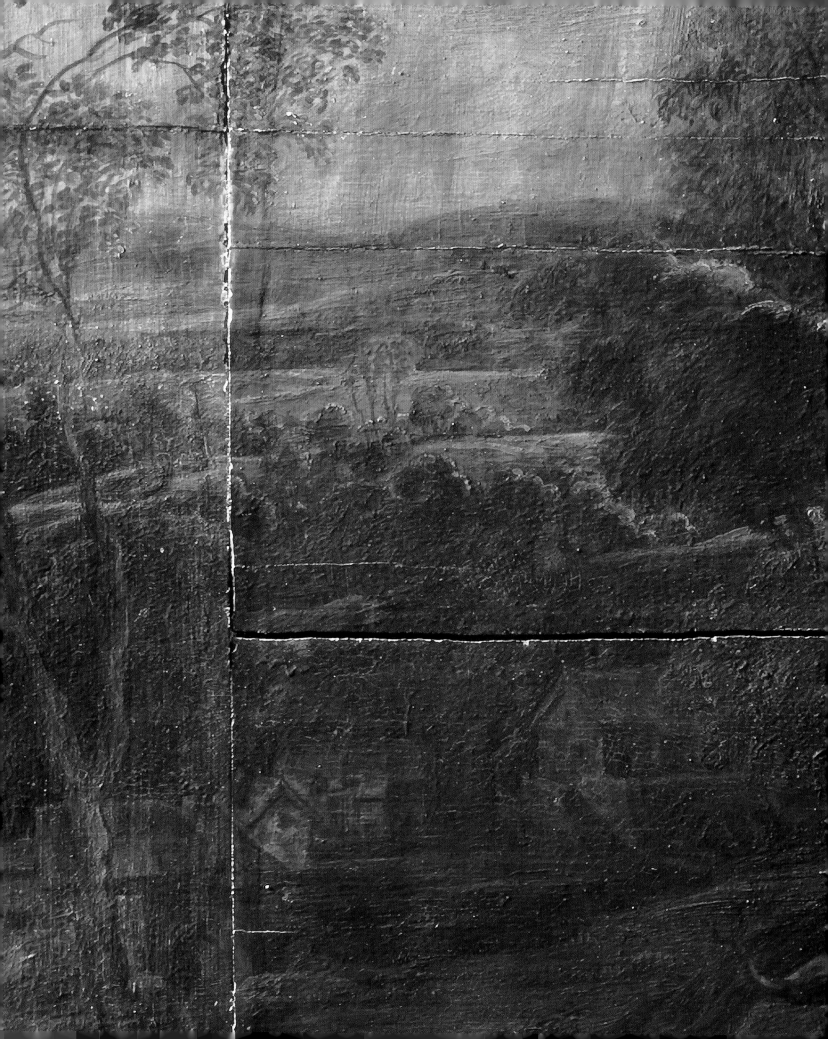

George Bisacca

Structural Treatment and Evaluation of Original Support

Treatment: George Bisacca, José de la Fuente and Georg Prast
Assisted by: Aleksandra Hola, Adam Pokorný and Johannes Schäfer

During the structural conservation treatment of the *The Stormy Landscape with Philemon and Baucis,* certain technical details emerged regarding the methodology employed by Rubens (and his panel makers) in the enlargement of his uncommissioned panels.[1] These observations support the generalized ideas set forth in the catalogue of the 2017 exhibition *Rubens. The Power of Transformation.*[2] That essay sought to dispel notions that the unorthodox constructions were due to Rubens's insistence on using small scraps of wood for reasons of frugality, or because these small pieces somehow improved the stability of the overall structure.

What follows is a chronological sequence of the treatment of the *The Stormy Landscape* and the evidence that came to light.

CONDITION PRIOR TO INTERVENTION

Prior to treatment in 2015, the panel exhibited numerous horizontal splits, many of which had been caused by the blockage of a heavy cradle, however others certainly predated its application (*fig. 1, pl. IX*). The complex panel construction was destined for problems from

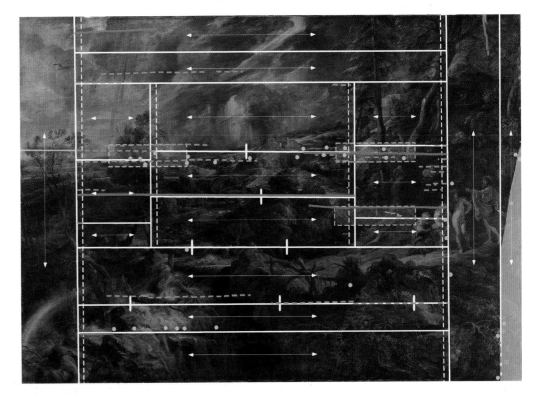

Fig. p. 48: Detail: Horizontal splits in the central section caused by additions contrary to the grain. Board on left is oriented vertically (horizontal line in upper area of this board is a saw cut across the grain from a later restoration).

Fig. 1: Map of significant features including configuration of boards, grain orientation, half-lap joints and dowel placement. Non original elements are also indicated: wooden inserts, splits and nails (see pl. IX).

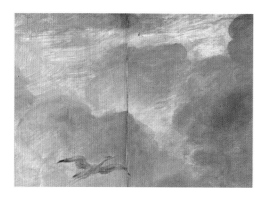

Fig. 2: Misalignment of design details (wingtip). Central horizontal section (on right) has shrunk across the grain by approximately 7 mm while vertical additions (left) retain original length.

Fig. 3: Overall reverse: cradle before intervention

its inception, owing to the two vertical elements on the extreme left and right oriented contrary to the grain of the rest of the panel. These two elements were now clearly separated from the main panel and held in place only by the cradle.

The vertical board on the left had also been sawn completely in two across the grain.

The vertical element on the right (which was composed of two boards) had suffered damage at some undetermined point. It probably sustained a serious impact, breaking the outermost board first along the joint from the bottom right and then diagonally across the grain. The paint film and ground in this area differ significantly from the rest of the panel, and questions have been raised about its authenticity.

The central section, consisting of only horizontally oriented elements, had shrunk approximately one centimeter with respect to the vertical sections, causing slight misalignment of some design details (*fig. 2*).

CRADLE AND CRADLE REMOVAL[3]

According to conservation records at the Kunsthistorisches Museum, the cradle seems to have been attached sometime between 1829 and 1830 (*fig. 3*).[4] It was constructed in the typical fashion, with the glued members adhered along the grain and the free sliding members

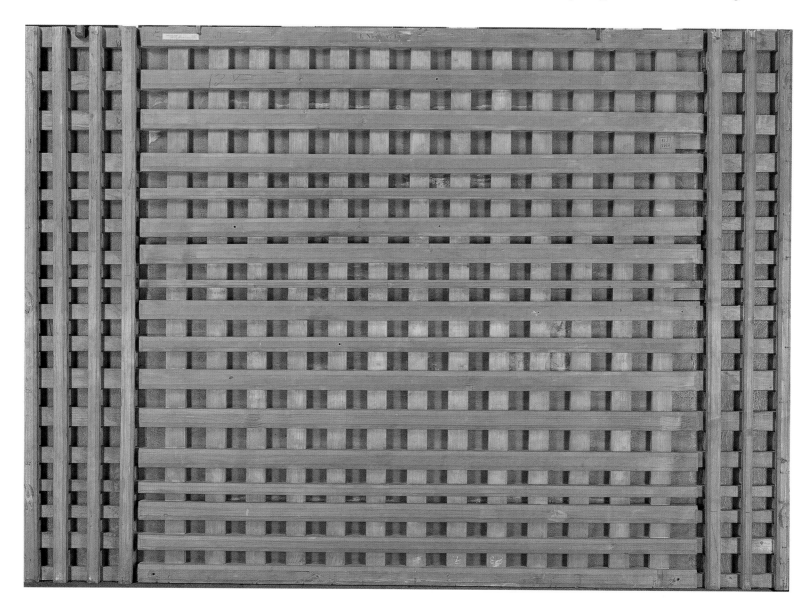

4

5

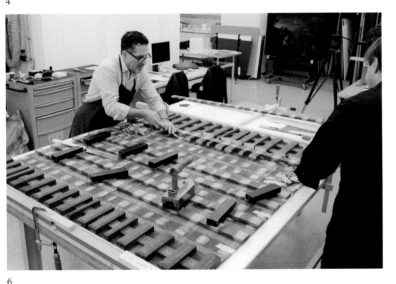

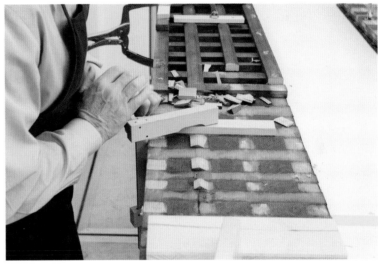

6

7

Fig. 4: Detail: saw cuts were first made across glued members in order to release blocked sliding members.

Fig. 5: Remaining blocks were pared away.

Fig. 6: Crossmembers were temporarily weighted to prevent it from warping.

Fig. 7: Demolition of cradle from vertical addition. Note: three blocks temporarily left in place to support previous repair

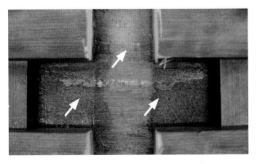

Fig. 8: Glue residue below a removed sliding member indicates that some sliding members were blocked from the moment of the cradle's application.

oriented across the grain – however with one ingenious modification: the fixed members of the central section are continuous across the entire width of the panel but are left unglued across the narrow vertical sections at the left and right, effectively becoming the sliding members of independently functioning cradles. This modification basically creates three independently functioning cradles held together by the shared horizontal members.

Cradles made of softer woods (such as the spruce or fir employed here) have a greater tendency to become blocked due to greater cumulative shrinkage and subsequent increased friction of the intersecting components, as in this case.

The straightforward removal of the cradle proceeded without incident. Japanese saws and hand tools were used to pare away the glued members after saw cuts were first made to release the sliding members (figs. 4-7).

Evidence indicated that various sliding members had been blocked from the outset because of glue that had seeped underneath during the gluing of the fixed members (fig. 8). The removal of the cradle effectively separated the panel into its three component sections: the central section composed of horizontally oriented wood grain, and the two vertically oriented sections at the left and right.

Fig. 9: During removal of the cradle: the initial 'core' panel with remnants of original gesso ground becomes immediately visible.

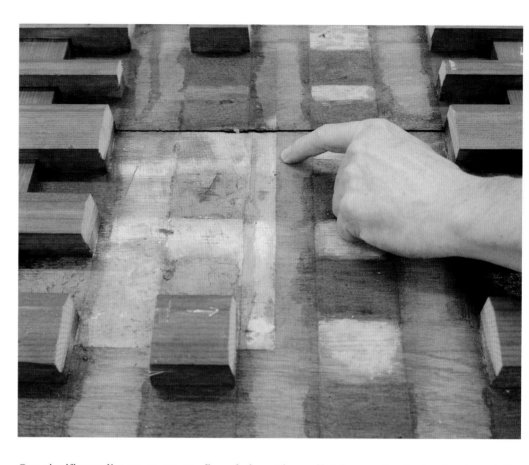

Fig. 10: Clearing the reverse of hide glue residue by careful scraping with sharpened steel scrapers.

Fig. 11: Removal of hide glue residue, later gesso fillings, wax, and dirt particles from inside open splits with scalpels to ensure better adhesion.

One significant discovery was confirmed almost immediately upon beginning treatment: the vertical edges of the initial 'core' panel became clearly visible on the reverse (*fig. 9*).

After complete removal of the cradle, hide glue residue, stain, and wax were mechanically removed from the reverse of the three sections with sharpened steel scrapers (*figs. 10*).[5] Extremely small amounts of wood fibers were ultimately removed in the process as evidenced by the fact that the grid pattern of the cradle still remained visible after scraping.

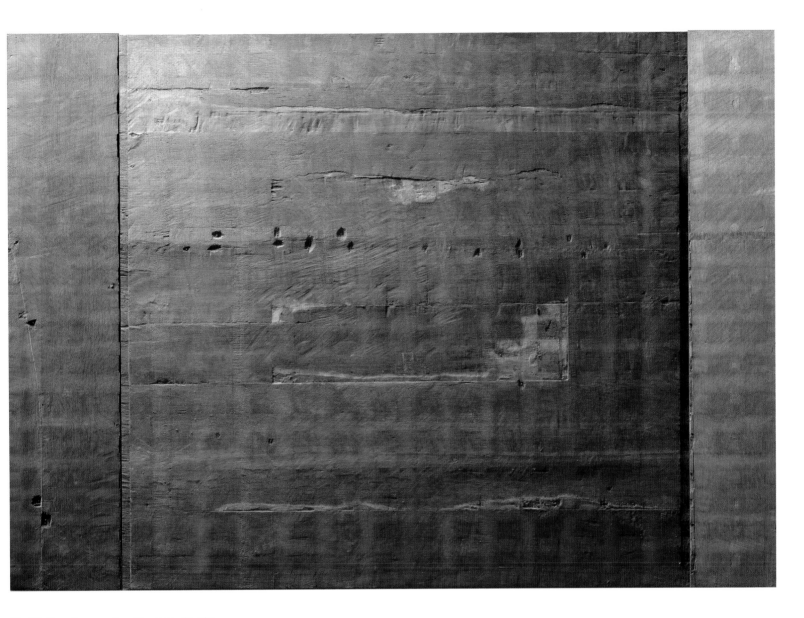

Fig. 12: Overall reverse in raking light after the removal of the cradle and consolidation of splits

READING OF CLEARED REVERSE SURFACE

It must be emphasized that the reverse surface is not the original surface. The reverse of the panel must have been planed in order to obtain a flat surface on which to apply the cradle. Despite the consequent loss of information, much can be learned by close examination (*fig. 12, pl. X*).

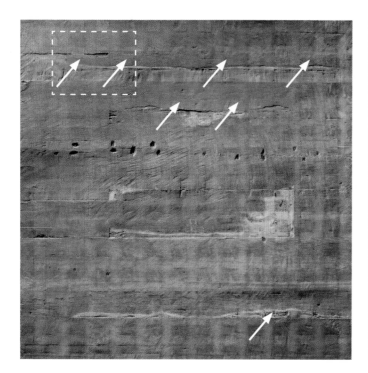

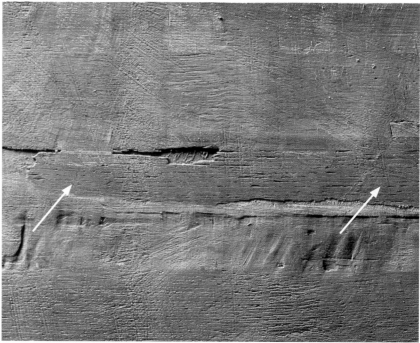

Fig. 13a: Detail: reverse of central section in raking light. Arrows indicate thin irregular remnants of oak from original backing boards probably planed away to obtain a flat surface for attachment of cradle.

Fig. 13b: enlarged view of fig. 13a: thin irregular remnants of oak-backing boards. Note: gesso ground continues beneath these remnants.

Remnants of Ground

The most conspicuous artefacts clearly visible on the reverse are the five areas partially covered by gesso. These are remnants of the original gesso preparation frequently found on the reverse of unthinned panels by Rubens (probably applied by studio assistants or the panel maker) and which served to equilibrate moisture exchange by creating a symmetrical layer structure on both sides of the panel. This coating is likely to have covered most of the panel but much was lost, possibly during the thinning of the panel for the application of the cradle. There is further evidence, however, that some or much of this coating may already have been planed away during the process of enlarging the panel. In at least four areas spanning two of the three stages, very thin remnants of high-quality oak cover these gessoed areas (*fig. 13, pl. X*). That is, the visible gesso clearly continues below the surface of these thin irregular fragments of oak (*figs. 13a-b*). This oak must have been part of an additional backing of horizontal boards applied to strengthen the half-lap joints after the first and before the second campaign of enlargement. There is no evidence that this backing continued onto the vertical sections on the left and right or, indeed, onto the two outermost horizontal boards of the second set of additions. It would make structural sense not to continue this horizontal backing onto the vertical sections because that would further obstruct expansion and contraction of the verticals. The thickness of the verticals, then, and the outermost horizontal boards of the final additions (see *Third Stage* section below) may well have been equal to the combined thickness of the existing painted elements plus this additional backing (*figs. 14-15*).[6]

Rectangular Inserts

Another interesting discovery is the existence of three horizontal inserts, two on the left and one on the right, which bridge across from the 'core' panel onto the first enlargement (*pl. X*). The asymmetric placement and slightly lower precision suggest that these three elements are not original but probably a very early repair, since all three are positioned over what appear to be preexisting cracks. These three inserts were likely to have been added just before the backing boards mentioned above. None of the inserts is visible on the paint surface; the two on the left are narrower and the wider one extends farther into the core panel. The existence of these repairs is further indication that cracks appeared comparatively early in the life of the panel.

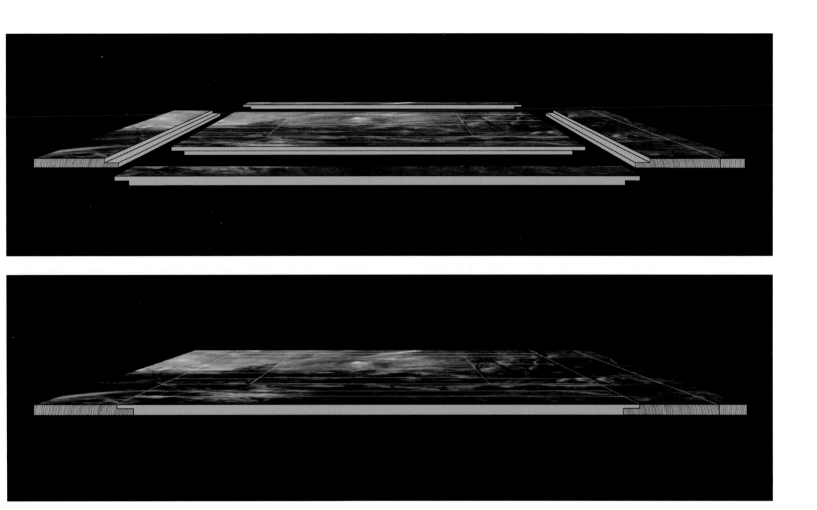

Fig. 14: Exploded image showing hypothetical backing of the central section. Backing boards are laminated to the central core and first set of additions only. The final four additions around the perimeter are then double thickness, equal to the laminated central section.

Fig. 15: Exploded image showing hypothetical backing of the composite seen from the bottom edge. No lamination is visible after the final additions are in place.

Gouged Cavities

A series of gouged cavities is present (especially visible in raking light) above and below the most significant splits. These are the sites of no fewer than thirty-five nails inserted from the painted surface, through the panel thickness, and into a horizontal batten or the backing boards mentioned above, with the intention of bringing the paint surface into alignment across the splits. This crude attempt at conservation was probably executed in the late eighteenth or early nineteenth century, as it predates the diffusion of the cradle as a common method of treatment.[7] The deep cavities themselves were gouged just prior to the application of the cradle in order to gain access to the nail shafts. This would allow them to be cut below surface level to avoid damaging the plane blade while resurfacing the reverse to obtain a flat surface on which to attach the cradle. During the present treatment, many of these nails were extracted but others were left in place because of the potential to damage the paint film (*fig. 12, pl. IX, X*).

Half-lap Joints

The existence of a central core panel had not been previously noted anywhere in the literature (except in the exhibition catalogue of 2017). It was first observed by the author upon initial examination of the panel prior to treatment. A very slight rectangular depression corresponding to the core section was detected on the paint surface in raking light. Closer scrutiny revealed the limits of the vertical joints in the paint film at the perimeter of the core panel.

With the removal of the cradle, not only was the rectangle clearly visible from the reverse, but the disparity in the measurements of the core between front and back virtually confirmed the presence of half-lap joints on the vertical edges of the core. The joint itself

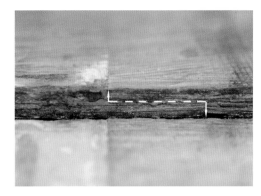

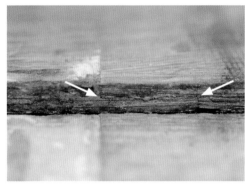

Fig. 16a-b: Detail: Half-lap joint between the central section and the first set of additions. (Open split was spread to reveal inner joint face during the intervention).

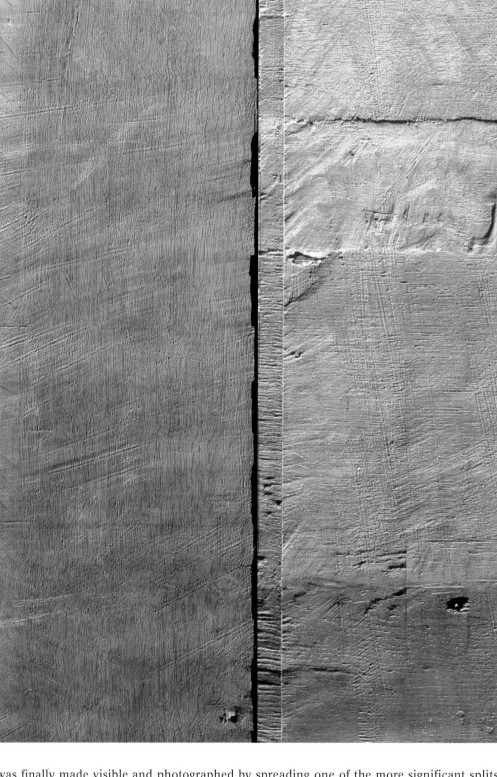

Fig. 17: Detail: juncture between vertical and horizontal elements. Note: shallow track from half-lap joint still visible on the edge of the horizontal section.

was finally made visible and photographed by spreading one of the more significant splits that bridged across from the core to the first enlargement (*fig. 16a-b*).

The vertical elements on the left and right of the overall construction were also attached by half-lap joints. The routed tracks of the joints are faint but still clearly visible along the vertical edges of the horizontal boards of the central section, and thin remnants of the overlapping joint are present on the edges of the vertical outer boards (*fig. 17*).

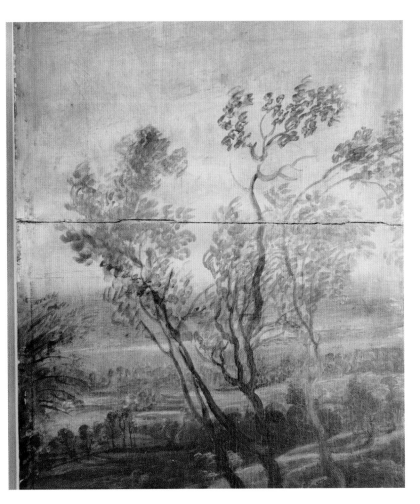

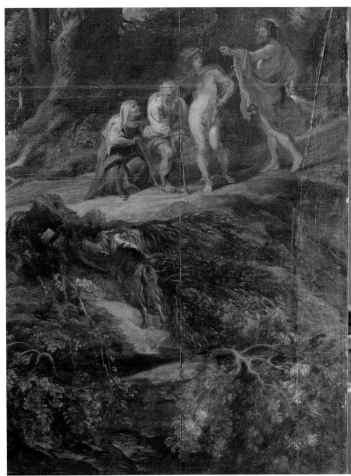

Fig. 18: Detail: saw cut across the left vertical addition

Fig. 19: Detail: repaired area at bottom right corner of right vertical addition

Cut Board

The single vertically oriented board on the extreme right (extreme left when viewed from the front) had been completely sawn across the grain into two pieces in a previous undocumented restoration treatment. The saw cut corresponds exactly with one of the principal horizontal splits in the main panel and was likely undertaken in an effort to close the gap created by the shrinkage along that split (*fig. 18*).

Broken Fragment

The vertically oriented section on the extreme left (extreme right when viewed from the front) is composed of two boards. The bottom section of the narrow board on the outside edge sustained a serious impact at some point, breaking the board off along the joint and then diagonally across to the outside of the panel. This is the area in the bottom-right corner of the painted image: the board broke straight up from the bottom along the joint, and then diagonally to the right just before Jupiter's proper left heel (*fig. 19*). The entire paint film over this area has been questioned in the past, not only because the *imprimatura* has a different tonality (a characteristic not uncommon in Rubens's additions), but also as the gesso preparation has deep scratches which were present before the paint was applied (very uncharacteristic of Rubens's grounds). Many assumed that this fragment was merely broken off and the original piece simply reattached, but close examination of the reverse revealed that the woodgrain is not continuous and does not match; the fragment was in fact lost and replaced with a different piece of oak. The fit is reasonably good, yet not at the level of the original carpentry (refer to the X radiograph in *pl. IV*).

Simple Splits

Several splits were repaired by various means of applying clamping pressure to bring the paint surface into alignment during curing of the adhesives (*figs. 20-22*). The choice of adhesive depended on numerous factors including accessibility of split, width of gap, pressure required to achieve surface alignment, and cleanliness of gluing faces. Adhesives ranged from codfish glue (Lee Valley high-tack fish glue) to polyvinyl acetate emulsion to two-component epoxies (Huntsman Araldite 2011) and gap filling carvable paste resin (Huntsman HV/AV1253). Splits were generally first cleaned (to the extent possible) of gesso fillings and adhesive residues before gluing (*fig. 11*).

Fig. 20: Insertion of short oak blocks into wide split between first and second set of additions. This split could not otherwise be closed because of intact lap-joint at left.

Fig. 21: Various clamps in place for accurate surface alignment during gluing process. Low-tack yellow tape protects paint surface during application of adhesive.

Fig. 22: Excess adhesive cleared from surface before curing

Fig. 23: Joining the two pieces of the left vertical addition with Araldite 1253. The fragile end-grain join is temporarily held in surface alignment before reinforcement of the reverse.

Fig. 24: Reinforcement of saw cut through left vertical addition. Deeper routed track filled with aged oak pieces in the correct grain orientation. Second wider track prepared for additional pieces to be inserted along the grain.

Fig. 25: Fitting of second set of blocks. Two tier 'stepped' repair exponentially increases stability of the repair.

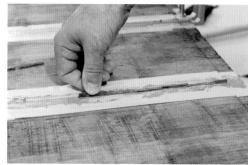

20

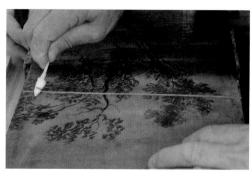

21

22

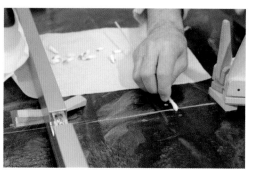

23

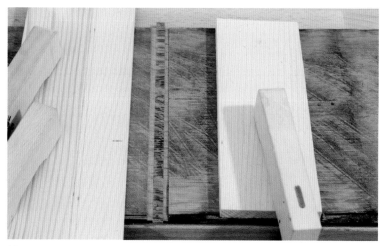

24

25

26

27

28

Fig. 26: Construction of one single support strainer made of beech

Fig. 27: Threaded brass discs with flexible nylon screws spot-glued to panel surface after isolating with Acryloid B-72

Fig. 28: Placement of the strainer over the brass discs and before insertion of laser-cut flat spring discs

Fig. 29: During arrangement of the 140 mechanisms that connect the three independent sections of the panel to the single support strainer

Endgrain re-attachment

As stated above, the vertically oriented board on the extreme right (extreme left when viewed from front) had been sawn completely in two across the grain. No adhesive alone, no matter how strong, is capable of creating a durable bond between two endgrain pieces. Therefore, a decision was made to rout a track 5 millimeters deep and 5 millimeters wide on each side of the cut. The track was filled with short oak blocks oriented in the grain direction and glued with a polyvinyl acetate emulsion. A second track 3 millimeters deep and two centimeters wide was then cut over the previous one, creating a stepped effect, greatly increasing the bond by staggering the depth of the cuts to reduce endgrain weakness (*figs. 23-25*).

Coating of the Reverse

As noted, the original reverse of the panel had likely been coated with a gesso preparation to equilibrate the rate of moisture exchange with that of the paint surface. That surface had been planed at least once previously. In the present treatment, after the removal of the cradle, the panel was again lightly scraped to remove glue residue, setting up a potential disequilibrium in moisture exchange between front and back.

A coating of Paraloid B-72 was applied as a partial moisture barrier.[8] This coating also acts as a release layer for the subsequent attachment of a new secondary support.

Secondary Support

This unusual case required a solution that would allow the three separate elements to remain independent of each other yet still read as a unified whole. Each section needed to be held firmly in place but without obstructing expansion and contraction in opposite directions.

The construction of three separate supports was considered as an option, but ultimately a single support was devised.

Strainer

A perimeter strainer with four additional vertical members was fabricated from evaporated beech (*figs. 26-29*). The two members aligning with the junctures between vertical and horizontal sections of the panel are double width (*figs. 30, 32*).

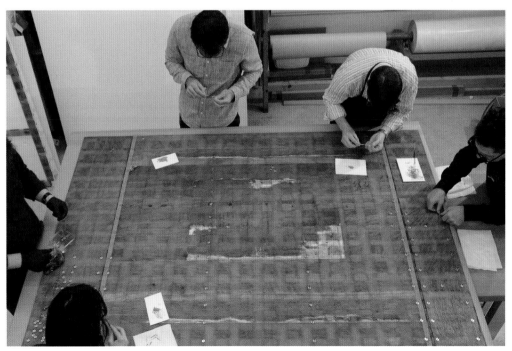

29

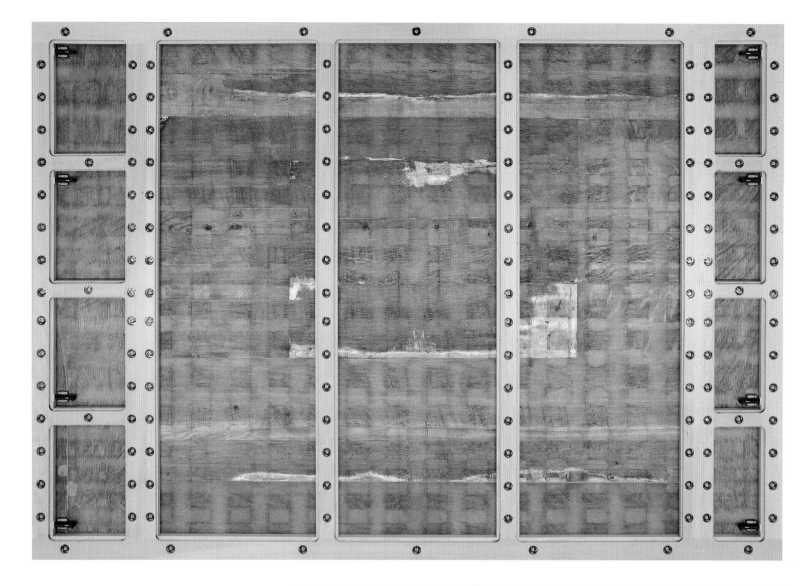

Fig. 30: Overall reverse after treatment. The two double width vertical members bridge across the open joints between the horizontal and vertical sections of the panel.

Fig. 31: Model showing the components of the spring mechanisms developed at the Metropolitan Museum of Art:
A: brass disc with threaded center hole
B: flexible nylon screw
C: laser cut, blue steel flat spring disc
D: brass grommet
E: hexagonal nut with hemispherical bottom (assembled unit at right)

Fig. 32: Second type of spring mechanism inside bottom right corner of support strainer. Mechanism (adhered to panel surface) pushes against strainer, moving vertical addition inward toward the open joint between the vertical and horizontal sections.

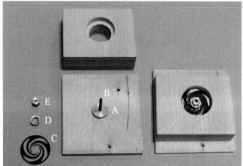

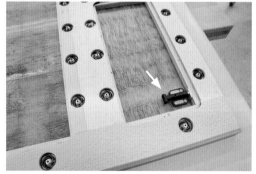

Spring Mechanisms

The strainer is connected to the panel by 140 adjustable spring mechanisms that permit three-dimensional movement. For this reason, the same mechanisms can be used for both the horizontal and vertical sections. The mechanisms, in double rows at the junctures between horizontal and vertical sections, can also be used to adjust the surface level of the paint film along the open joint (*fig. 30*). Additional thin shims were also inserted between the panel and the strainer for this purpose.

The mechanisms were developed at the Metropolitan Museum of Art in collaboration with Design Development Associates (*fig. 31*).[9] The mechanisms were adhered to the panel with Araldite 1253 carvable resin after first isolating the contact points with a second layer of Paraloid B-72.[10]

These mechanisms addressed issues of slight expansion and contraction and any minimal convex flexing of the panel; they also served to finely adjust the surface level along the two joints between the vertical and horizontal sections of the panel. However, the three sections remain independent of each other and there was some likelihood that the two vertical junctures could spread slightly over time, becoming increasingly visible and compromising the seamlessness of the overall image.

In order to counteract this tendency, a second type of spring mechanism, oriented horizontally, was attached to the two vertical sections and placed just inside the outermost vertical elements of the support strainer, four on each side. By exerting spring pressure against the side of the strainer, the vertical sections of the panel are constantly pushed inward, effectively tightening the open vertical joints and minimizing their visual impact (*fig. 32*).

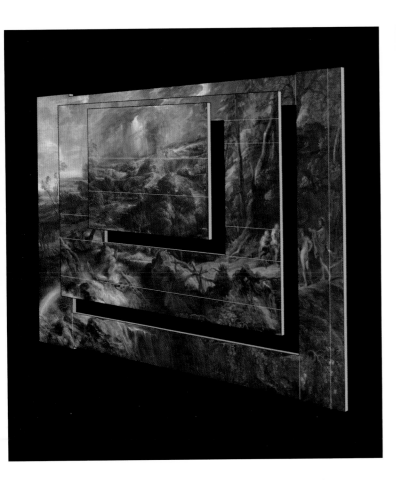 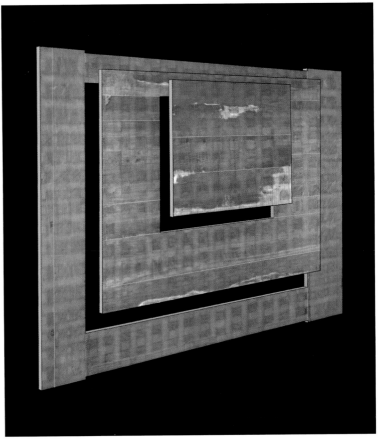

CONSTRUCTION RATIONALE

Three distinct stages in the construction of the panel can be discerned from physical evidence on both the front and reverse of the panel. A certain structural logic pertains at each stage and this coincides with aesthetic considerations regarding the image itself, such as the adjustment of the horizon line, the shift in perspective, or the proximity of the viewer (*figs. 33, 34*).

Initial Stage

The initial stage consists of three horizontally disposed boards, one wider and two of similar width, butt-joined together. This is the simplest method of constructing a rectangle of this size. Rubens organizes the initial idea as a centralized pyramidal composition with a castle at the apex.[11]

Fig. 33: Exploded image of the three stages (obverse)

Fig. 34: Exploded image of the three stages (reverse)

Fig. 35: Detail: 'Feathering' in raking light, a haphazard attempt to integrate the ground between the second to the third stage

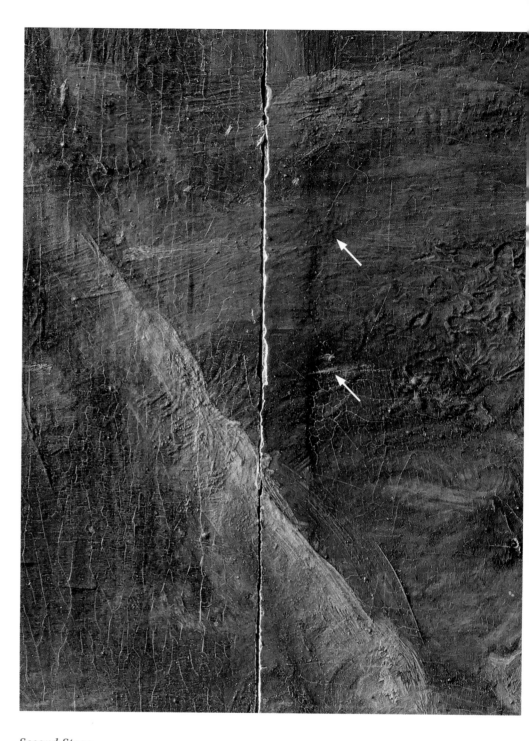

Fig. 35: Detail: 'Feathering' in raking light, a haphazard attempt to integrate the ground between the second to the third stage

Second Stage

In the second stage, the panel was enlarged on all four sides. First, three short boards with horizontal grain were added to both the left and right of the core panel. When viewed from the front, those on the right are wider than those on the left.

As stated above, endgrain additions are particularly weak but can be greatly strengthened by using half-lap joints, thereby gaining some gluing surface along the grain. Since a paint film already existed on the core panel, the laps had to be cut into the reverse of the core panel and the face of the additions, which had yet to be painted (*figs. 12, 14, 15, 17, 36*).

In order to plane the lap on the reverse of the core panel, it seems likely that the panel had to be placed face down. This would seem to be an indication that the existing paint film must have already been reasonably dry, suggesting the passage of a fair amount of time (at least a number of months) so as not to cause damage.[12] It would also make sense that the additions were supplied with a gesso ground before attachment so that the surface level

could be more accurately aligned.

Next, additions were made to the top and bottom of the panel, one board on top and two on the bottom. These boards are continuous, bridging across the core panel and the first additions to the vertical edges. This procedure is sound carpentry, as the continuous boards strengthen the lap joints and keep them in plane.

Taken together, these four additions not only make structural sense, they also serve to illustrate Rubens's calculated adjustments to the initial composition: the wider additions on the right and bottom serve to shift the perspective more diagonally from the bottom right toward the upper left while also articulating greater detail of the underbrush and the destructive power of the water in the foreground and, at the same time, bringing the viewer closer into the scene.

Some slight surface level discrepancies must have been present from the outset because relatively crudely applied gesso is 'feathered in' across the joints from the additions onto the core panel at several points (*fig. 35*).[13]

The two boards of the lower addition are to be considered part of the same enlargement stage because the joint is perfectly smooth, suggesting that the ground was spread in a single application after the boards were joined but before they were incorporated into the panel structure. Nowhere is there any additional gesso applied to mask a level difference (see *fig. 27a-b* in the essay by Slama & Gruber).

Third Stage
In the third and definitive stage, boards were added on all four sides except that, here, the additions to the left and right, while also being attached by half-lap, were instead fixed *contrary to the grain of the rest of the panel*, a configuration that has led to most of the subsequent deformations (*figs. 12, 14, 15, 17*).

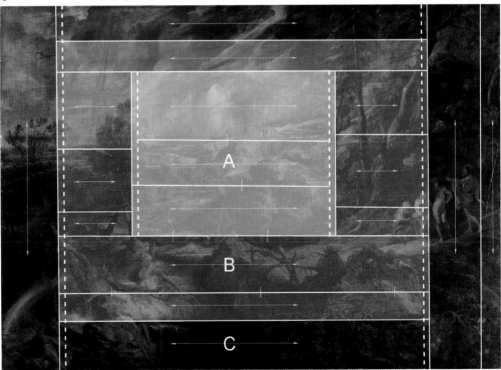

Fig. 36: Graphic of the three stages A, B, and C plus joints and grain directions

It seems likely that, faced with the task of a second set of additions which would bring the total width of the panel across the grain to nearly one and a half meters, the panel maker decided that a secondary backing was necessary in order to increase the stiffness of the overall structure, which at that point was only approximately 7 mm thick. It would follow logically that this backing was added before the perimeter additions.[14] Once the backing was in place,

it makes no sense to laminate the final four perimeter additions; they, instead, could be more easily fabricated in full, double thickness – butt joints for the long grain horizontal attachments to the top and bottom, half-lap joints for the vertical crossgrain additions. The sequence then would be:

- Laminate the new backing boards across the entire width of the existing panel, bridging across the core panel and the first set of additions.
- Add double thickness boards to the top and bottom of the new composite.
- Rout tracks approximately 2.5 cm wide to the vertical edges on the left and right, passing through the full thickness of the backing boards (and the newly attached boards top and bottom) and barely penetrating the surface of the panel below. (The routing of the track for the lap joint can be more easily and precisely executed if it is planed after the backing is in place).
- Rout a corresponding track to the face side of two double thick boards and attach them across the grain by half lap to the main panel.[15]

One is tempted to question why Michiel Vrient, a woodworker of exceptional skill and knowledge, would attach these final elements contrary to the grain.[16] One explanation could be that once all of the horizontal elements had been added, the panel was approaching one and a half meters across the grain and consequently had a greater tendency to warp. Was the desire to maintain overall planarity an overriding factor in the decision to contravene fundamental woodworking principles?

The four additions in the final phase bear a certain similarity to the previous group – slightly narrower on the top and wider on the bottom, and narrower on the left and wider on the right. While these adjustments amplify the considerations undertaken in the second stage, they are somewhat less significant, concerned more with maintaining the rectangular proportion. The major impetus for these additions is the creation of the space necessary to incorporate the figures of Jupiter, Mercury, Baucis, and Philemon, whose inclusion effectively transforms the subject of the painting from a stormy landscape (however dynamic) into a poetic mythological narrative from Ovid's *Metamorphoses*.

1 For other cases of additions, see i.a.: Hartwieg 2018; Brown 1996; Brown 2000, 279–288; Poll-Frommel & Schmidt & Renger 1993; Renger 1994; Plesters 1983; Sonnenburg & Preusser 1979.

2 Bisacca 2017, 103–109.

3 All references within the text from this point forward (unless otherwise noted) are made looking at the reverse of the panel, so that the left side of the panel corresponds to the right side of the painted surface.

4 Elke Oberthaler kindly furnished this information; see also her essay in this volume.

5 Given the thinness of the panel (6–7 mm), it was decided to scrape all residue mechanically rather than risk adverse effects of swelling caused by the use of an aqueous solution.

6 A similar example exists in the Metropolitan Museum's *Forest with a Deer Hunt at Dawn* (1990.196) where the two vertically oriented boards of the core panel have been extended at the top and bottom by short endgrain extensions. The entire central section had then been backed by three continuous boards, also with vertical grain. Finally, vertical boards, each equal in thickness to the central composite, were added on the left and right. For an exploded diagram, see Liedtke 1992, 104.

7 Similar treatments have been observed at the Prado Museum on panels by Bonifacio de' Pitati, *Adoration of the Shepherds* (P000269), Quentin Massys, *Christ Presented to the People* (P002801), Master of the Prado Redemption, *Triptych of the Redemption: Crucifixion* (P001888) and others, and seem to date from the late-eighteenth century.

8 Moisture barriers such as this are only applied to panels that no longer retain their original surface. Panels with original surfaces are less in need because they may retain vestiges of wax sealants or other coatings. They have also been impacted over time by surface dirt, which slows moisture exchange. The aesthetic intrusion to an original surface caused by such a modern synthetic coating also cannot be discounted. Acryloid B-72 does not form an impermeable membrane.

9 The mechanisms were first presented at the 42nd Annual Conference of the American Institute for Conservation in 2014: Miller & Bisacca 2014. The mechanisms are commercially available at www.desdev.net.

10 Araldite 1253 is produced by Huntsman and Acryloid B-72 is produced by Rohm & Haas.

11 Compare the descriptions of the three phases of construction with the corresponding descriptions in Gruber & Slama in the present volume.

12 It must be borne in mind that minor smudges to the existing paint film as a result of the manipulation inherent in the enlargement process would not have posed a serious problem for Rubens. He was, after all, still in the process of creating the image and would have necessarily painted freely back and forth across the additions in order to better integrate them into a unified composition.

13 This application is readily visible in strong raking light. Rubens brilliantly incorporated the irregular edge of this gesso in the upper portion of the sky as the natural shape of a cloud.

14 We can deduce that this backing was roughly 7–8 mm thick. The visible traces of the routed lap on the left and right vertical edges are very shallow; the two tracks barely penetrated the existing panel. We also know that the then existing panel had not yet been significantly thinned because of the presence of the remnants of gesso on the reverse. This means that the half-lap joint consisted of two equal halves – 7–8 mm of the existing panel plus 7–8 mm of the backing boards.

15 Further evidence of this reading is the fact that, while original gesso is present on the core panel and the upper and lower boards of the first addition, no trace is to be found on any of the four boards of the final additions. This is because, when the entire reverse was planed for the application of the cradle, the backing boards were completely eliminated along with half the thickness of the final perimeter additions.

16 No firm documentary source or physical evidence connects Michiel Vrient (Vriendt) to this panel – aside from the extreme precision of its execution, which is in itself a kind of signature, and the fact that he does appear in documentary sources for many of Rubens's major commissions. His stamp 'MV' appears, for example, on the reverse of *The Vision of Saint Hubert,* 1617–1620 at the Prado (P001411), on *The Meeting of Abraham and Melchizedek,* 1626 (1958.4.1) at the National Gallery of Art, Washington, and on the *Portrait of Susanna Lunden* (NG852) at the National Gallery, London. For further information about Vrient, who died in 1637, see: Gepts 1954–1960; Van Damme 1990, 223–226, 234; Duverger 1977;
http://jordaensvandyck.org/antwerp-panel-makers-and-their-marks/#michielvrient [last accessed: 11.4.2019].

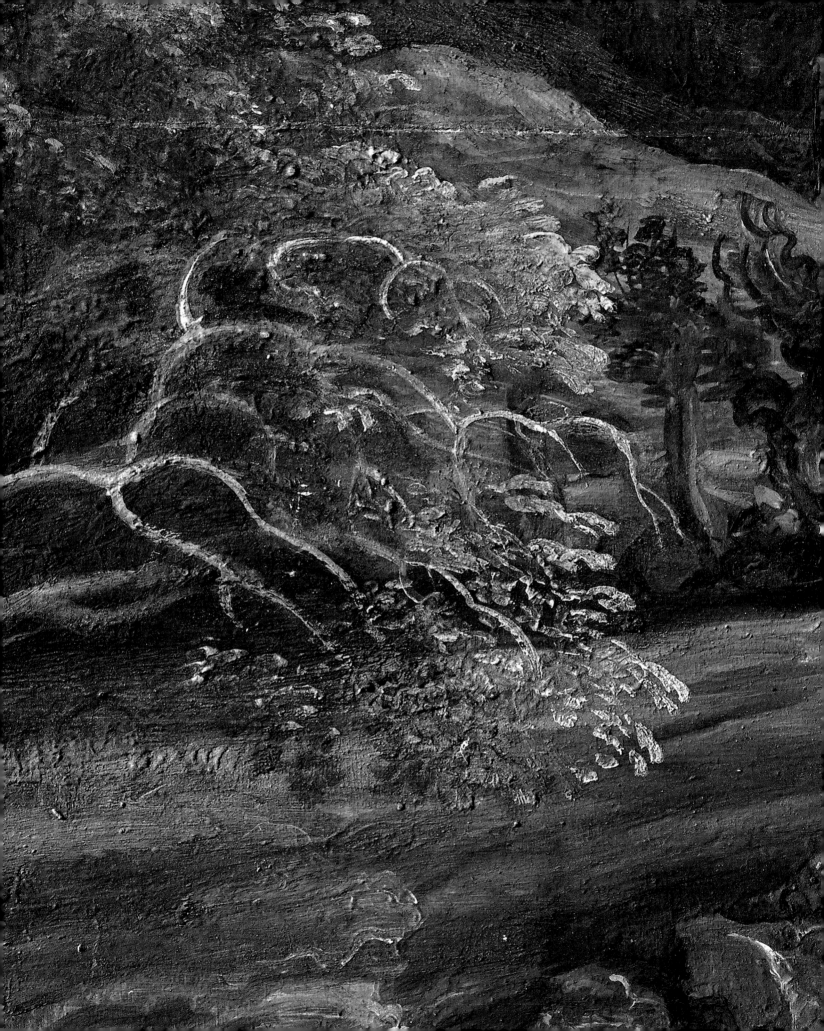

Pascale Fraiture

Dendrochronological Study

PURPOSE OF THE STUDY

The objectives of the dendrochronological study were to obtain information 1) on the dating of the wood itself for the different enlargements of the panel (*fig. 1*), in terms of *termini post quos* for felling and use; 2) on the supply conditions for the oak used to furnish panels for Rubens (provenance, quality selection, etc.); 3) on the woodworking techniques to produce supports for Rubens's paintings (cutting techniques, plank manufacture, etc.).

DESCRIPTION OF THE WOOD USED AND OF THE TREE-RING SERIES SAMPLED

All the planks are made of oak (*Quercus robur* L. or *Q. petraea* Liebl.). The 'original' panel (phase *a*) is imbedded in the middle of the construction, and no direct access to the edges is possible. The wood could only be studied by x-radiography. Measuring tree rings by x-radiography is not practicable on slow-growing oak trees because the rings cannot be identified with certainty. Fortunately, the central board (*fig. 2*) presents rather rapid growth (wide rings; mean ring width: 1.89 mm); this has made the recording of a reliable series of 95 ring widths on the central board possible.

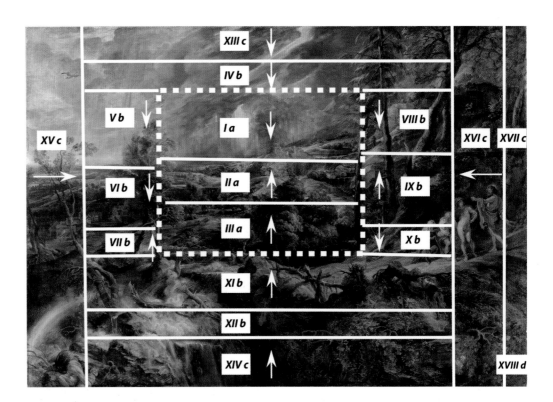

Fig. 1: Diagram of the support with KHM numbering of the panel members; the arrows indicate the direction of the wood growth, from the pith to the sapwood. Image © KHM Vienna; annotations: Dendrochronology Lab © KIK-IRPA, Brussels

Fig. 2: Detail of the x-radiograph of plank II a: the growth is rather rapid; the tree rings are measurable. X-radiograph: KaHM Vienna

The second phase of the construction (phase *b*) consists of nine horizontal planks, all around the original panel. Our intervention took place during structural work on the panel in November 2015, after the removal of the cradle. For this phase, the transverse section of the wood was accessible on the lateral edges of the panel, since the vertical boards added in a third phase were separated. Most of the planks for this phase were semi-radially or even tangentially cut (*fig. 3*). This and the fact that the support is thin, fragile and damaged have made the dendrochronological measurements very difficult. As a result, some planks were measured in different segments, others could only be measured partially or not at all.

The third phase (phase *c*) consists of the addition of horizontal boards at the top and bottom as well as vertical additions at the left and right.[1] The dendrochronological measurements of the horizontal planks met the same difficulties as for the previous phase. The study was done after the lateral parts were removed from the main horizontal support, and during their structural treatment. The left part consists of a single board, the right of three different elements, two of the same phase and a replacement in its lower right part. On these boards, the transverse section of the wood was accessible on the top and bottom edges (*fig. 4*). However, only the left plank and the wider of the right planks could be analysed, the small ones containing too few rings to be dated.

Fig. 3: Details of the left edge of the horizontal plank *XI b*. The plank is tangentially cut at the beginning of growth (upper photo) and semi-radial afterwards (lower photos). The growth was rapid at the beginning (upper) and slowed progressively as the tree became older (lower). Pictures: Dendrochronology Lab (P. Fraiture), working photos © KIK-IRPA, Brussels

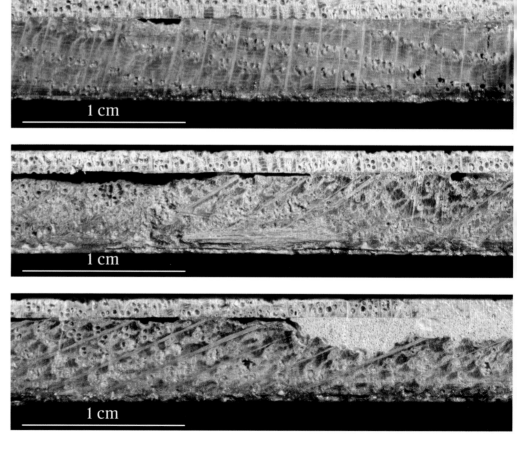

The growth rate of the trees used to produce the boards varies significantly from one plank to another, from rapid to very slow or irregular growth (*figs. 4 and 5*).

Fig. 4: Detail of the top edge of the left vertical plank XV c: the plank is radially cut and shows rapid growth. Photo: Dendrochronology Lab (P. Fraiture), working photo, 2015 © KIK-IRPA, Brussels

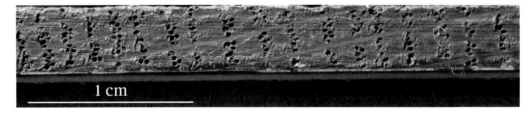

Fig. 5: Detail of the top edge of the right vertical plank XVI c: the plank is semi-radially cut and the wood has been damaged and repaired with putty. This has prevented the measurement of a continuous and reliable series of ring widths. Photo: Dendrochronology Lab (P. Fraiture), working photo, 2015 © KIK-IRPA, Brussels

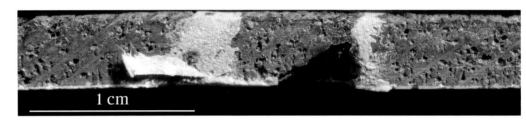

DENDROCHRONOLOGICAL SYNCHRONISATION AND DATING

Some ring series were measured in several segments (see above). When only one edge of a plank was measured and the result did not match with longer series from the panel, it was not possible to reconstruct long enough sequences from these segments to be usable.

The series from the different panel members were compared, regardless of the construction phase from which they came, in order to examine whether any planks came from the same tree. This revealed only one pair originating from a single timber, both planks from the second phase (planks *VIII b* and *IX b*).

In the end, eight ring series were available for dating the three construction phases of the support; they number between 71 and 223 rings. They were compared to our reference database to be dated and to determine the provenance of the wood. Six were definitively dated (*fig. 6*), using the regional and individual chronologies originating from the area around the Baltic Sea; this indicates that the trees used to produce these planks came from this vast geographic zone.[2]

Fig. 6: Bar diagram of the ring series of the dated planks for the panel, in chronological order, grayscaled according to the construction phases. Graph: Dendrochronology Lab (P. Fraiture), 2018 © KIK-IRPA, Brussels

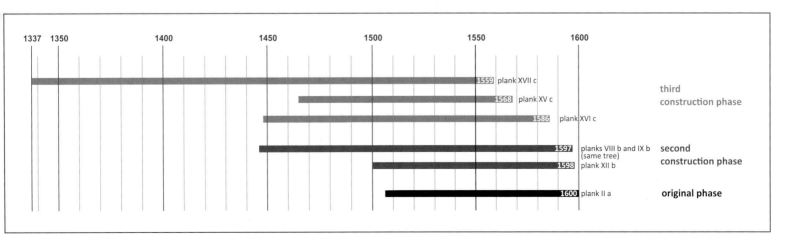

INTERPRETATION OF THE RESULTS

It should be noted that the planks giving the oldest results are precisely those used for the third phase, while the dated plank for the original phase contains the youngest tree ring, 1600 (*fig. 6*). However, no trace of sapwood is preserved on any of the dated planks; the results obtained are thus each to be considered a *terminus post quem* for the felling of the tree. A minimum of 6 sapwood rings, corresponding to 6 years, can be added to the last ring measured on each dated plank, given the Baltic provenance of the oaks, in order to estimate the oldest date after which the tree was felled.[3]

However, it must be emphasised that the sapwood could vary considerably from one tree to another, particularly in the case of this support given the important differences in the growth rhythms of the planks, the ages of the trees, and the widths of the planks. Though the minimum can be added to each dated plank (6), no maximum can be deduced (a maximum that could reach 36 sapwood rings)[4].

The interval of time between the felling of the trees in the forest and the use of the wood must also be taken into account. This can vary considerably from one panel to another and is thus impossible to specify in this case. We thus propose the *termini post quos* given for the felling of the trees also as *termini post quos* for the construction periods.

If we consider the results obtained for each construction phase, we conclude:
a *terminus post quem* of 1606 (1600 + 6) for the original panel (phase *a*);
a *terminus post quem* of 1604 (1598 + 6) for the second construction phase (*b*);
and a *terminus post quem* of 1592 (1586 + 6) for the third construction phase (*c*).

Consequently, on the one hand, we obtained very close results from one phase to another, and on the other hand these are precisely inversely chronological with respect to the chronology of the construction phases. This inversion could seem unexpected but can easily be explained by the total absence of sapwood (and therefore the unknown part of heartwood lost on all of the planks), the unknown time elapsed between felling and use of the wood as well as – even more probably in this particular case – the storage of boards or timbers in the panel maker's workshop or even in the artist's studio.

The study of this complex support provides an explicit illustration of the complexity of the interpretation of a dendrochronological result in the study of a panel painting without sapwood. However, in the end, the analysis provides a *terminus post quem* of 1606 for the manufacture of the original panel painted by Rubens.

ACKNOWLEDGMENTS

We warmly thank our dear friend Rebecca Miller († 20 March 2017) for the help she provided us in translating or correcting the English publication of our studies.

1 These vertical parts were already studied by dendrochronology in 1991, but without any result. See Klein 1991, 1.

2 Our Baltic reference database is divided into several sub-groups of reference series, which are interpreted as reflecting different sub-regions exploited in the Baltic area. See Hillam & Tyers 1995; Fraiture 2009. These sub-groups can be termed 'Baltic dendro-typologies'. The six dated planks of the panel best correlate with 'Baltic dendro-typology no. 1', the most widespread and commonly found when dating Flemish paintings of the 15th and 16th centuries, still in use but less common for 17th-century paintings.

3 A study of more than 650 oaks from the Baltic countries (Lithuania, Latvia, Estonia) and southern Finland has indicated a range of 6 to 19 sapwood rings. See Sohar & Vitas & Läänelaid 2012.

4 An initial statistical analysis was conducted in 1986 on 179 oaks from northern Poland; it demonstrated a range of 9–36 sapwood rings for these trees. See Eckstein & Wazny & Bauch & Klein 1986. As the provenance zones of the trees used for the Rubens support are not precisely known (Gdansk region or more eastern regions towards the Baltic countries), both statistical ranges are used to discuss the results.

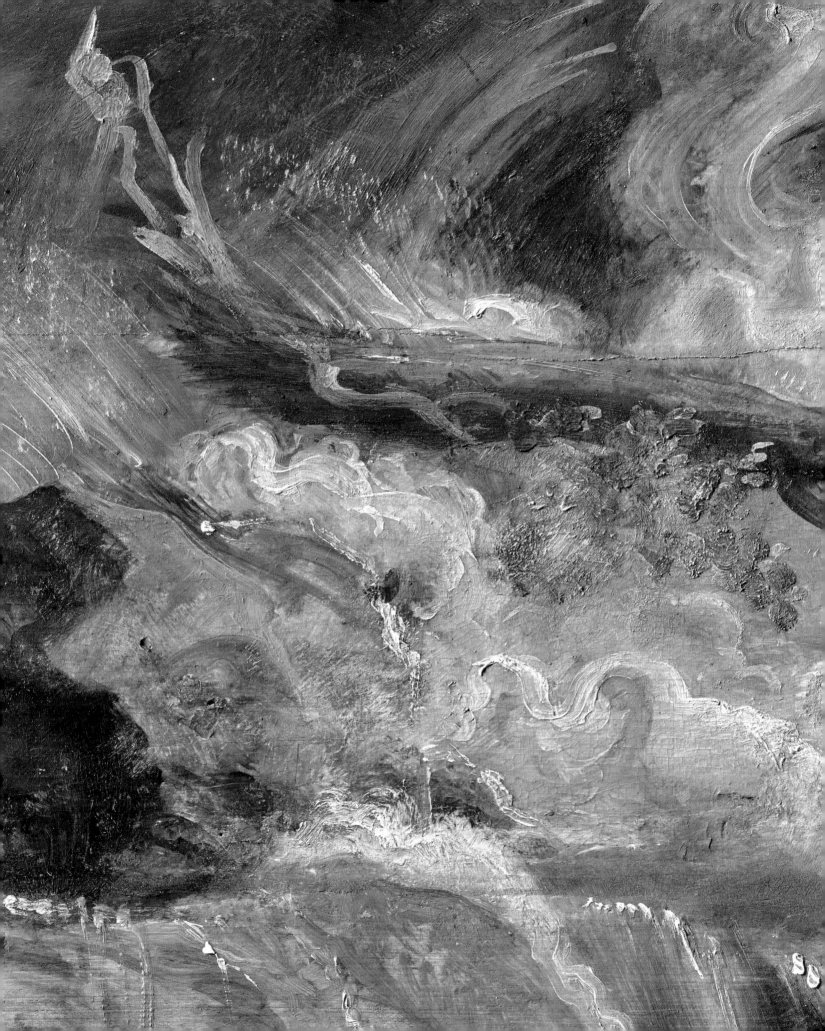

Ina Slama & Gerlinde Gruber

The Process of Creation and Observations on Painting Technique

Fig. 1: X-radiograph
The white contours denote the underlying, lead-based paint layers that document the composition's complex genesis.

During the restoration of Rubens's *Stormy Landscape* extensive technical examinations were carried out.[1] In particular, the X-radiograph (*figs. 1-2, pl. IV*) provided significant new details about the construction of the wooden support, as well as fascinating insights into the genesis of the composition. This imaging method clearly revealed that the large format painting was, in fact, built around a 66 x 85 cm "core" panel that had been enlarged in two separate phases. (For the technical details see the essay by Bisacca in this volume).[2]

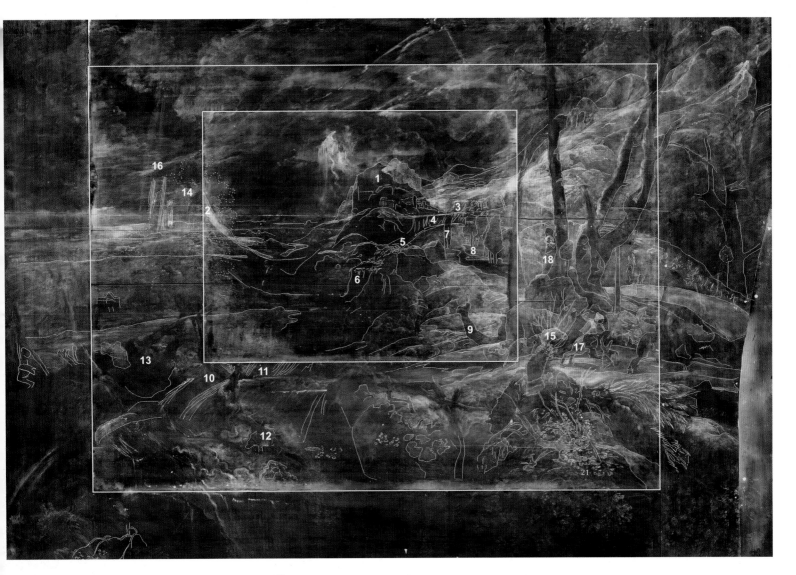

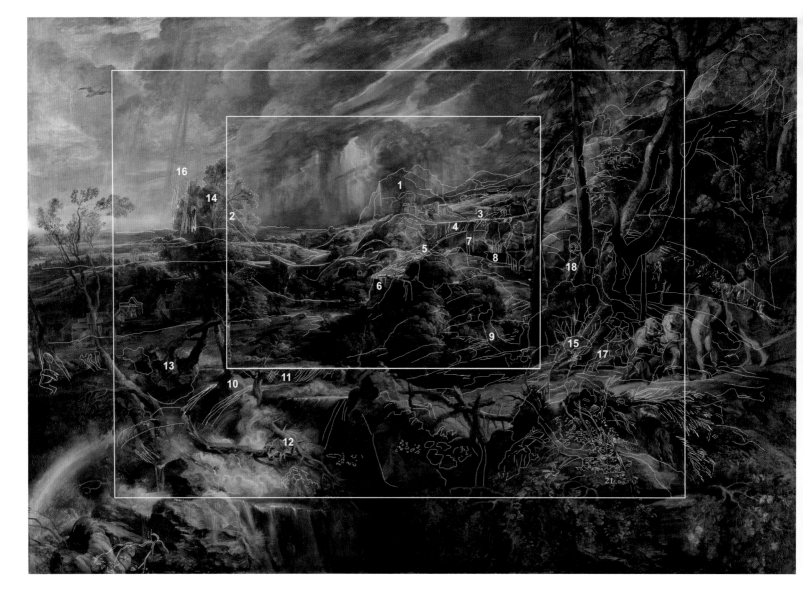

Fig. 2: Normal illumination showing the white contours that delineate the areas where lead-white is shown in the X-radiograph.

The re-working of and modifications to the composition by the artist himself – "pentimenti" – play an important role in the development of *The Stormy Landscape*, which was initially conceived as a "pure" landscape (and remained so) for quite some time.

Due to the amount of complex information surrounding the numerous changes to and the genesis of the painting, it was decided to introduce digitally modified images[3] to help visualize specific changes, such as the composition from the core panel (*figs. 3-4*), and the painting after the first enlargement (*figs. 10-11*).[4]

Four separate phases of development could be identified:

PROCESS OF CREATION

I. CORE PANEL (*FIGS. 3-4*)[5]

Rubens seemingly composed his initial landscape around a slightly decentralized mountain topped by a fortress. Beyond the fortress lie two additional mountains, underpainted with orange and yellow passages [1].

This distant landscape was framed by steep mountain slopes. Clearly visible in the X-radiograph (along the left edge of the core panel) is a passage of vigorously applied, upward-sweeping brushwork (light in color) [2]. The waterfall to the right of the fortress was initially positioned further up [3] and cascaded down three additional steps to the left [4, 5, 6]. The second waterfall [4] forked [7] with one passage running along the side of a small coniferous forest [8]. The pollard willow [9], on the small elevation in the foreground, is set

Fig. 3: Detail of the core panel: X-radiograph showing the white contours that delineate the areas where lead-white was used.

Fig. 4: Detail of the core panel: Normal illumination showing the contours that delineate the underlying lead-white paint layer. Digital editing was used to recreate this stage of the composition.

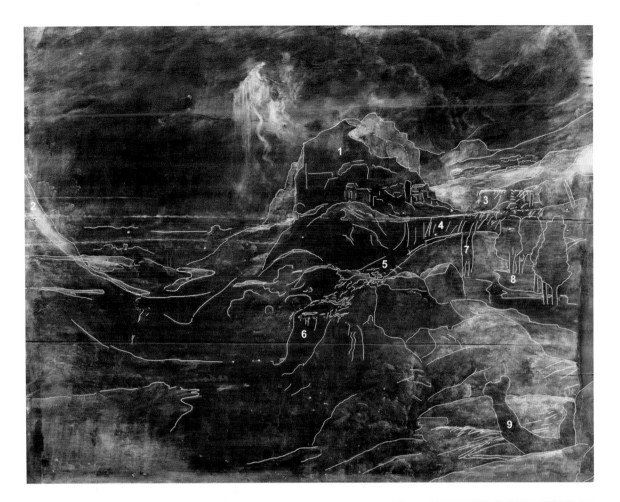

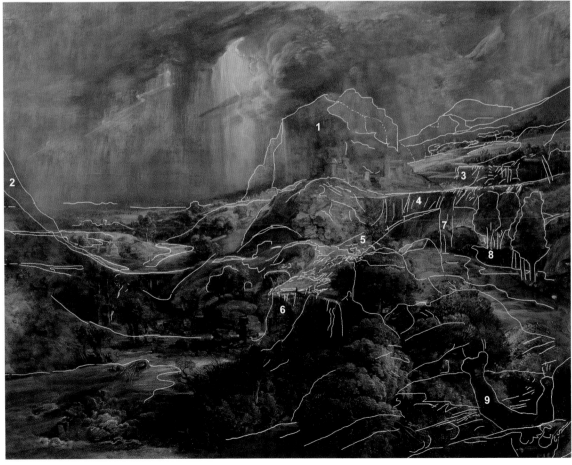

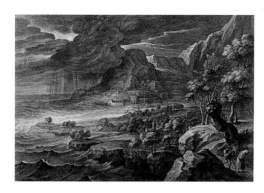

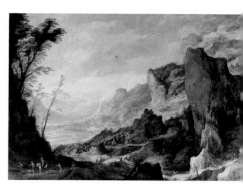

Fig. 5: Schelte Adamsz. Bolswert, *The Stormy Landscape*, engraving after Rubens, inverted image, 305 x 433 mm. Vienna, Albertina

Fig. 6: Pieter Bruegel the Elder, *Flight into Egypt*, oak panel, 37.1 x 55.6 cm. London, Courtauld Institute Collection

Fig. 7: Joos de Momper, *Large Mountainous Landscape* with Riders, canvas, 209 x 286 cm. Vienna, KHM

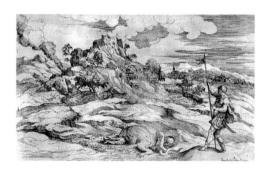

Fig. 8: Giovanni Francesco Camocio, after Titian, *Landscape with a Dragon*, woodcut, 195 x 320 mm. London, The British Museum

Fig. 9: Detail from Lucas Van Uden, *Landscape with Philemon and Baucis*, pen and wash, 201 x 307 mm. Stockholm, National Museum

off against the lighter middle-ground.

The general composition described above shares similarities with another landscape by Rubens. Unfortunately, this painting is now lost and only known from an engraving by Schelte à Bolswert (*fig. 5*). To what extent the stormy atmosphere was present at this stage is speculative. Important to note is that Rubens only began to use coarsely ground lead-tin yellow mixtures once he commenced with the second enlargement of the painting, which suggests that the thunderbolts were most likely introduced at a later stage in painting.

Compositional elements, placed slightly off-centre, such as the mountain in the background, the bowing trees and the semi-transparent build-up of the hills and cliffs, appear to echo both formal and technical aspects of Pieter Bruegel the Elder's *Flight into Egypt* (Courtauld Institute, London, *fig. 6*),[6] which, as we know, was in Rubens's collection. Another painting mentioned in this inventory that also reflects several of the formal compositional elements found in the earlier core panel (e.g. the wide valley framed by steep cliffs) is Pieter Bruegel's *View of St. Gotthard*. The original of this painting is lost, but Fritz Grossmann was the first to suggest that the composition may be recorded in de Momper's *Large Mountainous Landscape* (*fig. 7*)[7] now in the Kunsthistorisches Museum. Momper's small central mountain, as well as the undulating path in the foreground and the wide valley (framed by steep cliffs), resemble Rubens's core composition. Landscapes with a slightly elevated horizon and an emphasis on spatial depth are also typical of Venetian painting, especially works by Titian, which were known from prints throughout Europe. The core composition is in fact reminiscent of Titian's *Landscape with a Dragon* (*fig. 8*). Both Bruegel (*fig. 6*) and Titian place their mountain range, with its meandering path or river, slightly off-centre in the upper third of the composition. This suggests that Rubens was inspired both by Flemish and Italian landscapes.[8] A wash drawing by Lucas Van Uden (*fig. 9* and see fig. 4)[9] preserves these elements in the painting, albeit from a later stage when the painting had already been extended. The drawing also shows that Rubens executed specific changes to the core section quite late in the genesis of the composition: see, for instance, the slightly decentralized mountain [1], the cascading waterfall [3, 4, 5, 6] and the coniferous forest [8].[10]

II. FIRST ENLARGEMENT

In the process of increasing the painting's format (with nine additional planks)[11] Rubens decided to reorient the composition by raising the vanishing point (see *figs. 10-11*).[12] He expanded the composition by changing the steep mountain slope at the left edge of the core composition [2] into a broad vista[13] spread out below a bright ultramarine blue-based sky, thereby creating a smooth transition to the larger format. To increase the dramatic effects of the storm he added a small flooded grove [10], a number of small waterfalls [11], a cow wedged between two tree trunks [12] and uprooted trees [13] (see also *fig. 12*). The wide crown of the tree we see today (*fig. 11* [14]) was initially much lower (see *fig. 2*). The right side was previously conceived as a denser cluster of mountains[14] and trees, with another pollard willow in the foreground [15]. There were also no figures present and no vibrant foreground coloration.

Fig. 10: Detail of the core composition after the first expansion. X-radiograph showing the contours delineating the underlying lead-based paint layer

Fig. 10: Detail of the core composition after the first expansion. X-radiograph showing the contours delineating the underlying lead-based paint layer

Fig. 11: Detail of the core composition after the first expansion: normal illumination showing the contours of the underlying lead-based paint layer, based on an X-radiograph. Using digital editing, it was attempted to map this stage of the composition.

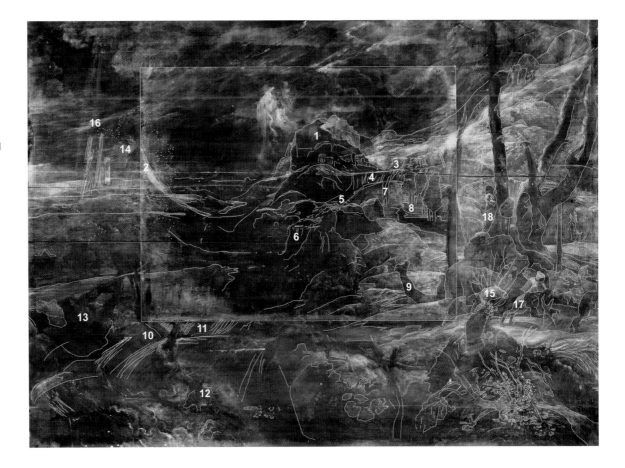

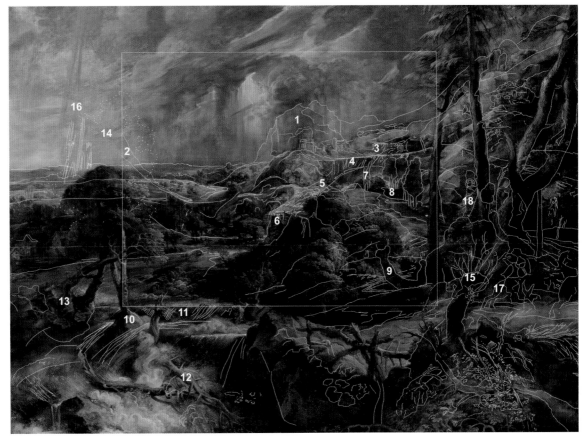

Fig. 12: Detail of uprooted trees

Fig. 13: Detail of an uprooted tree and a falling rider from: Leonardo Da Vinci, *A Deluge,* inv. 12376, drawing, black chalk, pen and ink, wash, 27 x 40.8 cm. Windsor Castle, Royal Library

Fig. 14: Detail of a man in search of safety from: Leonardo Da Vinci, *A Deluge,* inv. 12376, drawing, black chalk, pen and ink, wash, 27 x 40.8 cm. Windsor Castle, Royal Library

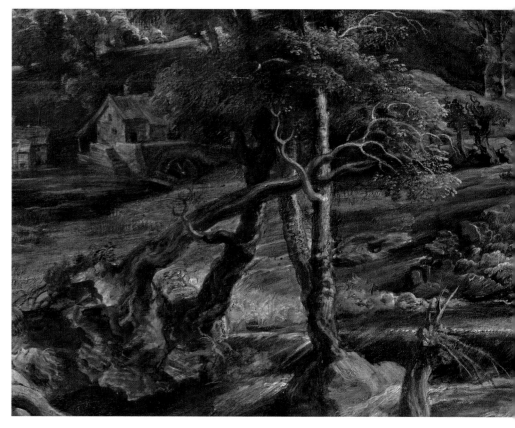

III. SECOND ENLARGEMENT

After again enlarging the panel by adding five more planks (i.e. to its present size),[15] Rubens set out applying accents of vivid azurite to the hills on the left, the distant mountains and the contours of the clouds. He added bolts of lightning and heavy rains too [16] and extended the tree crown into the expanded format. Rubens now also introduced active figures into what was until then a pure landscape. Like Leonardo in his series of eleven drawings of the deluge, which illustrate the devastation caused by floods (*figs. 13-14*),[16] Rubens shows desperate people clinging to trees (*figs. 15-16*), with other trees uprooted (*fig. 12*). He also depicts a dying mother clutching an infant (*fig. 17*), a man clinging to a cliff (*fig. 18*) and a group of three fleeing riders (in scale – half the size of Philemon and Baucis) (*figs. 10* [17] and *19 a-b*). The results of the X-ray fluorescence analysis show that the cape and bonnet of one of the riders were not only outlined in lead-white but were also mixed with lead-tin yellow pigment. This suggests that the level of finish to the group on horseback, located

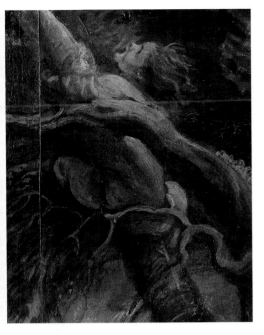

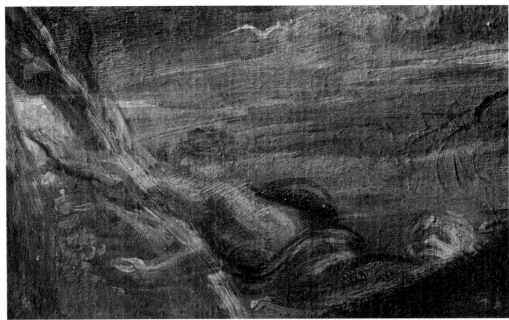

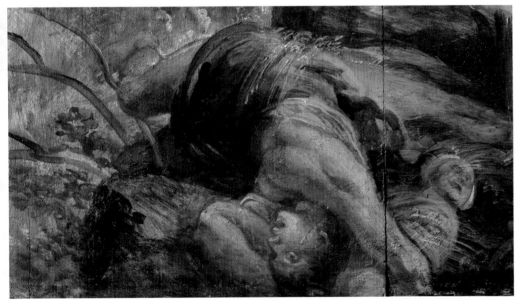

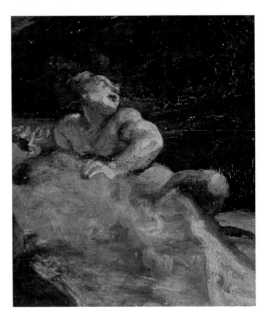

Fig. 15: Detail of a man clinging to a tree, original size ca. 14 cm

Fig. 16: Detail of sketched figures carried away by the flood, painted directly onto the paint surface of the raging water, original size ca. 4 cm

Fig. 17: Detail of a dying mother clutching her infant. Here, too, the figures were eventually integrated into the landscape. Pentimenti underneath the child's face show the earlier positioning of the brambles, original size ca. 16 cm.

Fig. 18: Detail of the sketched figure on the rock. Additional modelling executed in pink/orange hues, original size 5 cm

beneath the figures of Philemon, Baucis, Jupiter and Mercury, must have been quite high.[17]All of the figures not only heighten the dramatic effect of the scene but also function as chromatic accents – similar to reflections of light on paths, water and tree tops. They are tactically positioned to harmonize and help balance the composition as a whole.[18]

IV. TRANSFORMATION INTO A MYTHOLOGICAL LANDSCAPE

In the final chapter of the composition's genesis, Rubens overpainted the figures on horseback with dark-grey paint (fig. 20), replacing the storyline with a mythological scene featuring Philemon, Baucis and the two gods. This darker intermediate layer was apparently not completely dry when Rubens continued to develop this passage by adding thicker layers of opaque paint. This resulted in the development of traction cracking and reticulation (shrinkage) of the upper paint layers. Rubens replaced the pollard willow (fig. 19a [15]) in the foreground (documented in the drawing now in Stockholm) with a fallen tree and a goat. The figure behind one of the trees, still visible in Van Uden's drawing (figs. 19a [18] and 19d), was re-worked as well.

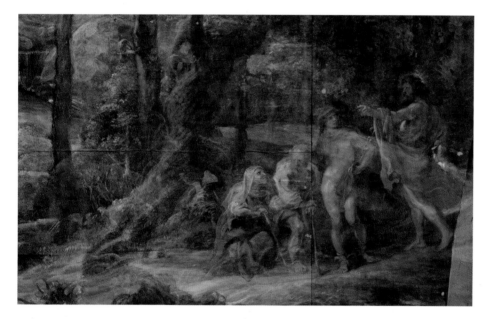

Fig. 19: Detail of a group of riders,
a) X-radiograph with white contours;
b) visible light image superimposed on an
X-radiograph;
c) detail, normal illumination: Rubens replaced horses
and riders with Philemon and Baucis;
d) detail from: Lucas Van Uden, *Landscape with
Philemon and Baucis,* pen and wash, 201 x 307 mm.
Stockholm, National Museum

Fig. 20: Raking light image: locally applied darker
intermediate layer to hide the group of riders (visible
in the crackled areas)

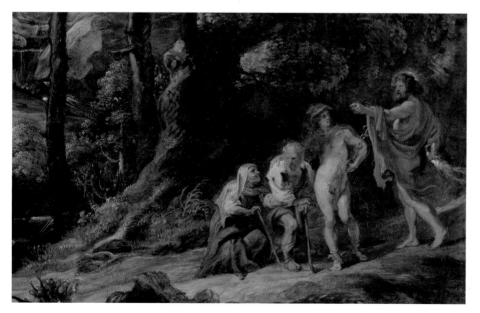

PREPARATION LAYERS AND INTEGRATION OF THE PANEL JOINTS

The infra-red image clearly shows the successive enlargement of the panel structure; it also reveals how the preparation methods used for the planks changed at each stage of development (*fig. 21*).[19] One assumes that the individual planks used to extend the composition were pre-primed and sanded in order to help achieve an even surface throughout the painting.[20] It would have made little sense to prime and then sand the extensions after having joined them to the painted section, as this would have distorted the wood and damaged the original paint surface. Furthermore, it would have been much more difficult to perfectly align the adjacent planks. To better integrate the new extensions a subsequent layer of gesso was applied over the panel joints, which extends over the interface and into both the extension and the already-painted central composition. The (localized) unevenness of the panel joint is visible in both incident and raking light (*fig. 22*).[21] A cross-section of the paintfilms[22] shows the overlapping paint layers of both the earlier composition and the later extension (*fig. 23*).[23] The azurite blue-layer, which covers the partial application of the second priming layer, helps create a color unity to better integrate the overlapping area connecting the earlier and later planks.

Fig. 21: Infra-red image after cleaning and filling: note the marked differentiation in density (brightness) within the wooden additions compared to the earlier central panel. These overlapping layers of gesso (with their slightly raised edges) border the joints of the two extensions (white arrow).

22

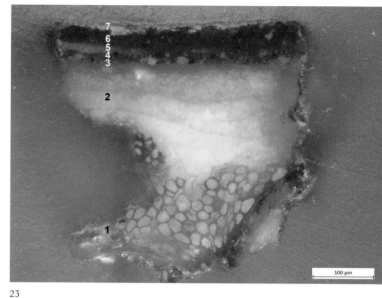

23

24

25

Fig. 22: Detail center left: gap between the first and second extension with a step in the priming layer (white arrow) and two-layered paint structure, raking light illumination. The black arrow marks the location of cross section 17, see Fig. 23.

Fig. 23: Cross section 17: this cross section shows a two-layered paint structure, from the first and second expansion in the area of the hills and the background. The white layer (5th from bottom) is the priming from the second expansion and overlaps the paint layer from the first expansion by ca. 2.5 cm. The intense blue color is largely composed of azurite with traces of lead-white, chalk and lead-tin yellow:
1. Support: oak panel
2. Multi-layered lighter priming from the first expansion: chalk and silica impurities; note the rich binding medium at the top
3. Traces of imprimatura: lead-white, chalk, silica,

possibly carbon black
4. Initial blue layer: azurite, chalk, silica
5. Overlapping priming: chalk
6. Second blue layer, which was applied during the second expansion: azurite, lead-white, lead-tin yellow, chalk and silica
7. Organic layer, remains of retouching

Fig. 24: Detail of the waterfall in the foreground: here, the greyish imprimatura is partially visible between the brown glazes. The arrows point to fingerprints.

Fig. 25: Cross-section 23: showing the structure of the paint layer including the greyish imprimatura and the darker underpainting, which acts as an intermediate layer separating the pentimenti of the rider from the dark-grey clothes of Baucis

1. Multi-layered light-colored priming. Note the rich binding medium at the top: chalk with silica impurities
2. Greyish imprimatura: chalk, lead-white, traces of ochre and carbon black
3. Light-brown, slightly bluish layer: lead-white, ochre, some chalk, presumably red lake and copper-based pigments
4. Greyish layer: lead-white, chalk, ochre, traces of carbon black and copper-based pigments
5. Dark intermediate layer which hides the group of riders and creates a neutral field on which to further develop the composition: carbon black, lead-white, ochre, traces of copper-based pigment
6. Initial greyish-blue layer: carbon black, copper-based pigment, lead-white, ochre, chalk
7. Second greyish-blue layer: copper-based pigment, lead-white, carbon black, ochre, chalk
8. Thin organic-based layer – varnish

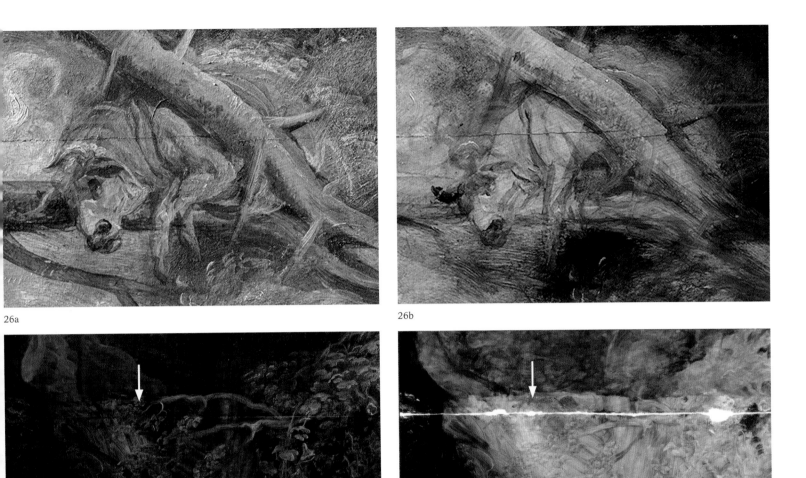

26a

26b

27a

27b

Figs. 26a-b: Detail of a cow: juxtaposed normal illumination and infra-red images. Note the sketch-like fluid brushwork of the underdrawing.

Fig. 27a-b: Detail of a cliff (bottom center): comparison between normal illumination and infra-red image after cleaning and filling of the border between the lowest and its adjacent plank. The transition from the first to the second extension.

The white colored, chalk-glue ground layers very likely were isolated with a thin, transparent, oil-based film to reduce the excessive absorbency of the porous priming layers. This preliminary modification of the ground would have minimized the differences in saturation – and therefore surface sheen – of subsequent paint layers. Like Pieter Bruegel the Elder a generation before him,[24] Rubens incorporated this technical requirement into his compositions. He often applied an oil-based, transparent, greyish, light-brown or ochre imprimatura with broad brushstrokes. Its specific function was to provide a vibrant, neutral, mid-tone when left in reserve.[25] In *The Stormy Landscape* these transparent layers are integrated effectively into the final painted surface, making it sometimes difficult to differentiate them from the subsequently applied brown glazes (*figs. 24-25*).

On top of the imprimatura Rubens applied both a sketch-like underdrawing and additional washed passages with a brush.[26] Comparisons of infra-red imaging and normal viewing reveal the characteristics and purposes of these gestural applications (*figs. 26a-b*).

A detail from the panel joint in the foreground (*figs. 27a-b*) illustrates Rubens's ingenuity. In the final stage of integrating the extensions he retained the difference in transparency between earlier and the final applications of priming. In doing this he incorporated the border between the two gesso layers to create a bank of fallen earth. To strengthen the illusion, Rubens added a series of horizontally extending roots and brambles. When comparing the incident and raking light macro-photographs from areas where the panel joints are located, one can clearly see how Rubens employed similar devices to distract the viewer's eye from the slight irregularities caused by the later extensions. He strategically placed painterly elements to areas of imperfection, for example waterfalls (*fig. 28*), trees (*fig. 29*), figures (*fig. 30*), birds and clouds, thereby uniting the (extended) pictorial space.

83

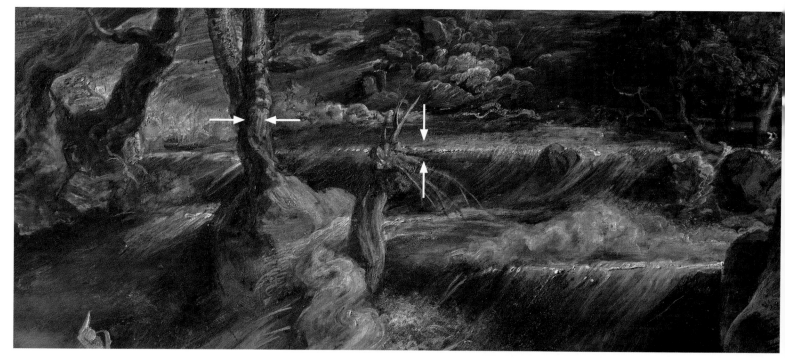

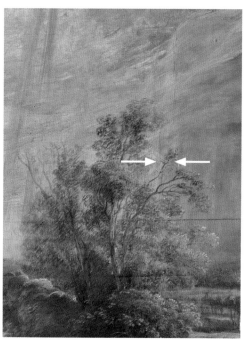

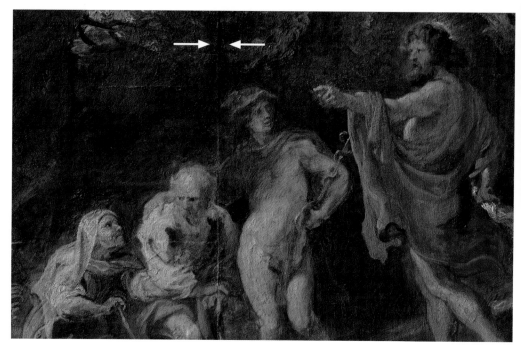

PAINT AND APPLICATION

Rubens's palette comprises the typical range of pigments obtainable from local dealers in seventeenth-century Flanders.[27] These include lead-white (sometimes extended with chalk),[28] lead-tin yellow, vermilion and red lake, ultramarine and indigo blue, various copper-based pigments (azurite blue and copper-resinate green), a selection of earth pigments (yellow and red ochre as well as a green-tinged umbra), and black pigments – carbon and bone black, also often extended with chalk.[29]

As binding media Rubens used both pre-polymerized oil and mixtures of oil and resin. Gas-chromatography has identified linseed oil, walnut oil, and pine resin, which Rubens also used in other paintings, according to their properties.[30] Rubens's handling allows the translucent imprimatura to shine through between more densely applied passages of paint, imbuing selected areas of the painting with a deep luminosity. By juxtaposing passages of transparent and opaque paint, applied with different brushes (to obtain a structured relief), Rubens adds depth and gives life to the painted surface (*fig. 31*). It is interesting to note that

Rubens utilized the quality of the grinding of pigments (fine to coarse) within his painting repertoire. His handling of paint changed during the course of the composition's development. Note, for example, the waterfall in the foreground (*fig. 32)*: in the core panel Rubens underpainted the passages of water with a streaky greyish-blue mixture and allowed the lighter-colored priming to shine through. In one of his earliest reworkings of this passage Rubens then applied additional opaque layers of similar color that covered almost entirely the earlier, looser application.

In general, Rubens employed a much more refined pigment quality and an overall increased transparency for the execution of the core composition (*fig. 33*), but changed his approach considerably during the first extension of the composition. A clear example is how he renders agitated water: by first applying a layer of coarsely ground white pigment[31] and letting it dry before applying a thin layer of a translucent dark greyish-blue glaze, which pooled up in the interstices of the underpainting, allowing scattered white pigment particles to simulate the spray. A dense application of lead-white conjures up the whitecaps (*fig. 34*), and he creates rapids by laying in horizontal lines of blue paint through which he then diagonally draws a loaded brush to simulate the rushing waters (*fig. 35*).

As discussed above, Rubens overpainted the riders with several layers of paint – all that remains of them is an uneven spot on the surface, visible in raking light (*fig. 36*). Over this passage Rubens applied, with almost calligraphic verve, a series of brushstrokes loaded with both fluid and thick paint to introduce a grouping of bright red ferns. But instead of mixing vermilion and ochre on his palette he chose to just dip the tip of the brush into the paint and mix them directly on the paint surface. These ferns, too, function as a decorative distraction from the uneven surface. Over time Rubens altered his painting technique, changing from highly precise brushstrokes (*fig. 37*) with carefully defined details to more summary, almost haphazard reworkings executed with what appears to have been a broad brush wielded from a considerable distance. It seems his intention was to realize comprehensive chromatic adjustments. For instance, to obscure the mountain on the right that clearly seemed too bright he applied a dark-green glaze (*fig. 38*). Or the colorful highlights in different shades of orange and light green placed on the small trees, hills and paths in the middle ground, which all help to unify this repeatedly reworked composition (*fig. 39*). Many of these paint mixtures contain coarsely ground pigments, which Rubens applied over earlier smoother passages (*fig. 40*). Here the pigment, which adds body and structure to the paint, is presumably lead-tin yellow.

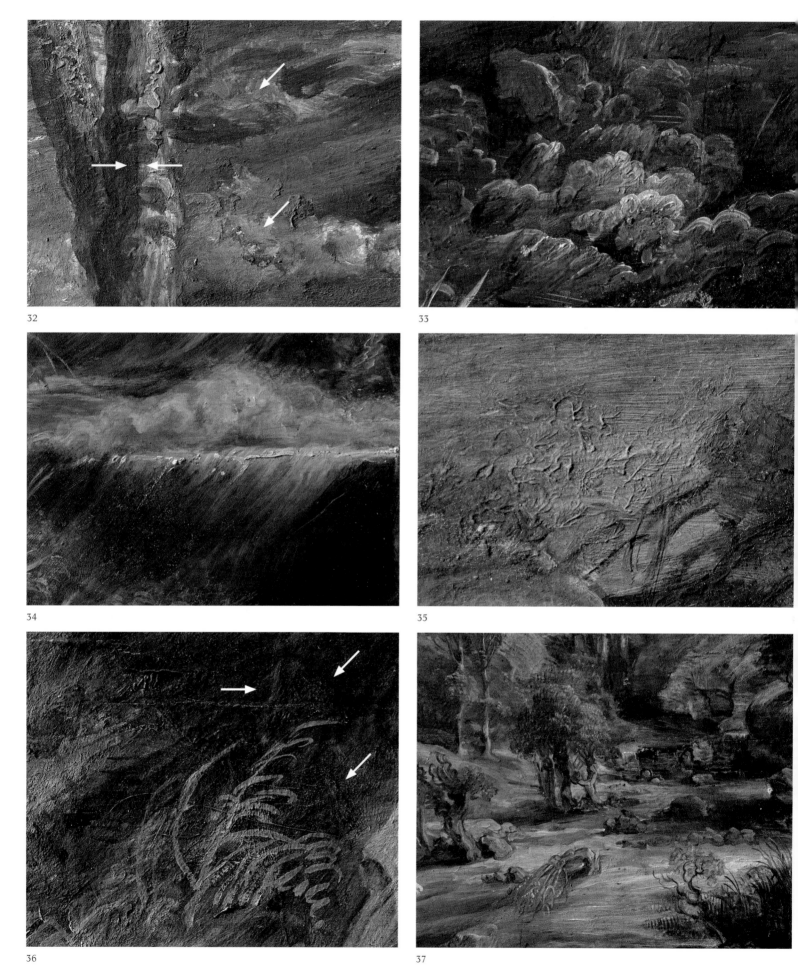

32

33

34

35

36

37

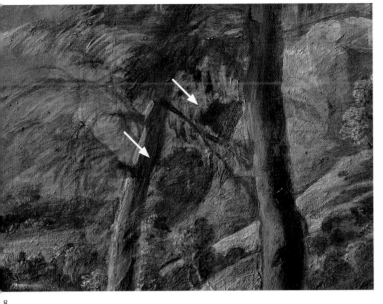

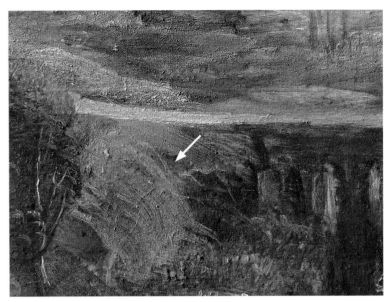

8

39

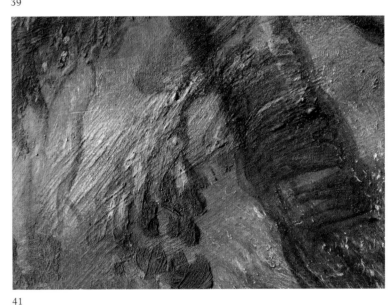

40

41

Fig. 32: Detail from the core composition and the first extension: note the broad brushstrokes and the semi-transparent paint used for the water. Losses to the upper paint layer reveal the build-up of this area.

Fig. 33: Detail from the core composition: foaming water

Fig. 34: Detail from the first extension: whitecaps, coarse white pigment beneath a blue-green glaze

Fig. 35: Detail from the first extension: water: the artist dabbed a soft brush on the still-wet paint layer.

Fig. 36: Detail of the revised rider (phase 3): thicker layers of paint mask the rider (a white arrow indicates his outlines). Loosely painted red grass distracts the viewer's gaze from the underlying shape, still visible in raking light.

Fig. 37: Detail from the core composition: the river with highly-detailed trees

Fig. 38: Detail of Rubens's summary retouchings. A mountain that was too light in color has been subdued.

Fig. 39: Detail of the final light-orange and light-green accents using coarse pigments. The white arrow indicates a small tree located in the core composition, which the artist cancelled broadly with brushstrokes of mixed pink.

Fig. 40: Detail of the final applications of coarsely ground orange-red and yellow-greenish paint to unify the different phases of development

Fig. 41: Detail of a tree: the underlying pentimenti remain visible due to their rough texture, which differs from that of the visible image.

Fig. 42: Detail of the sky at top left: drips visible in the top blue-grey paint layer over greyish imprimatura

42

Fig. 43: Detail of the brambles in *The Watering Place*, ca. 1620, London, National Gallery

Fig. 44: Detail of the brambles at foreground right in *The Stormy Landscape*. Vienna, KHM

Fig. 45: Detail of the brambles in *Autumn Landscape with a View of Het Steen in the Early Morning*. London, National Gallery

Its history, development and painterly quality make *The Stormy Landscape* a creative universe in itself. Pentimenti – for instance in the area of the rainbow – continue to play a prominent role in the finished composition (*fig. 41*) since they impart their qualities to a further-developed and transformed surface, whether dense or fluidly modeled, transparent or opaque in nature. Numerous details, which document the immediacy of the artistic process, have been preserved in the paintfilm, including fingerprints[32] (*fig. 24*) and dripping paint (*fig. 42*). The latter recurs frequently in Rubens's oeuvre[33] and it appears that they clearly did not concern or distract him. All of these artifacts bear witness to the years of artistic dialogue between Rubens and this painting, and imbue it with a highly personal character.

TIMEFRAME FOR THE ALTERATIONS

As with most works by Rubens, his finished landscapes have neither signatures nor dates, which makes attempts toward a chronology somewhat challenging. In the 1928 catalogue raisonné, Gustav Glück first dated *The Stormy Landscape* to around 1622/24 (1620/25). Christopher Brown dates the work to the late 1620s.[34]

In his nineteenth-century catalogue,[35] Max Rooses accepts only the foreground and the sky as autograph. In his opinion the middle-ground was too schematic and detailed to be by Rubens, and he suggests that it was executed by Lucas Van Uden (1595–1672) with some later retouchings by Rubens.[36] He also dates it rather late, to around 1640. One of the reasons why he believed it to be a collaborative effort was that it appeared to have been executed within a short time span (the differences in the handling were best explained by two different artists at work).

The present evaluation of *The Stormy Landscape* is based both on recent technological findings and additional stylistic analyses, which strongly suggest a long genesis. Note, for example, how the brambles in *The Watering Place* (London, National Gallery, ca. 1620; *fig. 43*) are more clearly defined (the stronger chiaroscuro increases space and depth), whereas the brushwork in the greenery in the painting in Vienna (*fig. 44*), and even more the brambles in *Autumn Landscape with a View of Het Steen in the Early Morning* (London, National Gallery, ca. 1636; *fig. 45*), are clearly more diffused in execution.

When comparing details from Van Uden's *Landscape with Rainbow* (*fig. 46*), a copy of a work by Rubens in the Louvre, with a similarly-scaled detail from the Vienna painting (*fig. 47*) the difference becomes evident. In particular, one can see that Van Uden's handling of the crowns of the trees lacks the tactile relief of the brushwork typical of Rubens. Van Uden's brushwork is much more schematic and repetitive, which argues against his involvement in the creation of *The Stormy Landscape*.

There is enough evidence to support the assumption that Rubens started *The Stormy Landscape* in the 1620s and continued to work on it into the late 1630s.[37]

In addition to *The Watering Place*, another important painting for a chronology of Rubens's work is a landscape by Paul Bril (1610, Prado, Madrid; *fig. 48*) that originally depicted *St Jerome in the Wilderness* but was altered by Rubens (probably after 1625) into a *Landscape with Psyche and Jupiter* by reworking both the hermit and parts of the landscape.[38] The eagle in the Vienna landscape (*fig. 50*) is reminiscent of that in the painting now in Madrid (*fig. 49*), particularly its form and gesture. However, with the more summary execution of the Vienna eagle one could argue that it most likely dates from the 1630s. Furthermore, there is an interesting stylistic comparison between the peasant couple in *Het Steen* (*fig. 51*) and the Philemon and Baucis group in the Vienna painting (*fig. 52*). Both the relatively thick and roughly applied highlights (e.g. cheek and right arm of Baucis) and Jupiter's pointing arm (*fig. 30*) are similar to those of the *Het Steen* peasant's hands. In addition to the earlier stylistic observations regarding the brambles (*see fig. 45*) and the eagle (*fig. 50*), note how Rubens used a pink/orange mixture to apply accents, which is typical of the palette he favored in his final decade. They too are applied with free, expressive brushstrokes over earlier passages (see *figs. 53* and *40*).

 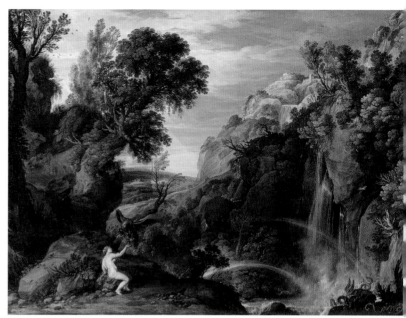

Fig. 46: Detail of trees in Lucas Van Uden, *Landscape with Rainbow*. Vienna, KHM

Fig. 47: Detail of trees in *The Stormy Landscape*. Vienna, KHM

Fig. 48: Paul Bril, *Landscape with Psyche and Jupiter, canvas,* 95 x 129 cm. 1610 and later re-worked by Rubens. Madrid, Museo del Prado

It is truly remarkable how Rubens negotiated the transformation of this large landscape composition. At each stage of the modification he was able to further develop both the overall atmosphere of the landscape and the iconography within, working first from inside outwards, and then in reverse again toward the center. It remains uniquely fascinating to discover that by repeatedly returning to this work, Rubens brought with him new, fresh ideas and perspectives about how he wanted this painting, which he undoubtedly painted for his own enjoyment, to develop.

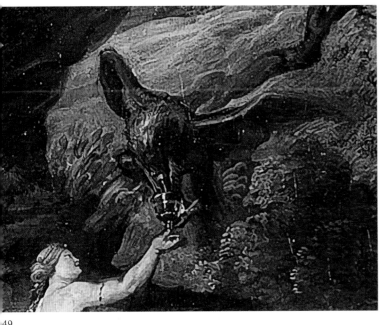

49

50

51

52

53

Fig. 49: Detail of Jupiter as an eagle in Paul Bril, *Landscape with Psyche and Jupiter*, re-worked by Rubens. Madrid, Museo del Prado

Fig. 50: Detail of Jupiter's eagle in *The Stormy Landscape*. Vienna, KHM

Fig. 51: Detail of peasants in *Autumn Landscape with a View of Het Steen in the Early Morning*. London, National Gallery

Fig. 52: Detail of Philemon and Baucis in *The Stormy Landscape*. Vienna, KHM

Fig. 53: Detail of impasto: final, vividly-colored accents applied with coarsely ground paint in *The Stormy Landscape*. Vienna, KHM

1 In addition to the X-radiography (X-ray device: Seifert – Isovolt, 25 kV/4mA/2min, 112 cm distance to the picture surface; Elke Oberthaler, Georg Prast, Ina Slama; image processing: Michael Eder, Michael Aumüller) the following examinations were carried out: infrared-reflectography (IRR) (device: OSIRIS wavelength range: 900-1700 nm, 18 cm distance between the painting surface and the camera. IRR and image processing: Michael Eder), visible-, raking light and UV fluorescence images as well as false color images (Andreas Uldrich; image processing: Thomas Ritter, Michael Aumüller, Sanela Antic, Ina Slama) and measurements of the thickness of the support (Ingrid Hopfner, Georg Prast, Ina Slama). All analyses of samples were carried out in the KHM's Conservation Science Department: cross section analyses (Sabine Stanek, assisted by Anneliese Földes), pigment analyses: REM-EDX (Martina Griesser), X-ray fluorescence analysis - XRF (Katharina Uhlir), binding media analyses: GC-MS (Václav Pitthard). Dendrochronology (Pascale Fraiture, KIK-IRPA).

2 See Bisacca 2017, 103-109; Gruber 2017, 274-275, 285-289; Oberthaler & Prast & Slama 2017, 112-115; for more on enlargements in Rubens's panel paintings, especially his landscapes, see: Sonnenburg 1980, 3-25; Davis & Bobak & Bobak & Straub 2020, 65-81, see also Martin 1970, 201; Brown 1996, app.; Brown & Reeve 1996, 117-119 (LZ 116-121); Brown 2000, 267-277 (LZ:267-277); Brown & Reeve & Wyld 1982, 27-39; Millar 1977, 631-635; Van Hout 2000, 697; Bruce-Gardner 1988, 591-596. For more on the enlargement of panel paintings see also: Poll-Frommel & Renger & Schmidt 1993, 24-35; Poll-Frommel & Schmidt 2001, 436; Hartwieg 2018, 273-292; Oliver & Healy & Roy & Billinge 2005, 4-22; Bisacca & De la Fuente 1998, 51-58.

3 Rubens's numerous modifications to this work are complex and can only be partially visualized with the aid of digital media. The resulting images are, as expected, open to varying interpretations, and can possibly be studied further as technical advancements in imaging are made.

4 The authors took into account both stylistic differences in brushwork and his choice of pigments, which changed in the course of the evolution of this composition, as well as their respective infrared-reflectograph, false infra-red and X-radiograph images. See also: Gifford 2019.

5 The small panel (ca. 66 x 85 cm) consists of three horizontal planks, which are, respectively, ca. 28, 18 and 20 cm wide. Starting from the middle plank, a dowel was inserted – slightly offset – into each of the adjacent planks (L ca. 2.5 cm, Diam. ca. 3 mm). Measurements and mapping by Georg Prast (see pl. IX, X, XII).

6 Muller 1989, 20-21, 128: *Specification* 1640, Nr. 191: "Vn paysage à l'huile avec la fuite en Egypte, du vieux Breugel" Grossmann 1966 (1973), 195 was already aware of this painting's key role for Rubens's landscapes.

7 Muller 1989, 13, 17, 18, 20-21. Grossmann 1954, Nr. 3, 79ff. For *View of St Gotthard* see esp. Grossmann 1966 (1973), 17.

8 Van Mander regarded Titian's landscape-xylographs and Bruegel's landscape prints as exemplary. Van Mander 1604, Van het Landtschap. Het achtste Capittel, fol. 36r, 24-25.

9 See the essay by Carina Fryklund in this publication, and Gruber 2017, 275, 289.

10 In the infrared-reflectograph the sketched grove is visible because of the carbon-containing liquid medium that was applied with a brush *(fig. 21)*.

11 A total of three planks were attached to the left and right edges, in addition to one at the top and two at the bottom. At this point, the panel measured ca. 112 x 153 cm. The exact dimensions can be seen in the mapping. A number of dowels were inserted to increase the stability of the butt-joint in the area of the horizontal joints: two between the lower edge of the core panel and the first extension, and three between the former and its adjoining board.

12 George Bisacca first discussed the theory that the asymmetrical extensions were guided by the desire to shift the perspective, adjust the horizon line and/or realign the light source in 2017. Bisacca 2017, 103-109.

13 The hills in the background are composed of azurite, lead-white and chalk.

14 At this point the central mountain range and the mountain slopes in *The Stormy Landscape* would have resembled, to some degree, those in *Pastoral Landscape with Rainbow* (St. Petersburg, Hermitage).

15 The panel was extended by a single plank, respectively, at the left, top and bottom, and by two planks on the right; today's measurements: 146.8 x 208.5 cm.

16 Leonardo da Vinci, *A Deluge*, ca. 1517/18, Windsor Castle, Royal Library (inv. 12376). We know from Roger de Piles / Philip Rubens that Rubens knew these drawings by Leonardo. Lusheck 2019.

17 Report by Katharina Uhlir 2015.

18 See also Oberthaler & Prast & Slama 2017, 116-121.

19 See also: White 2007, 184. Brown & Reeve & Wyld 1982, 38-39.

20 For more details, see Bisacca's essay in this publication and Van Zuien 2014, 8-9; Poll-Frommel & Schmidt 2001, 436; White 2007, 184. In *The Stormy Landscape*, the priming for the enlargements also contained resinous and oily components. Analytical report by Sabine Stanek 2016; for priming see also Sonnenburg 1979, 85-92; and Sonnenburg 1980, 11-12.

21 In the infrared-reflectography of *The Stormy Landscape* the overlapping gesso and paint layers between the core panel and the first extension are far less noticeable than those between the first and second extension. Similar gesso was used in Rubens's *The Watering Place,* see Brown & Reeve & Wyld 1982, 38, 39, and in *The Rainbow Landscape,* inv. no. P63, The Wallace Collection, London; Davis & Bobak & Bobak & Straub 2020, 70-72.

22 Report by Sabine Stanek & Martina Griesser 2016/2017.

23 See Bruce-Gardner 1988, 596 and Roy 1999, 92-93.

24 In some of the works of Pieter Bruegel the Elder (1526–1569), the priming was isolated with a thin, streaky imprimatura that consists mainly of an oil-bound mixture of lead-white and chalk, with traces of ochre and black pigment. See Oberthaler 2019, 421, e-book 375.

25 The imprimatura of *The Stormy Landscape* is not consistent because different materials were used for the various extensions. At the upper end of the right edge a *barb* has remained despite a slight cropping of the panel, showing both the imprimatura and a grayish-blue background under the trees. Since carbon black is only present in very small quantities, the imprimatura is hardly visible in the IRR. See also Brown 1996, 101, and Brown & Reeve 1996,

app. 116-121. For the streaky imprimatura in Rubens's paintings, tempera-based and aqueous binding media were analyzed in addition to an oily binding medium (analytical report: Stanek 2016). See also Van Hout 1998, 205-210; Van Hout & Balis 2012, 42-45, 72; Sonnenburg 1980, 11-18; Plesters 1983, 36-38; Oberthaler 2015, 23; Oberthaler 2015a, 264-266; Boersma & Van Loon & Boon 2007, 82-88; Holubec & Meyer-Stork 2012, 64.

26 Van Hout & Balis 2012, 62-63; Sonnenburg 1980, 18-20; Oliver & Healy & Roy & Billinge 2005, 9-11; Brown & Reeve 1996, 117; Oberthaler 2015a, 265-266; Bruce-Gardner 1988, 596; Farnell & Van Hout 2007; Schäfer & Saint-George 2006, 34-35.

27 Kirby 1999, 33-39; Plesters 1983, 38-40; Sonnenburg 1979, 197.

28 Studies on lead-white: Fabian & Fortunato 2010, 426-447.

29 Report Uhlir. 2016; see also Brown 1996, 102-103; Holubec & Meyer-Stork 2012, 67-68.

30 Report Stanek 2016; Report Pitthard 2017. Jo Kirby argues that the deep shades and high saturation of the paints are the result of pre-treating the oily binding medium (by heating it and possibly adding lead salts) which gives it a thicker consistency and better drying properties; Kirby 1999, 32. Walnut oil was mostly used for light colors, especially for white and blue pigments, as well as for light flesh colors and pale yellow. However, the chemical analysis of several paintings showed that walnut oil was also used as a binding medium for black pigments. Pine resin was found in the transparent greens of both *The Stormy Landscape* and *Autumn Landscape with a View of Het Steen in the Early Morning*, London, National Gallery. See also Sonnenburg 1979, 197-199. Plesters 1983, 40, 41; Keith 1999, 104 (note 14); for more on various painting agents see also: De Mayerne 1620/1901; Bischof 2004, 74, 145, 159, 219, 220, 222.

31 As white pigments are not visible in the X-radiograph we can exclude the use of lead-white.

32 Here, however, it seems the fingerprints left in the paint were unintentional, unlike Pieter Bruegel the Elder's calculated use of them to help create a finely broken and structured surface quality.

33 A possible reason for the running paint may have been that the artist wiped his brush, loaded with solvent/medium, across the edge of the panel, thus partially dissolving the still-fresh paint at the edge. Examples featuring similar effects: *Venus Frigida*, Rubens (1614), inv.no. 709 Koniklijk Museum voor schone Kunsten, Antwerp, *Venus in Front of the Mirror,* Rubens (1614/15), inv.no. GE120, Liechtenstein Collection, Vienna.

34 Catalogue raisonné 1928, 183-184. For a survey of the various dates see exhib. cat. Vienna 1977, 105. Brown, exhib. cat. London, 1996, 56

35 Rooses 1886–1892, no. 1168, 359-360

36 Rooses 1886–1892, vol. IV, no. 1168, 359-360. In 1994 Balis suggested that the core panel of *The Watering Place* in the National Gallery, London, may be a copy by Lucas Van Uden of Rubens's *Shepherd with his Flock in a Woody Landscape* because he considers the brushwork "tame and hesitant". Rubens may have retouched it later; Balis 1994, 97-127, esp. 117. Brown explained the stylistic differences by pointing out the extensive time needed for the development and completion of *The Watering Place*; Brown 1996, 55. Later, however, he too agreed that Rubens had reworked a copy. Brown 2000, 269-270.

37 Rubens tended to rework paintings in his possession repeatedly. See f.e. *The Prodigal Son*, KMSK Antwerp; a painting also started by him in the 1620s and reworked in the 1630s.Van Hout & Balis 2012, 77-79. In his *Holy Family with a Parrot*, KMSKA, Rubens also altered a number of details many years later; Van Zuien 2014, 7; Van Hout 2014, 9-26.

38 See Vergara 2016, 110-115. An X-ray of the painting in the Prado reveals that part of Psyche's red drapery was originally St. Jerome striking his chest with a stone, just to the right of Psyche; the saint was completely painted over by Rubens. Pijl 1998, 660-667, fig. 9 shows details of the X-ray, and fig. 8 shows a painting by Maerten Ryckaert, *Landscape with a Draughtsman* in a private collection. https://www.museodelprado.es/en/the-collection/art-work/landscape-with-psyche-and-jupiter/191cc2c4-2562-47bd-89aa-97cbf65c6bd7?searchid=597af422-543e-384d-63e3-a9e4ff76786b. (19.4.2018), see also: Belkin 2009, 185-188; Belkin rejects the idea of Ryckaert's paintings as a terminus post quem; she dates Rubens's reworking to ca. 1617/18, arguing that Psyche's body better resembles bodies painted during this period: Belkin 2009, 187.

Ina Slama

Condition and Conservation/Restoration Measures to the Painting's Surface

Considerable appreciation is extended towards the experienced members of the Getty Panel Painting Initiative[1] for their focused intervention to stabilize the weakened and unstable 17 member wooden panel construction,[2] upon which Rubens's *Stormy Landscape* is painted (*fig. 1*). This structural intervention, coupled with the consolidation of the locally loosened paintfilm, established the basis of the conservation/restoration procedures described below.

Covering the entire surface of the *The Stormy Landscape* was a non-original, multilayered, uneven, discolored varnish. The noticeably degraded state of the varnish had also shifted the intended chromatic range of the painting and compromised the sense of transparency and depth within many painted passages. The underlying paintfilm was however, despite a few localized damages, in a near excellent state of preservation. The most obvious forms of degradation were detaching paint, compression cleavage and smaller paint losses within the areas of cracks and panel joints.[3] Earlier attempts to disguise these structural faults in the panel resulted in extensive over-filling (several cm. in width) and copious retouching

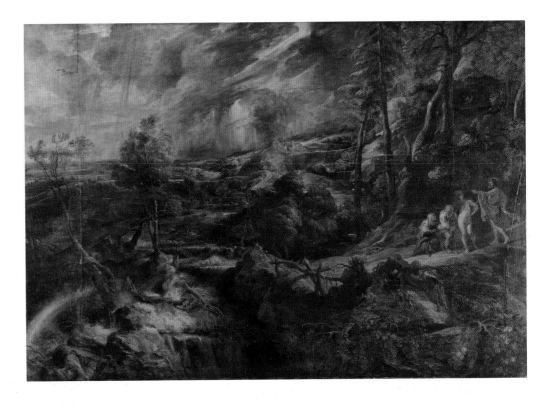

Fig. 1: Before conservation/restoration

95

Fig. 2: Detail of the central panel section (including left extension) as well as extensive overfilling and overpainting to area of panel joint

Fig. 3: Detail of the mechanically reduced and liberally overpainted losses before the restoration.
In the X-radiography the losses can be seen as darker areas.

(*figs. 2, 9a, 12a*). The most extensive areas of reworking were to be found along the junction between the (viewing) left, vertical addition and the central section of the panel.[4] Here one can also find a later wooden insert as well as a substantial loss within the paintfilm measuring approx. 12 x 3 cm (*fig. 3*). This larger loss was caused by the mechanical reduction (using a hand plane) of the panels surface to better register the warped central panel section[5] to that of the addition.

Exactly when these modifications were undertaken is not known, however, an earlier copy of the painting, in watercolor, by Anton Koch (from 1814) clearly shows the overpainted passages to the aforementioned areas of repair. Clear to see is the extended passage of the tree top which straddles both sides of the planed panel joint and so provides valuable information regarding the painting's restoration history (*figs. 4a-b*).[6] Numerous older retouchings and the slightly curved repainted addition at the lower right[7] had clearly darkened with age and had become more apparent in the course of the varnish reduction. Earlier attempts to clean the painting had created localized zones of blanching (*fig. 5*) and further resulted in the removal of original applications of glazing. In an attempt to stabilize the panel in the area of the extensive cracks, 35 nails were driven through the front of the panel[8] into a strip of wood positioned on the reverse of the panel structure[9] (*figs. 6a-b*). This form of repair not only created substantial deformation and loss to the overlying paintfilm, but also introduced unpredictable stress (tension cracks and indentations from hammering in) to the complete wooden support. The areas in which the nails were driven had been generously filled with gesso and reworked (*fig. 7a*).

Before starting with the structural work on the panel itself, several preparatory measures needed to be attended to. These included the removal of all previous repair material covering the nail heads as well as considerable amounts of aged and hardened filling material, which had seeped into the crevices, between the individual planks of wood (*fig. 7b, 8a-d, 9b*). This was conducted under magnification (6-16 x) using a stereomicroscope and various specialized knives and instruments. These procedures allowed the panel conservators the necessary access to specific areas of the wooden support to carry out the required structural treatments, which included removing the nails and consolidating the boards.

After the structural intervention was completed (see the essay by George Bisacca), the treatment to the painting's surface could be continued.

Fig. 4a: A: Josef Anton Koch, *Landscape with Philemon, Baucis, Zeus and Hermes*, watercolor, signed, dated 1814. 42.5 x 60.5 cm. Private collection

Fig. 4b: Detail from fig. 4a: tree top

As the surface of the painting was covered with several, different varnish layers (from earlier restorations) it was necessary to test a variety of organic solvents to determine the optimal solvent system for the varnish reduction. The most applicable solvents to evenly reduce the degraded, natural resin varnish films, proved to be a range of concentrations requiring both Ethanol and Isooctan.[10] The reduction of the older varnish was carried out in numerous passes until the desired level was achieved (*figs. 10a-b*). Areas which harbored thicker, less soluble additions of overpaint needed to be carefully swelled and reduced (under magnification) using localized applications of solvent-gels in combination with scalpels and other precision tools. Using these processes it was not only possible to reduce the discolored varnish layers but also to uncover well preserved passages of original painting, which had been completely obscured for generations. *Figs. 9a-d* document, in a series of images, the area showing a waterfall (viewing front left) – before, during and after treatment. Here one can see the re-emergence of the splashing water, which had been previously concealed, as well as big parts of the original paint layer of the tree top to the left (*see fig. 12b*).

After the removal of overpaint, reduction of the degraded varnish and re-saturation of the paintfilm,[11] the overall chromatic expression of the painting was distinctly enhanced: *The Stormy Landscape* had recovered much of its intended brilliance, balance and depth. The equilibrium between the darkest and most vivid passages had been regained and of noted significance is the recovery of the tactile brushwork of the artist, with its nuances in application and handling.

The blueish cast of the distant background, which had been masked through the filter of the yellowed, older varnish, had been re-established. This plays a subtle, yet significant role in restoring the intended atmospheric perspective within the composition (*figs. 10a-b*).[12] Also, throughout the central zone of the landscape, one can now appreciate how the artist adjusted and varied the fall of light to enhance the plasticity within the terrain and trees.

After the application of an initial brushed varnish layer, numerous areas of loss were filled with gesso[13] (*fig. 11a*) and leveled, with special attention given to the more irregular zones concentrated within the two vertical panel joints. The two planks used to extend the composition at both sides were not permanently attached (glued) to the end-grain of the (horizontally oriented) central panel construction. This was avoided due to the anisotropic behavior[14] of the various panel members. Instead, the panel conservators were able to align

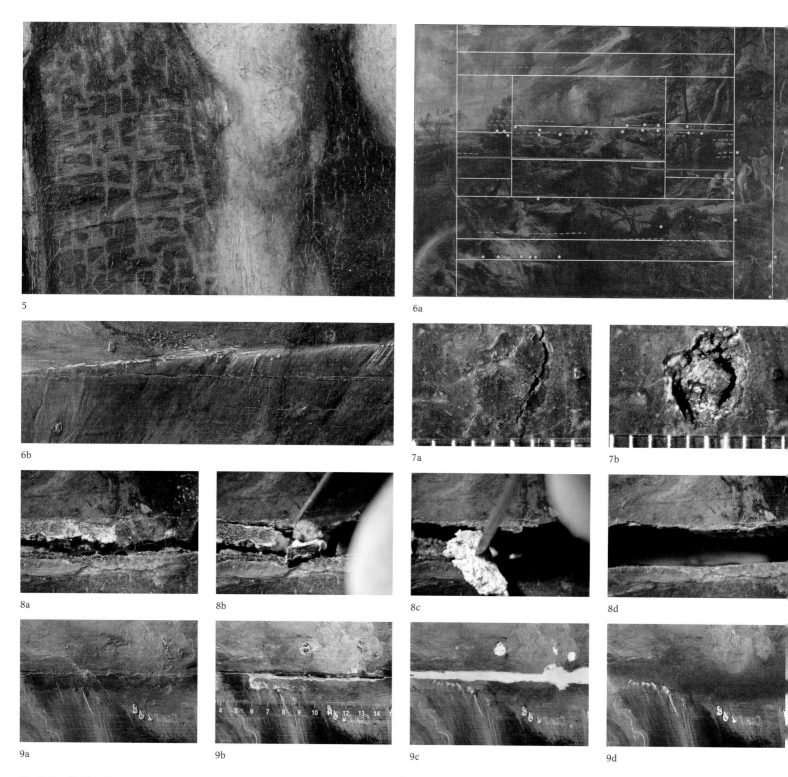

5

6a

6b

7a

7b

8a

8b

8c

8d

9a

9b

9c

9d

Fig. 5: Detail: blanching to the paintfilm, within a network of cracks, caused by aggressive solvents

Fig. 6a: Schematic showing the construction of the panel. Damages: (Green – cracks), (Red – ruptures), (Yellow – nails). Schematic by Georg Prast

Fig. 6b: Detail: four nails, which have been driven through the surface of the painting

Figs. 7a-b: Photomicrographs of the overfilled and overpainted nail, before and after cleaning

Figs. 8a-d: Photomicrographs before, during and after the removal of overfilling and overpaint covering the rupture in the panel support

Figs. 9a-d: Detail of the waterfall at the left, before, during and after removal of overfilling and overpaint, filling and retouching

Figs. 10a-b: Details of the fortress and mountain in the background at right, before and after varnish reduction

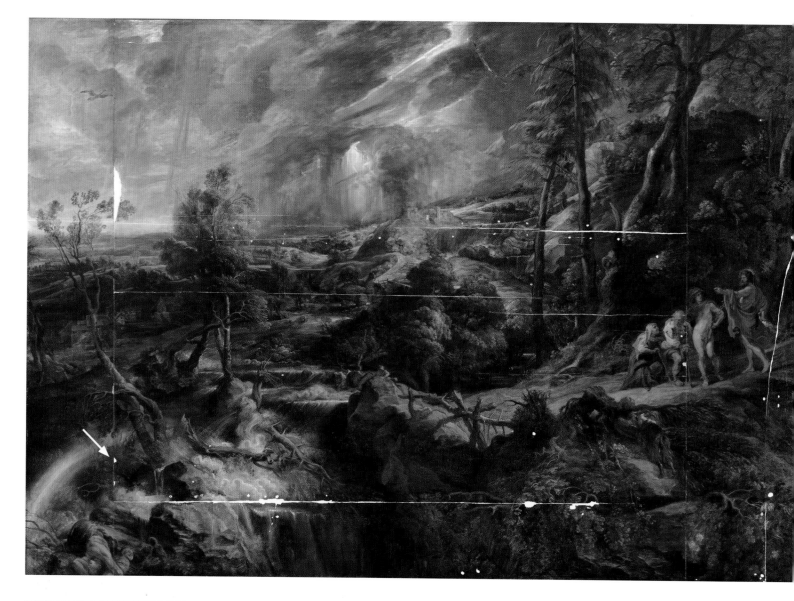

Fig. 11a: Overall image after cleaning, filling and varnishing. The arrow shows the location of Fig. 11b.

Fig. 11b: Detail after filling and before leveling of the loss between the central panel and the vertical addition at left. To avoid any filling material to enter the panel joint, silicon film was used as a barrier.

the outer wooden members to the central section using a fitted wooden support at the reverse equipped with adjustable tensioning devices.[15] To avoid that any filling material entered the fine slit between the outer and central wooden sections, a double layer of siliconized film was positioned (*fig. 11b*). This allowed for a clean connection without hindering any slight movement that may occur within the structure as a whole. To the areas of loss that were filled with gesso, a series of fine layers of gouache paint was applied to provide both a foundation color, as well as to simulate the surface quality of surrounding original paint-film.[16] Subsequently a thin layer of varnish was applied to isolate the gouache underpainting (as to allow further retouching in watercolors) as well as to help create a uniform surface sheen over the painting's surface. The development of the retouching process using water-based media allows for a high degree of reversibility, a factor of paramount concern in the conservation of artworks.

Due to the nature and variety of the damages to the painting, several methods in approaching the restoration were considered:

The compensation to losses would be carried out with water-based media and applied by brush using fine points and lines (*fig. 12a-b*).

Fig. 13a shows how thin and semi-transparent the application of the paint in the sky was applied. While twice enlarging the painting, Rubens (or his studio) covered the joint between the panel elements with priming material, which in places left a slightly raised outer edge from the spatula used. Because the edges of this layer were slightly raised, in relation to the

Figs. 12a-b: Detail of a vertical joint, wooden insert, splits and extensive reworkings before and after restoration

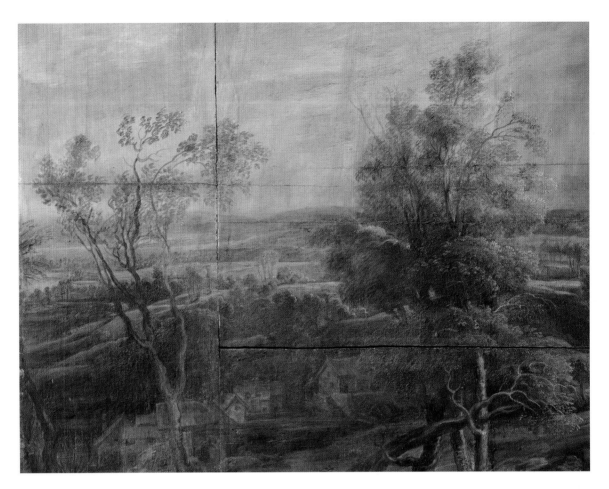

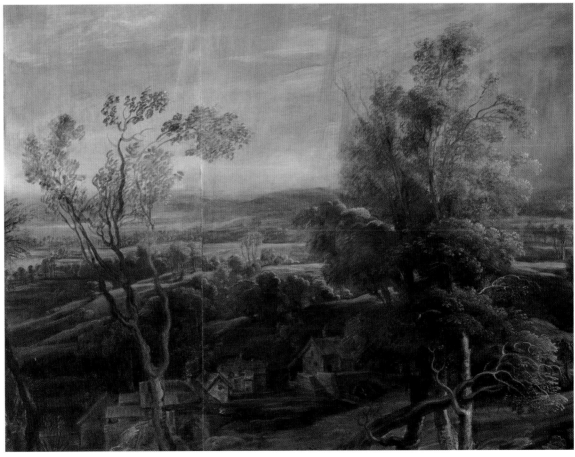

original paint surface, they were particularly exposed to mechanical and chemical abrasion. Through natural aging and earlier attempts to clean the surface of the work, these contours became ever more noticeable and thus distracting within the composition. Therefore, an additional focus during the restoration was to address this visual discrepancy, and through calculated retouching, to interrupt and help minimize this optical "shift" or "step". Concentrating first on the most obviously affected areas[17], a sequence of fine points was applied using watercolor, which as they receded (ca. 1.5 cm) from the damage, became less populated, to finally dissolve into the surrounding paint layers (*fig. 13b*).

A similar process was adopted in the integration of the narrow, slightly curved addition at the lower (viewing) right edge. Due to the rougher surface, the darkened and cupped repaint, in addition to the overfilled joint to the original panel, this early and large repair had become increasingly obvious (*fig. 14a*). After consolidation of the cupped paintfilm, a similar integration process, using ever more open patterns of fine points of retouching was utilized, which aided in diminishing the boundary between original and addition, without denying its history within the work (*fig. 14b*).

On to the surface of a network of solvent damaged cracks (*fig. 15a*), fine points of oil-resin retouching were set down, which, by varying the distance to one another, could convincingly reproduce the quality of color and transparency in the surrounding paintfilm (*fig. 15b*).

For the largest and most obvious damage, located within the sky and tree top at the left (*figs. 16a-l*), a modified approach to retouching was necessary. As noted with the other losses, after the removal of the earlier fillings and retouching, the damaged area was seized and

Figs. 14a-b: Earlier repair before and after restoration

Figs. 15a-b: Detail of small bushes in the background. Above the condition before the restoration. Along the network of cracks can be seen noticeable solvent damage. Below the same area of damage, re-integrated with a series of small points of oil-resin retouching.

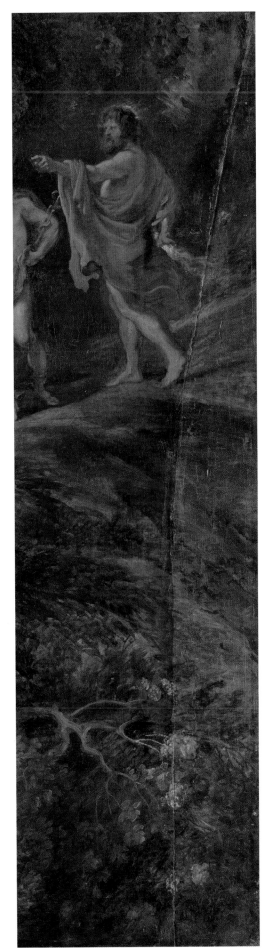

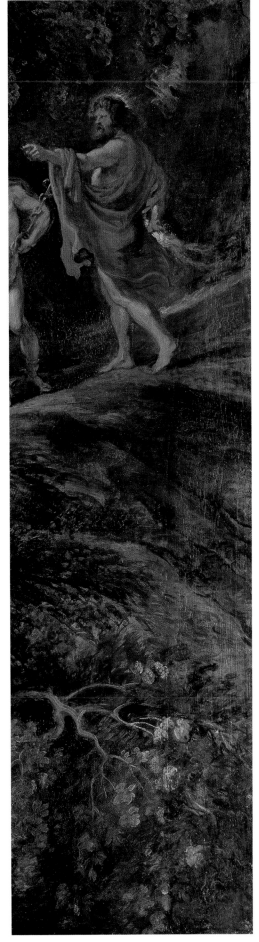

Fig. 16: The extensive damage to the tree top at left:
a: before restoration,
b: during the cleaning process,
c: after removal of overfilling and overpainting,
d: after filling.
e-g: during the application of gouache for surface simulation,
h-i: gouache retouching,
j: during the watercolor retouching,
k-l: after oil-resin retouching.

filled with gesso and leveled to slightly below the surface of the surrounding original pain

To this filling exacting applications of gouache paint were laid on which replicated th necessary tonal and tactile qualities of the artist's color mixture and brushwork. The cha lenge of this task involved working through a slow and calculated procedure with the air of creating a surface structure that matched and aligned with the spontaneous and gestura quality of the original application technique. These characteristics included: the thicknes of the brush, the stiffness of the hairs, the shade of color, the viscosity of the paint and th angle and pressure of the brush. Once the desired quality of surface relief was obtained,

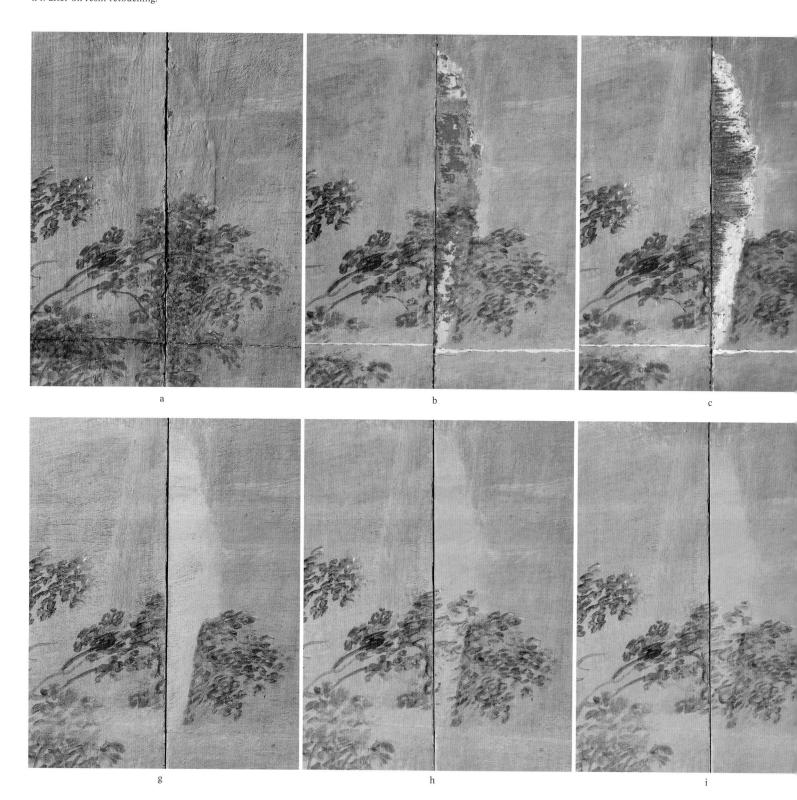

number of thin layers of gouache paint was applied using a network of fine colored lines. It was important to be consistent with Rubens's technique in allowing the brushed imprimatura respectively translucent underpainting to filter through the thin colored paintlayer, and in so doing influencing the final color.

After simulating the overall gesture and arrangement of the leaves using Photoshop, tests by hand were carried out on samples to optimize the size, shape, angle and color of the leaves. Highly diluted gouache was used for the first layers and developed further using watercolors. Final glazes and mainly brownish transparent accents were sparingly set down using oil-resin paint.[18]

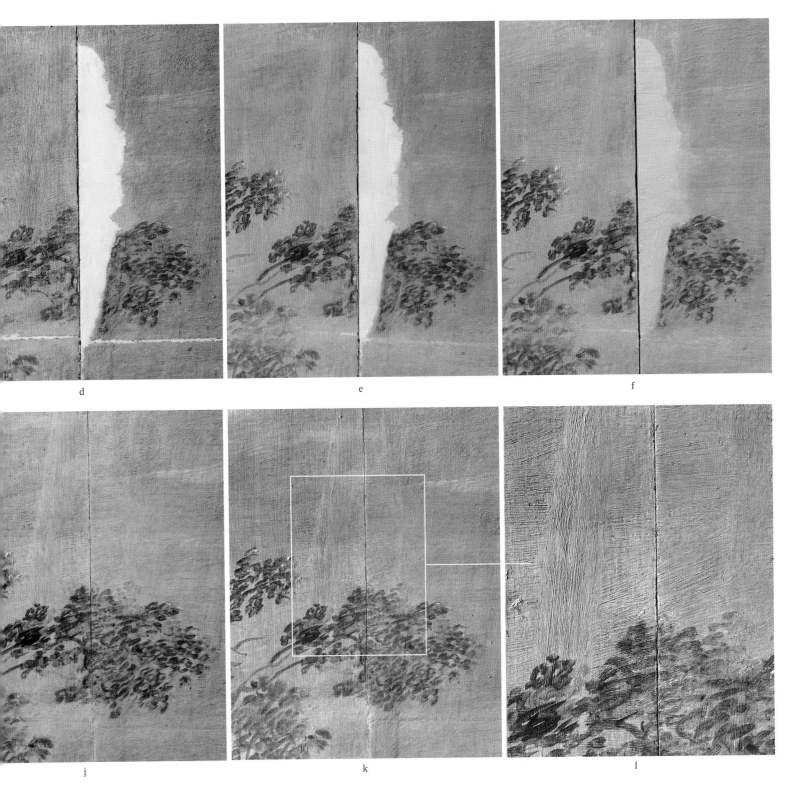

d e f

j k l

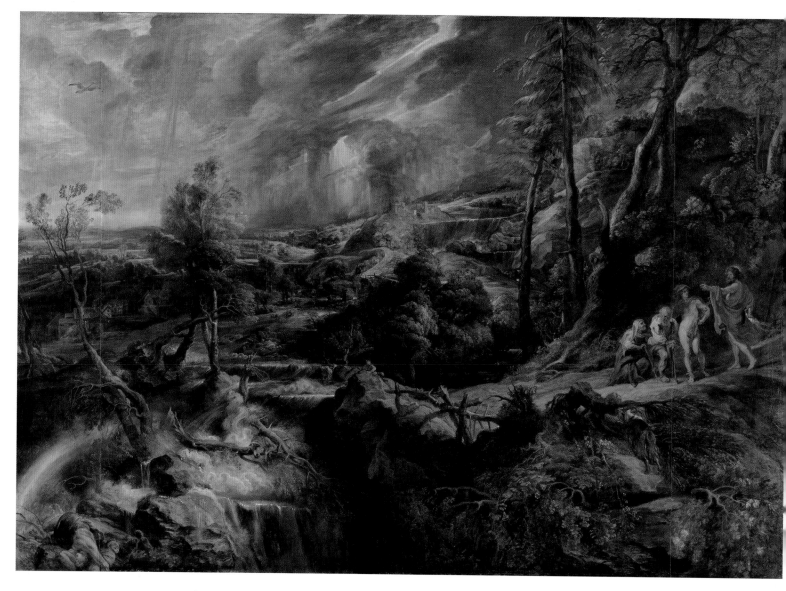

Fig. 17: After conservation/restoration

To adjust the saturation and overall surface sheen of the painting, a final spray application of natural resin varnish was applied (*fig. 17*).

For presentation and protection, the present frame for the large format painting was modified to accept UV absorbing, non-glare security glass at front and a plexiglass encasement at reverse.[19]

1 I would like to thank George Bisacca and José de la Fuente for generously offering their expertise along with Georg Prast from the KHM for his valuable participation in the treatment, including photographic documentation of the restoration process and the various mappings, as well as Aleksandra Hola, Adam Pokorný und Johannes Schäfer (Trainees) for their cooperation. Special thanks go out to Elke Oberthaler and Gerlinde Gruber for their enthusiasm, opinions, rewarding discussions and progressive support during this project. I would also like to thank Andreas Uldrich for the excellent quality of the photographs and Michael Eder for the infra-red image and the assembling of the X-radiograph, which have repeatedly sharpened my understanding of the painting technique.

2 Overall size; 147 cm x 208 cm x 0.4-0.8 cm.

3 See also the essay from George Bisacca in this volume, as well as Oberthaler & Prast & Slama 2017, 112-116.

4 The central panel construction consists of 14 horizontal wooden elements of varying widths. The vertical addition at viewing right consists of two wooden planks of differing widths. The viewing left addition is made of one plank. The joints between both additions and the central panel construction were open.

5 The x-ray image of the painting, in comparison with the high resolution photographs in normal light, afforded the localization of numerous damages and anomalies within the painting and panel structure. This information was pivotal in creating the entire conservation/restoration treatment.

6 The first documented treatment of the painting is from Feb. 7th, 1946 till 1949 from Elisabeth Krippel. The treatment was noted as follows; "Through the effects of higher humidity the varnish is defunct. Regenerated, surface stripped."

7 The highest and widest measurements from this asymmetrical, later addition: 94.5 x 9.0 cm (see pl. IX, X). Even before the removal of the cradle, it was possible to determine, with the aid of the X-ray image, that this insert was not a repair with original material, but a different piece of oak-wood, fitted, glued and prepared with a different priming and painting material.

8 The fact that most of the different types of hand-made nails were used (late 18th early 19th cent.), strongly suggests that the repair was most likely performed on several occasions. In fact, a similar attempt at stabilization was noted to have been carried out on another multi-panel structure by Rubens, from the Liechtenstein Collection: *Portrait of Albert and his Brother Nikolaus Rubens*. This extended panel was once similarly nailed from the front, around the outer edges, onto an auxiliary frame at the reverse. The frame and nails have since been removed, during a conservation treatment from 1980. I thank Robert Wald for this insight.

9 These wooden strips would have been removed before the initial cradle was applied.

10 In varying concentrations: Ethanol:Isooctan 1:1 - 1:4.

11 Mastic resin (Chios 1A quality, Kremer Pigmente) dissolved in 2x rectified Balsam turpentine oil (10% solution). The same concentration was used as an interim varnish and for the later spray applications.

12 Leonardo 2005, 125, 127 and 136.

13 Filling material: Champagne and Bolognese Chalk 3:2, with 6% rabbit skin glue. The fill material would be prepared and applied in sequential, diluted layers by brush.

14 Anisotropic: A material whose properties vary when measured in different directions. In this case with wood which exhibits different rates of swelling and shrinking depending on three different directions – length, width, depth.

15 Oberthaler & Prast & Slama 2017, 111-115, figs. 9, 10.

16 Gouache paint, Schmincke. This procedure is vital for a successful retouching, as it not only replicates the surrounding original surface, but also can include secondary characteristics, such as age cracking etc.

17 Along the outermost contour of the overlapping priming application.

18 I would also like to take this opportunity to thank my colleagues, above all Eva Goetz, Ingrid Hopfner, Michael Odlozil and Robert Wald, for the constant and very pleasant professional exchange and assistance during the restoration process.

19 Rudolf Hlava, Markus Geyer together with Georg Prast carried out all the preparatory work for the support construction as well as the creation of a temporary working frame and the integrated climate control display case for which I thank them deeply.

Carina Fryklund

After Rubens: A Drawing by Lucas Van Uden

Probably shortly after the second enlargement of *Landscape with Philemon and Baucis*, Rubens introduced a group of small-scale figures on horseback visible in x-radiographs, positioned close to the present larger figures of Philemon, Baucis, Jupiter, and Mercury.[1] The recent technical examination of the painting has shown that the composition began with a core panel that was enlarged in several stages as the artist's ideas developed, transforming what was initially a pure landscape into the present landscape and mythological scene.[2] Also introduced into the foreground at this time were a pollarded willow, a small cliff, a figure leaning on a tree, and a wide path along the right-hand side. The mountain and castle complex in the centre of the composition was previously larger, and the meandering path extending into the foreground more prominent. In the middle ground, to the right of the central mountain, was a coniferous woodland. A drawing in the Nationalmuseum in Stockholm, here attributed to the Flemish landscape specialist Lucas Van Uden (*fig. 1,* see below), records an intermediary stage in the development of the painting, when the equestrian figures and the path on the right-hand side had been eliminated by Rubens through overpainting while the remaining elements mentioned above were still visible.[3] Rubens would eventually paint over these details as well. The composition must, therefore, have been copied *before* the finishing touches were applied, and the draughtsman would have been present in Rubens's

Fig. 1: Lucas Van Uden (after P.P. Rubens), *Landscape with Philemon and Baucis.* Stockholm, National Museum, inv.no. 1911/1863

Fig. 2: Lucas Van Uden (after P.P. Rubens), *Landscape with a Cart Crossing a Ford.* New York, The Metropolitan Museum of Art, inv.no. 25.62 (as Lodewijk de Vadder)

Figs. 3a-c: Details (left to right) from: Stockholm, Nationalmuseum, inv.no. NMH 1957/1863; Berlin, Kupferstichkabinett, inv.no. 12052, and Stockholm, Nationalmuseum, inv.no. NMH 1911/1863

Figs. 4a-c: Details (left to right) from: Stockholm, Nationalmuseum, inv.no. NMH 1959/1863; from Stockholm, Nationalmuseum, inv.no. NMH 1911/1863, and Stockholm, Nationalmuseum, inv.no. NMH 1957/1863

studio when the elaboration of this painting took place. The existence of the drawing may indicate the passage of a considerable length of time between the alterations, enough for the picture to be known and copied before the final stage.

The Stockholm drawing (*fig. 1*) is done in pen and ink, enhanced by blue, green, ochre and grey watercolour, over a preliminary sketch in black chalk. Careful study has revealed a grid ruled in black chalk to enable the artist to transfer the composition square by square to a different format.[4] Although executed in a distinctive loose and summary drawing style, with broadly applied watercolours, the drawing provides an accurate record of Rubens's composition. The draughtsmanship is closely related to that of a sheet in the Metropolitan Museum of Art in New York (*fig. 2*), which reproduces the composition of Rubens's *Landscape with a Cart Crossing a Ford ('La Charette embourbée')* of the late 1610s in The State Hermitage Museum in St. Petersburg. This has been identified by Julius Held as an item listed in François Basan's catalogue (1775) of Pierre-Jean Mariette's collection.[5] Despite Mariette's and Basan's confidence in its authenticity, Held did not accept the New York sheet as an original by Rubens, who is not known to have made 'complete' compositional drawings for his landscapes. In Held's view, it is "too fuzzily drawn" and "lacks the structural clarity" expected from Rubens.[6] The colouristic treatment reminded Held of Lucas Van Uden (1595–1672), an artist strongly influenced by Rubens, who made painted and etched copies of the master's landscapes, and elsewhere reworked compositions to form new ones with a capriccio character.

Although the unusually free penwork of the Stockholm and New York drawings contrasts with Van Uden's more familiar detailed renderings of woodland scenery with their subtle and atmospheric use of watercolour, both sheets display his characteristic mannerisms – the semi-circular, striped modelling of slender tree trunks, their angular root systems and cotton wool foliage combined with broad horizontal hatching – as seen in the artist's signature drawings (*fig. 3*).[7] These, while derived from Rubens's late landscapes, simultaneously reveal a debt to Jan Brueghel the Elder. The small figures, done in nervous and hasty flourishes, are comparable to those in a signed drawing in Stockholm (*fig. 4b*).[8] The greater freedom than that of Van Uden's secure work of the 1640s may be attributed to the function of such

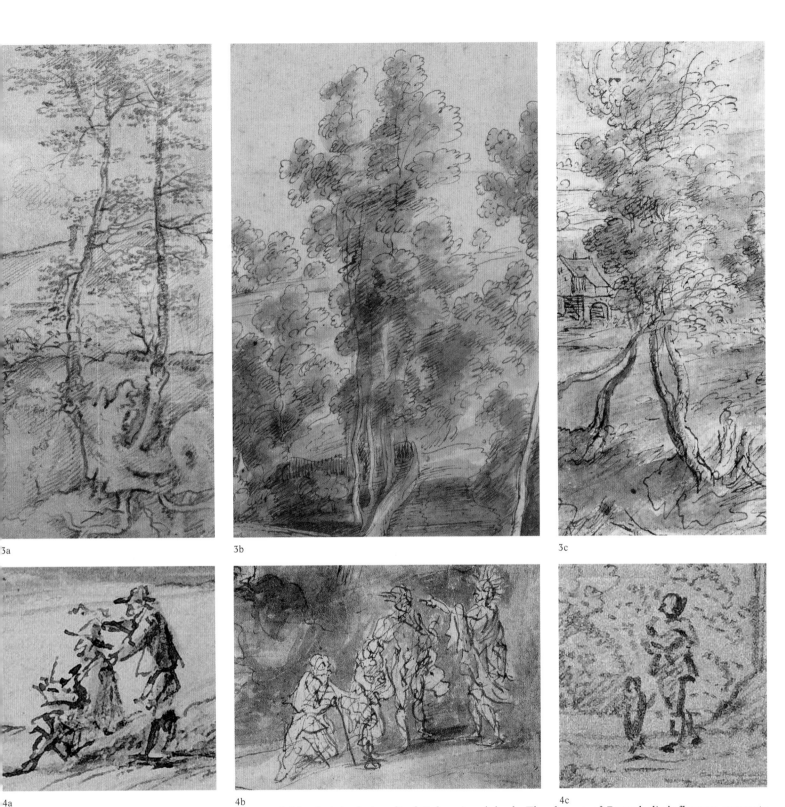

3a

3b

3c

4a

4b

4c

quickly sketched *ricordi* of Rubens's originals. The degree of Brueghel's influence suggests they may be early works, no later than the 1630s. Of several loosely drawn landscapes found in Amsterdam, Berlin, Brussels, Paris, London, and Munich,[9] casually grouped together in the literature, two sheets come closest to the Stockholm and New York copies after Rubens, although undoubtedly of later date: a drawing in the Kupferstichkabinett in Berlin (*fig. 5*), with an early inscription naming Van Uden as the artist, and another in the Musée du Louvre in Paris, formerly in Mariette's collection (*fig. 6*).[10]

Van Uden's career remains something of an enigma. He was born at Antwerp in 1595 and trained by his father. He lived until 1672, enjoying a long and successful career specializing in topographical views and decorative landscapes.[11] At one time it was thought that he

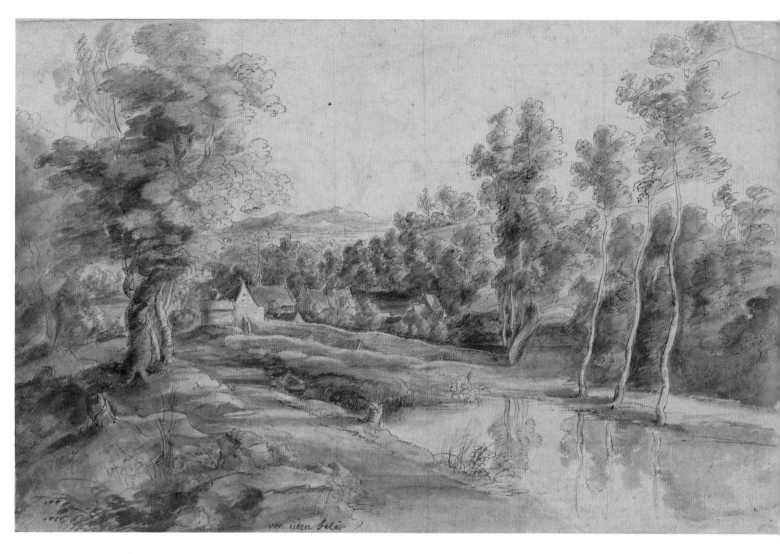

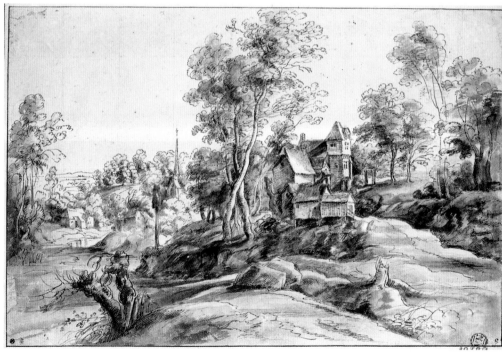

Fig. 5: Lucas Van Uden, *Wooded Landscape with a Monastery.* Berlin, Kupferstichkabinett, inv.no. 12052

Fig. 6: Lucas Van Uden, *Landscape with a Village.* Paris, Musée du Louvre, Département des arts graphiques, Cabinet de dessins, inv.no. 20209

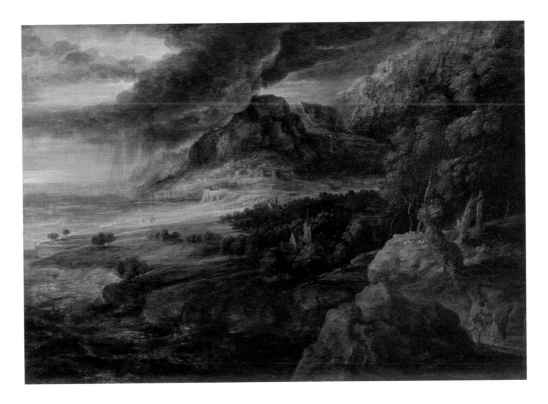

entered Rubens's studio when he was in his early twenties, around 1615, and remained there painting landscape backgrounds until after becoming a master in the painters' guild in 1626/27.[12] This idea has been discounted for lack of documentary proof, but it does not seem unlikely that Van Uden played a role in the master's studio over the years. His etching of *The Watering Place* after Rubens's painting in the National Gallery in London renders the composition as we know it but shows a branch of the leftmost tree that was painted out in the last stage of the elaboration. This suggests Van Uden's presence in the master's studio at the time the painting was on the easel, about 1618.[13] Two of his painted copies after Rubens, the *Ulysses and Nausicaa* in the Bowes Museum at Barnard Castle, after the original now in the Palazzo Pitti in Florence, and a *Stormy Coast Landscape* in the Bayerische Staatsgemäldesammlungen in Munich (*fig. 7*), after a lost original, are both signed and dated 1635.[14] This may imply that they were painted at Rubens's invitation and, presumably, under his supervision.

The studio was an integral factor in Rubens's artistic production, and he was clearly not averse to treating art as a business. Assistants were employed in making copies, and Rubens also had painters execute works after his sketches, which he then put up for sale. When, in 1640, the English miniaturist Edward Norgate had seen a landscape with a view of the Escorial in Rubens's studio that his master, Charles I of England, was keen on obtaining for his collection, the landscape specialist Pieter Verhulst executed the painting after an original first sketch by Rubens "according to the capacity of the master but with my supervision". There are undated versions of the same composition by Van Uden.[15]

The 1630s were important years for the development of landscape painting in Europe, and it is hardly surprising, therefore, that Rubens in the last decade of his life should have chosen to make his landscapes known to a wider public through two series of engravings. Only one print was certainly published before his death in 1640, the remainder probably in the following decade.[16] Van Uden made four etchings based on important 'early' landscapes by Rubens from the second half of the 1610s.[17] A delicate etcher with a light touch, he does not follow Rubens's originals very closely, and seems to have made the etchings from his own copies of Rubens's prototypes. Although his *Waggoners Shifting a Cart in a Ford* (*fig. 8*) clearly echoes Rubens's *Landscape with a Cart Crossing a Ford* in the State Hermitage Museum in St. Petersburg, Van Uden published it as his own composition. His claim may have

Fig. 8: Lucas Van Uden, *Waggoners Shifting a Cart in a Ford*, etching (B. 48; Holl. 41)

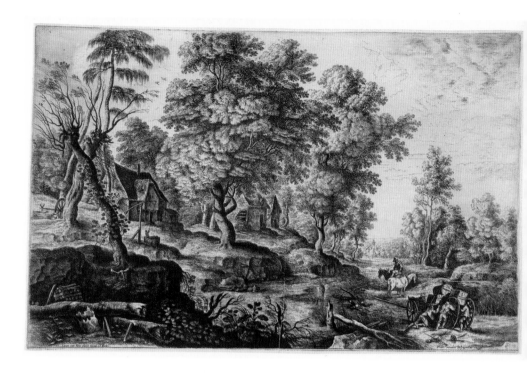

been founded on the fact that the etching was based on a copy he had made of a now lost variant by Rubens.[18] It has seemed to some critics unlikely that Rubens would have approved of Van Uden's etchings, so unlike the forceful and accurate prints by engravers working under the master's supervision. It may have been in the early 1640s that, inspired by the success of Schelte A. Bolswert's engravings Van Uden filled some of the gaps in the public's knowledge of Rubens's landscapes by etching a few of those that he knew.[19]

1 Exhib. cat. Vienna & Frankfurt 2017/18, pp. 116–117 (Oberthaler, Prast and Slama).

2 Exhib. cat. Vienna & Frankfurt 2017/18, pp. 103–109 (Bisacca); pp. 111–121 (Oberthaler, Prast and Slama); and p. 274 (Gruber *et al.*).

3 Lucas Van Uden (after Rubens), *Landscape with Philemon and Baucis*, pen and brown ink, brown and grey wash, watercolours, over traces of black chalk, on cream-coloured laid paper; squared for transfer in black chalk; framing lines added in black ink, 200 × 306 mm. Stockholm Nationalmuseum, inv.no. NMH 1911/1863. Annotated by an early hand in pen and brown ink at the bottom right, *Rubens*, and numbered in pen and black ink in the lower right corner, *1720*. Prov. Carl Gustaf Tessin; Kongl. Biblioteket (cat. 1790, no. 1720, as Rubens); Kongl. Museum (L. 1638); see Burckhardt 1940, p. 27 (under no. 12); Adler 1982, p. 109 (under no. 29); and exhib. cat. Vienna & Frankfurt 2017/18, pp. 117-118 (Oberthaler, Prast and Slama), 275, 289 (Gruber).

4 For a list of copies after Rubens's *Landscape with Philemon and Baucis,* see Adler 1982, under no. 29. To these may be added a painting (oil on oak, 31 x 46.5 cm), possibly by Lucas Van Uden, in Prague, Narodní Galerie, inv. no. O 12946 (identical to Adler, no. 29, copy 3?); see Slavicek 2000, no. 271; and another, on the British art market (Noortman) in 1988 (oil on wood, 43 x 63 cm); see Weltkunst, 58 (1988), p. 165.

5 Pen and black ink, blue, green, ochre, and grey watercolour, 220 x 293 mm, New York, The Metropolitan Museum of Art, inv.no. 25.62 (as Lodewijk de Vadder); see Held 1959, I, p. 34, n. 2 (as Lucas Van Uden), and Adler 1982, under no. 19 (copy 5). The drawing still has the Mariette mount and bears his mark (L. 1852). For Rubens's corresponding painting, see Adler 1982, no. 19. A painting attributed to Lucas Van Uden (oil on wood, 85.1 x 126.4 cm) that is a close repetition, with minor differences in the *staffage*, of Rubens's St. Petersburg painting, was on the British art market in 2012 (Sphinx Fine Art); for which see Adler 1982, under no. 19 (copy 4). A pen drawing acquired by the Nationalmuseum in Stockholm (inv.no. NMH Anck. 413) in 1896 would seem to be a second copy by the same artist responsible for the Mariette sheet, presumably made after his own earlier drawn copy rather than Rubens's original painting.

6 Held 1959, I, p. 34 n. 2.

7 See *Landscape with a Distant View of a Country Estate* (signed by Van Uden), Stockholm, Nationalmuseum, inv. no. NMH 1959/1863; see exhib. cat. New York 2016, no. 47; *Landscape with a Country Road near a Farmhouse*, inv.no. 1957/1863; and *Landscape with a Group of Trees by a Sandy Road*, inv.no. NMH 1956/1863; see exhib. cat. Paris 2016, no. 114.

8 Stockholm, Nationalmuseum, inv.no. NMH 1959/1863 (as in n. 7).

9 These loosely drawn landscapes, variously ascribed to Lucas Van Uden, Lodewijk de Vadder, Anthony Van Dyck, and others, have not yet been studied in sufficient detail. See the examples in Amsterdam, Prentenkabinet, inv.no. 1458 (after Rubens); Brussels, Musée des Beaux-Arts de Belgique, inv.no. 4060/472; exhib. cat. Antwerp 1971, no. 81 (as De Vadder); Berlin, Kupferstichkabinett, inv.nos. 4509, 12052, and 14073; Bock and Rosenberg 1930, nos. 4509 and 12052 (both as Van Uden), 14073 (Style of De Vadder); Paris, Musée du Louvre, Cabinet de dessins, inv. nos. 20209, and 20559 (sign. De Vadder); Lugt 1949, II, no. 1271 (as School of Rubens); Munich, Staatliche Graphische Sammlungen, inv.no. 41542, and 1909:68; Glück 1945, no. 4 (inv.no. 41542, as copy after Rubens), and Wegner 1973, nos. 961 (as Van Uden), 974 (as De Vadder); London, The British Museum, inv.nos. Sloane 5214-138, Gg. 2-240, Gg. 2-317, and 1856.7.12.984; Hind 1923, II, nos. 76-78 (as Van Dyck); and Royalton-Kisch in exhib. cat. Antwerp & London 1999, no. 41 (Gg. 2-240, as Van Uden).

10 Berlin, Kupferstichkabinett, inv.no. 12052; and Paris, Musée du Louvre, Cabinet de dessins, inv.no. 20209 (as in n. 9).

11 Thiéry 1953 (2nd ed. 1987), pp. 62-66; and Hairs 1977, pp. 18-19.

12 Rooses 1903, pp. 211-212, 282, 334, 575. Cf. Van Puyvelde 1964, pp. 140, 199, 233; Hairs 1977, pp. 18-19; Thiéry 1987 (2nd ed.), pp. 167-174. In Rubens's estate was listed *A landscape* by Van Uden, which sold for 100 florins, and *A Landscape*, this one a copy made on wood panel by the artist, which fetched 200 florins for the heirs; see Génard, p. 88, cited by Hairs 1977, p. 19.

13 Martin 1968, p. 210; Balis in exhib. cat. Tokyo 1994, p. 117. Cf. n. 3. Like the Vienna *Landscape with Philemon and Baucis,* Rubens's *Watering Place* landscape went through several enlargements by the artist before attaining its present size. Arnout Balis believed the original panel with which Rubens's started was not by his own hand but a small-scale copy by Lucas Van Uden of the *Landscape with a Shepherd*, also in the National Gallery, London.

14 Lucas Van Uden, *Ulysses and Nausicaa*, 1635, oil on oak, 53.3 x 74.3 cm, Barnard Castle, The Bowes Museum, inv.no. B.M. 16; see Adler 1982, under no. 28 (copy 2); and Brown 1996, pp. 105, 106. Brown noted that a grid was drawn on the *imprimatura* layer to enable Van Uden to copy the original square by square. Lucas Van Uden, *Stormy Coast Landscape*, 1635, oil on wood, 40 x 58 cm. Munich, Bayerische Staatsgemäldesammlungen, inv.no. 4981 (Staatsgalerie im Neuen Schloss Schleißheim); see Adler 1982, under no. 30 (copy 2).

15 Letter by Rubens, dated 15 March 1640, addressed to Balthasar Gerbier, cited after Balis in exhib. cat. Tokyo 1994, p. 116. For Pieter Verhulst's *Landscape with a View of the Escorial*, Coll. Earl of Radnor, Longford Castle, see Adler 1982, under no. 38 (copy 1); and Balis in exhib. cat. Tokyo 1994, p. 116. Brown 1996, p. 40, believed Rubens's letter referred to Van Uden's copy of the same motif in the Fitzwilliam Museum, Cambridge; see Adler 1982, under no. 38 (copies 4 and 7).

16 Schelte à Bolswert's engraving of the *Landscape with a Draw Well*, which bears the date 1638; see Adler 1982, no. 69 (copy).

17 For Van Uden's etchings *The Farm at Laeken, The Watering Place, Farmhands with Cattle by a Stream*, and *Waggoners Shifting a Cart in a Ford*, see Hollstein, nos. 41-44; and Adler 1982, nos. 20 (copy 3); 25 (copy 23). A drawing of *The Watering Place* attributed to Van Uden is in Paris, Petit Palais, Coll. Dutuit, inv.no. 75; see Adler 1982, no. 25 (copy 22).

18 Martin 1968, pp. 210-211. In the case of *The Watering Place*, Van Uden signed the first state himself; the second state was inscribed: *Lucas van Uden pinxit et excud*. Only in the fourth state did Rubens's name appear as responsible for the prototype. Rubens's name does not appear at all on the etching *Waggoners Shifting a Cart in a Ford* (B. 48).

19 Martin 1968, p. 211; and Brown 1996, p. 106.

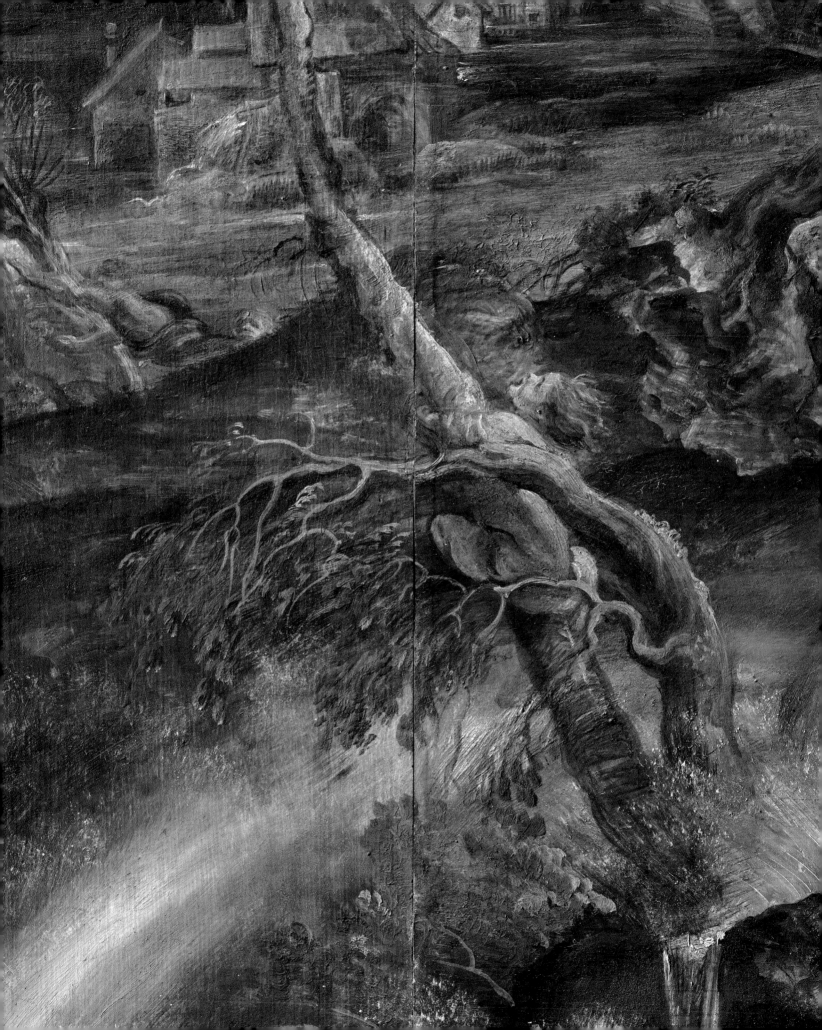

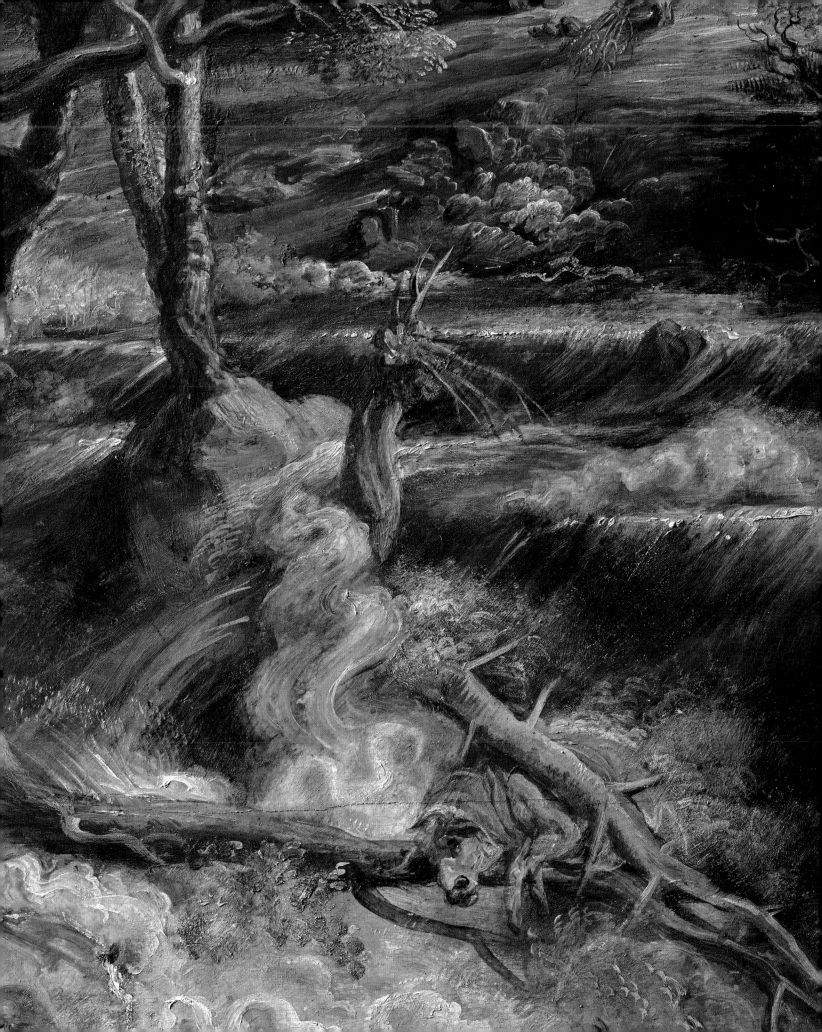

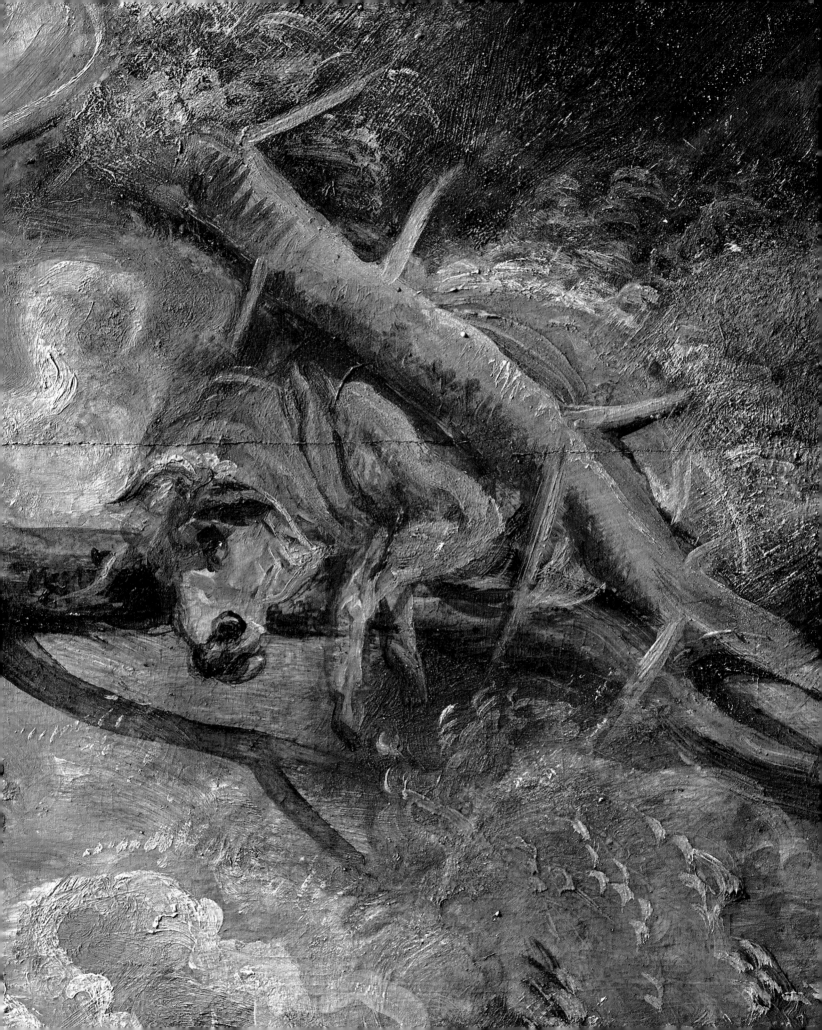

Bibliography

Adler 1980
Wolfgang Adler, *Jan Wildens. Der Landschafts-mitarbeiter des Rubens*, Fridingen 1980

Adler 1982
Wolfgang Adler, *Landscapes and Hunting Scenes* (Corpus Rubenianum Ludwig Burchard, Vol. XVIII.1), London & Oxford & New York 1982

Adler 1985
Wolfgang Adler, *Das Interesse an Rubens' Landschafts-kunst in seiner Zeit und ihre Bewertung durch die Kunstgeschichtsschreibung*, in: Arnout Balis (ed.), *Rubens and his World. Bijdragen – Etudes – Studies – Beiträge. Opgedragen aan Prof. Dr. Ir. R.-A. d'Hulst*, Antwerp 1985, 319-329

Alpers 1971
Svetlana Alpers, *The Decoration of the Torre de la Parada* (Corpus Rubenianum Ludwig Burchard, Vol. IX), Brussels 1971

Arents 2001
Prosper Arents, *De Bibliotheek van Pieter Pauwel Rubens: een reconstructie* (De Gulden Passer, LXXVIII–LXXIX), ed. A.K.L. Thijs et al., Antwerp 2001

Balis et al. 1993
Arnout Balis et al., *Les Chasses de Maximilien*, Paris 1993

Balis 1994
Arnout Balis, *"Fatto da un mio discepolo". Rubens's studio practices reviewed*, in: Toshiharu Nakamura (ed.), *Rubens and his Workshop. The Flight of Lot and his Family from Sodom*, Tokio 1994, 97-127

Bartilla 2016
Stefan Bartilla, Review of Corina Kleinert, *Peter Paul Rubens (1577–1640) and his Landscapes. Ideas on Nature and Art*, Turnhout 2014, in: Journal für Kunstgeschichte 20, 2016, 3, 238-249

Belkin 2009
Kristin Lohse Belkin, *Copies and Adaptions from Renaissance and Later Artists. German and Netherlandish Artists* (Corpus Rubenianum Ludwig Burchard, Vol. XXVI/1), London & Turnhout 2009

Berger 1883
Adolf Berger, *Inventar der Kunstsammlung des Erzherzogs Leopold Wilhelm von Österreich. Nach der Originalhandschrift im fürstlich Schwarzenberg'schen Centralarchive*, in: Jahrbuch der Kunsthistorischen Sammlungen des Allerhöchsten Kaiserhauses 1, 1883, LXXIX-CLXXVII

Bertini 1998
Giuseppe Bertini, *Otto van Veen, Cosimo Masi and the Art Market in Antwerp at the End of the Sixteenth Century*, in: The Burlington Magazine 140, no. 1139, Feb. 1998, 119-120

Bisacca 2017
George Bisacca, *Rubens' Puzzle*, in: exhib. cat. Vienna & Frankfurt 2017, 103-109

Bisacca & De la Fuente 1998
George Bisacca & José de la Fuente, *Consideraciones técnicas de la construcción y restauración del soporte de las Tres Gracias de Rubens*, in: exhib. cat. *Las Tres Gracias' de Rubens: Estudio técnico y Restauración*, Madrid 1998, 51-66

Bischoff 2004
Gudrun Bischoff, *Das De Mayerne-Manuskript. Die Rezepte der Werkstoffe, Maltechniken und Gemälderestaurierung, Kommentierte Ausgabe*, Diplomarbeit, Munich 2004

Bock & Rosenberg 1930
Elfried Bock & Justus Rosenberg, *Staatliche Museen zu Berlin. Die Niederländischen Meister: Beschreibendes Verzeichnis sämtlicher Zeichnungen*, 2 vols., Berlin 1930

Boersma & Van Loon & Boon 2007
Annetje Boersma & Annelies van Loon & Jaap Boon, *Rubens' Oil Sketches for the Achilles Series. A Focus on the Imprimitura Layer and Drawing Material*, in: Art Matters 4, 2007, 82-90

Brown 1996
Christopher Brown, *The Making of the Landscapes*, in: exhib. cat. London 1996, 95-104

Brown 2000
Christopher Brown, *The Construction and Development of Rubens's Landscapes: Reflections on the London Exhibition*, in: Hans Vlieghe & Arnout Balis & Carl Van de Velde (eds.), *Concept, Design & Execution in Flemish Painting (1550–1700)*, Turnhout 2000, 267-278

Brown & Reeve 1996
Christopher Brown & Martin Reeve, *The Structure of Rubens´s Landscapes*, in: exhib. cat. London 1996, 116-121

Brown & Reeve & Wyld 1982
Christopher Brown & Anthony Reeve & Martin Wyld, *Rubens' "The Watering Place"*, in: National Gallery Technical Bulletin 6, 1982, 26-39

Bruce-Gardner 1988
Robert Bruce-Gardner, *Rubens´s Landscape by Moonlight: Technical Examination*, in: The Burlington Magazine 130, 1988, 591-596

Burckhardt 1940
Jacob Burckhardt, Preface to Gustav Glück, *Die Landschaften von Peter Paul Rubens*, Vienna 1940

Büttner 2006
Nils Büttner, *Herr P.P. Rubens*, Göttingen 2006

catalogue raisonné 1892
Eduard Ritter von Engerth & Wilhelm von Wartenegg, *Führer durch die Gemäldegalerie, Alte Meister, II. Niederländische und deutsche Schulen*, Vienna 1892

catalogue raisonné 1928
Ludwig von Baldass & Ernst H. Buschbeck & Gustav Glück & Johannes Wilde, *Katalog der Gemäldegalerie*, Vienna 1928

catalogue raisonné 1938
Ludwig von Baldass & Ernst H. Buschbeck & Joseph Alexander Graf Raczynski & Johannes Wilde, *Katalog der Gemäldegalerie*, Vienna 1938

Davis & Bobak & Bobak & Straub 2020
Lucy Davis with Simon & Thomas Bobak & Michaela Straub, *The Making of the Two Great Landscapes*, in: Lucy Davis (ed.), *Rubens. The Two Great Landscapes*, London 2020, 65-81

Deiters 2016
Wencke Deiters, *Die Wiener Gemäldegalerie unter Gustav Glück. Von der Kaiserlichen Sammlung zum Modernen Museum*, Vienna 2016

De Mayerne 1620/1901
Das De Mayerne Manuskript (1620), in: Ernst Berger (ed.), *Quellen für Maltechnik während der Renaissance und deren Folgezeit*, Munich 1901, 98-410

Dittmann 2001
Lorenz Dittmann, *Die Wiederkehr der antiken Götter im Bilde. Versuch einer Deutung*, Paderborn & Munich & Vienna & Zürich 2001

Dreyer 1985
Peter Dreyer, *A Woodcut by Titian as a Model for Netherlandish Landscape Drawings in the Kupferstichkabinett, Berlin*, in: The Burlington Magazine 127, no. 992, 1985, 762, 766-767

Duverger 1977
Erik Duverger, *Vrindt Michiel*, in: Nationaal biografisch woordenboek 7, Brussels 1977, cols. 1030-1036

Duverger 1984–2009
Erik Duverger, *Antwerpse kunstinventarissen uit de zeventiende eeuw (Fontes Historiae Artis Neerlandicae. Bronnen voor de kunstgeschiedenis van de Nederlanden, I), I–XIV*, Brussels 1984–2009

Eckstein & Wazny & Bauch & Klein 1986
Daniel Eckstein & Tomasz Wazny & Josef Bauch & Peter Klein, *New Evidence for the Dendrochronological Dating of Netherlandish Paintings*, in: Nature 320, 1986, 465-466

Engerth 1884
Eduard R. von Engerth, *Kunsthistorische Sammlungen des Allerhöchsten Kaiserhauses, Gemälde. Beschreibendes Verzeichnis, II. Band: Niederländische Schulen*, Vienna 1884

exhib. cat. Antwerp 1971
Frans Baudouin & Roger-A. d'Hulst (eds.), *Rubens en zijn tijd: Tekeningen uit Belgische verzamelingen*, exhib. cat. Antwerp (Rubenshuis), Antwerp 1971

exhib. cat. Antwerp 2004
Kristin Lohse Belkin & Fiona Healy (eds.), *A House of Art. Rubens as Collector*, exhib. cat. Antwerp (Rubenshuis & Rubenianum), Antwerp 2004

exhib. cat. Antwerp & London 1999
Martin Royalton-Kisch, *The Light of Nature. Landscape Drawings and Watercolours by Van Dyck and His Contemporaries*, exhib. cat. Antwerp (Rubenshuis) & London (British Museum), London 1999

exhib. cat. Brunswick 2004
Nils Büttner & Ulrich Heinen, *Peter Paul Rubens. Barocke Leidenschaften*, exhib. cat. Brunswick (Herzog Anton Ulrich-Museum), Munich 2004

exhib. cat. Brussels 2019
Véronique Bücken & Ingrid De Meûter (eds.), *Bernard van Orley. Brussels and the Renaissance*, exhib. cat. Brussels (Paleis voor Schone Kunsten BOZAR), Brussels 2019

exhib. cat. Dresden 2016
Uta Neidhardt & Konstanze Krüger, *Das Paradies auf Erden. Flämische Landschaften von Bruegel bis Rubens*, exhib. cat. Dresden (Kunsthalle Lipsiusbau), Dresden 2016

exhib. cat. Essen & Vienna 2003/2004
Klaus Ertz & Alexander Wied & Karl Schütz (eds.), *Die Flämische Landschaft 1520–1700*, exhib. cat. Essen (Kulturstiftung Ruhr) & Vienna (Kunsthistorisches Museum), Vienna 2003

exhib. cat. London 1996
Christopher Brown, *Rubens's Landscapes. Making & Meaning*, exhib. cat. London (National Gallery), London 1996

exhib. cat. New York 2016
Colin B. Bailey et al. (eds.), *Treasures from the Nationalmuseum of Sweden: The Collections of Count Tessin*, exhib. cat. New York (The Morgan Library & Museum), New York 2016

exhib. cat. Paris 2016
Guillaume Faroult et al. (eds.), *Un Suédois à Paris au XVIIIe siècle. La collection Tessin*, exhib. cat. Paris (Musée du Louvre), Paris 2016

exhib. cat. Rome 1976
Maria Catelli Isola (ed.), *Immagini da Tiziano. Stampe dal Sec. XVI al Sec. XIX dalle collezioni del Gabinetto Nazionale delle Stampe*, exhib. cat. Rome (Villa della Farnesina alla Lungara), Rome 1976

exhib. cat. San Martino al Cimino 1999
Didier Bodart, *Il Dipingere di Fiandra. 100 dipinti fiamminghi dal '400 al '700*, exhib. cat. San Martino al Cimino (Palazzo Doria Pamphili), Viterbo 1999

exhib. cat. Tokio 1994
T. Nakamura et al. (eds.), *Rubens and his Workshop: The Flight of Lot and his Family from Sodom*, exhib. cat. Tokio (National Museum of Western Art), Tokio 1994

exhib. cat. Vienna 1977
Klaus Demus & Günther Heinz & Wolfgang Prohaska & Anna Maria Schwarzenberg & Karl Schütz (eds.), *Peter Paul Rubens 1577–1640. Ausstellung zur 400. Wiederkehr seines Geburtstages*, exhib. cat. Vienna (Kunsthistorisches Museum), Vienna 1977

exhib. cat. Vienna 2004
Johann Kräftner et al. (eds.), *Rubens in Wien: Die Meisterwerke / Rubens in Vienna: The Masterpieces*, exhib. cat. Vienna (Liechtenstein Museum & Kunsthistorisches Museum & Gemäldegalerie der Akademie für Bildende Künste), Vienna 2004

exhib. cat. Vienna & Frankfurt 2017
Gerlinde Gruber & Sabine Haag & Stefan Weppelmann & Jochen Sander (eds.), *Rubens. Kraft der Verwandlung*, exhib. cat. Vienna (Kunsthistorisches Museum) & Frankfurt (Städel Museum), Munich 2017

Fabian & Fortunato 2010
Daniel Fabian & Giuseppino Fortunato, *Tracing White: A Study of Lead White Pigments found in Seventeenth-Century Paintings using High Precision Lead Isotope Abundance Ratios*, in: Jo Kirby & Susie Nash & Joanna Cannon (eds.), *Trade in Artists' Materials. Markets and Commerce in Europe to 1700*, London 2010, 426-447

Farnell & Van Hout 2007
Susan Farnell & Nico Van Hout, *The Prodigal Son by Rubens. Painting Technique and Restoration*, in: Rubens Bulletin 1, 2007, online: http://www.kmska.be/export/sites/kmska/contentDocuments/Collectie/Rubensbulletin_-_1_5.pdf (9.6.2017)

Filipczak 2010
Zirka Z. Filipczak, *Rubens Adapts the Poses of Classical Scupltures for Deliberately Ambiguous and other Emotions*, in: Nederlands Kunsthistorisch Jaarboek (NJK) 60, 2010, 124-149

Fraiture 2009
Pascale Fraiture, *Contribution of Dendrochronology to Understanding of Wood Procurement Sources of Panel Paintings in the Former Southern Netherlands from 1450 to 1650*, in: Dendrochronologia 27, 2009, 95-111

Génard 1865
Pieter Génard, *De nalatenschap van P.P. Rubens*, in: Antwerpsch Archievenblad 2, 1865, 69-179

Gepts 1954–1960
Gilberte Gepts, *Tafereelmaker Michiel Vriendt, leverancier van Rubens*, in: Jaarboek Koninklijk Museum voor Schone Kunsten, Antwerp, 1954–1960, 83-87

Gifford 2019
E. Melanie Gifford, *Rubens's Invention and Evolution: Material Evidence in The Fall of the Phaeton*, in: Journal of Historians of Netherlandish Art 11/2, 2019, https://jhna.org/articles/rubens-invention-evolution-fall-of-phaeton/ (27.10.2020)

Grossmann 1954
Fritz Grossmann, *The Drawings of Pieter Bruegel the Elder in the Museum Boymans and Some Problems of Attribution*, in: Bulletin Museum Boymans Rotterdam 5, 1954, 41-63, 76-85

Grossmann 1966 (1973)
Fritz Grossmann, *Bruegel. The Paintings*, London 1966 (1973)

Gruber 2006/2007
Gerlinde Gruber, *Das Bilderverzeichnis der Pressburger Burg von 1781. Ein Beitrag zur Sammlungsgeschichte der Gemäldegalerie des Kunsthistorischen Museums*, in: Jahrbuch des Kunsthistorischen Museums Wien 8/9, 2006/2007, 354-400

Gruber 2017
Gerlinde Gruber, *Materielle Wandlungen*, in exhib. cat. Vienna & Frankfurt 2017, 273-298

Gruber & Oberthaler 2015
Gerlinde Gruber & Elke Oberthaler, *Das "Pelzchen" – ein ungewöhnliches Bildnis der Helena Fourment (1614–1673) und seine Genese*, Ansichtssache 13, Kunsthistorisches Museum, Vienna 2015

Haag & Swoboda (eds.) 2010
Sabine Haag & Gudrun Swoboda (eds.), *Die Galerie Kaiser Karls VI: in Wien. Solimenas Widmungsbild und Storffers Inventar (1720–1733)*, Vienna 2010

Hairs 1977
Marie-Louise Hairs, *Dans le sillage de Rubens: les peintres d'histoire anversois au XVIIe siècle*, Liège 1977

Hartwieg 2018
Babette Hartwieg, *Formatveränderungen an Holztafelbildern von Rubens – Beobachtungen an den Beständen der Berliner Gemäldegalerie*, in: Justus Lange & Birgit Ulrike Münch (eds.), *Reframing Jordaens. Pictor doctus – Techniken – Werkstattpraxis / Pictor doctus – Techniques – Workshop practice*, Petersberg 2018, 273-292

Haskell & Penny 1982
Francis Haskell & Nicholas Penny, *Taste and the Antique: the Lure of Classical Sculpture, 1500–1900*, New Haven 1982

Hazlehurst 1987
Franklin Hamilton Hazlehurst, *A New Source for Rubens's Château de Steen*, in: The Burlington Magazine 129, no. 1014, Sept. 1987, 588-590

Held 1959
Julius S. Held, *Rubens: Selected Drawings*, 2 vols., New York 1959 (2nd ed.: Oxford 1986)

Held 1979
Julius S. Held, *Rubens and Aguilonius: New Points of Contact*, in: The Art Bulletin 61, June 1979, 257-264

Hillam & Tyers 1995
Jennifer Hillam & Ian Tyers, *Reliability and Dendrochronological Analysis: Tests using the Fletcher Archive of Panel-Painting Data*, in: Archaeometry 37/2, 1995, 395-405

Hind 1923
Arthur M. Hind, *Catalogue of Drawings by Dutch and Flemish Artists Preserved in the Department of Prints and Drawings in the British Museum, Vol. 2, Drawings by Rubens, Van Dyck, and Other Artists of the Flemish School of the XVIIth Century*, London 1923

Hoecker 1916
Rudolf Hoecker, *Das Lehrgedicht des Karel van Mander, Text, Übersetzung und Kommentar, nebst Anhang über Manders Geschichtskonstruktion und Kunsttheorie*, The Hague 1916

Hollstein 1986
F.W.H. Hollstein, *Dutch and Flemish Etchings, Engravings and Woodcuts ca. 1450-1700*, Vol. XXX, compiled by Ger Luijten, Amsterdam 1986

Holubec & Meyer-Stork 2012
Inken Holubec & Ilka Meyer-Stork, *Die Himmelfahrt Mariae von Peter Paul Rubens*, in: VDR Beiträge 2, 2012, 57-73

Hoppe-Harnoncourt 2001
Alice Hoppe-Harnoncourt, *Geschichte der Restaurierung an der K.K. Gemäldegalerie, I. Teil: 1772 bis 1828*, in: Jahrbuch des kunsthistorischen Museums Wien 2, 2001, 135-206

Hoppe-Harnoncourt 2012
Alice Hoppe-Harnoncourt, *The Restoration of Paintings at the Beginning of the Nineteenth Century in the Imperial Gallery*, in: Noémie Étienne (ed.), *La restauration des oeuvres d'art en Europe entre 1789 et 1815: pratiques, transfers, enjeux. Actes du colloque international tenu à l'Université de Genève en octobre 2010*, CeROArt HS 2012, https://doi.org/10.4000/ceroart.2336 (20.8.2020)

Hoppe-Harnoncourt 2018
Alice Hoppe-Harnoncourt, *Antwerpen – Brüssel – Prag – Wien. Spurensuche zur Wiener Bruegel-Sammlung*, in: Elke Oberthaler & Sabine Pénot & Manfred Sellink & Ron Spronk with Alice Hoppe-Harnoncourt, *Bruegel. Die Hand des Meisters*, Vienna 2018, e-book, 413-440

Hoppe-Harnoncourt 2019
Alice Hoppe-Harnoncourt, *Antwerp – Brussels – Prague – Vienna. On the Tracks of the Vienna Bruegels*, in: Alice Hoppe-Harnoncourt & Elke Oberthaler & Sabine Pénot & Manfred Sellink & Ron Spronk, *Bruegel. The Hand of the Master. The 450th Anniversary Edition. Essays in Context*, Veurne 2019, 372-391

Huber-Rebenich 2001
Gerlinde Huber-Rebenich, *Die Macht der Tradition. Metamorphosen-Illustrationen im späten 16. und frühen 17. Jahrhundert*, in: Luba Freedman & Gerlinde Huber-Rebenich, *Wege zum Mythos* (Ikonographische Repertorien zur Rezeption des antiken Mythos in Europa, Beiheft III), Berlin 2001, 141-162

Jaffé 2017
David Jaffé, *Rubens's Aids to Inventing*, in: Gerlinde Gruber et al. (eds.), *Rubens. The Power of Transformation*, exhib. cat. Vienna (Kunsthistorisches Museum) & Frankfurt (Städel Museum), Vienna & Frankfurt 2017, 51-59

Keith 1999
Larry Keith, *The Rubens Studio and the Drunken Silenus supported by Satyrs*, in: National Gallery Technical Bulletin 20, 1999, 96-104

Kern 2012
Ulrike Kern, *Samuel van Hoogstraten and the Cartesian rainbow debate: Color and Optics in a Seventeenth-century Treatise of Art Theory*, in: Simiolus: Netherlands Quarterly for the History of Art 36, Nr. 1/2, 2012, 103-114

Kieser 1933
Emil Kieser, *Antikes im Werke des Rubens*, in: Münchner Jahrbuch der Bildenden Kunst 10, 1933, 110-135

Kirby 1999
Jo Kirby, *The Painter's Trade in the Seventeenth Century: Theory and Practice*, in: National Gallery Technical Bulletin 20, 1999, 5-49

Klein 1991
Peter Klein, *Bericht über die dendrochronologische Untersuchung der Gemäldetafel "Gewitterlandschaft" (P.P.Rubens, Inv.-Nr. 690)*, Hamburg 1991, Typoskript

Kleinert 2014
Corina Kleinert, *Peter Paul Rubens (1577–1640) and His Landscapes: Ideas on Nature and Art* (Pictura Nova, Vol. XX), Turnhout 2014

Lavin 2018
Irving Lavin, *Leonardo's Watery Chaos*, published 2018, https://www.ias.edu/ideas/lavin-leonardo-chaos (14.7.2020)

Leonardo 2005
Leonardo da Vinci, *A Treatise on Painting*, translated by John Francis Rigaud, Mineola (NY) 2005

Liedtke 1992
Walter Liedtke, *Addenda to Flemish Paintings in the Metropolitan Museum of Art*, in: Metropolitan Museum Journal 27, 1992, 101-120

Logan 2001
Anne-Marie Logan, *Distinguishing the Drawings by Anthony van Dyck from those of Peter Paul Rubens*, in: Hans Vlieghe (ed.), *Van Dyck 1599–1999. Conjectures and Refutations*, Turnhout 2001, 7-28

Logan 2005
Anne Marie Logan, *Rubens as a Draftsman*, in: *Peter Paul Rubens. The Drawings*, exhib. cat. New York (Metropolitan Museum), New York 2005, 31-32

Lugt 1927
Frits Lugt, *Pieter Bruegel und Italien*, in: *Festschrift für Max J. Friedländer zum 60. Geburtstag*, Leipzig 1927, 111-129

Lugt 1949
Frits Lugt, *Inventaire des dessins des écoles du nord, publié sous les auspices du Cabinet de Dessins. École flamande*, 2 vols., Paris 1949

Lusheck 2019
Catherine H. Lusheck, *Leonardo's Brambles and Their Afterlife in Rubens's Studies of Nature*, in: Constance Moffatt & Sara Taglialagamba (eds.), *Leonardo da Vinci – Nature and Architecture*, Leiden & Boston 2019, 123-167

Mareš 1887
Franz Mareš, *Beiträge zur Kenntniss der Kunstbestrebungen des Erzherzogs Leopold Wilhelm*, in: Jahrbuch der Kunsthistorischen Sammlungen des Allerhöchsten Kaiserhauses 5, 1887, 343-363

Martin 1966
Gregory Martin, *Two Closely Related Landscapes by Rubens*, in: The Burlington Magazine 108, 1966, 180-184

Martin 1968
Gregory Martin, *Lucas van Uden's Etchings after Rubens*, in: Apollo 1968, 210-211

Martin 1970
Gregory Martin, *The Flemish School. National Gallery Catalogues*, London 1970

Mechel 1783
Christian von Mechel, *Verzeichniß der Gemälde der Kaiserlichen Königlichen Bilder Gallerie in Wien*, Vienna 1783

Meißner 1823
Paul Traugott Meißner, *Die Heitzung mit erwärmter Luft, erfunden, systematisch bearbeitet und als das wohlfeilste, bequemste, der Gesundheit zuträglichste, und zugleich die Feuersgefahr am meisten entfernende Mittel zur Erwärmung der Gebäude aller Art*, 2nd ed., Vienna 1823

Miele 1996
Hans Miele, *Pieter Bruegel. Die Zeichnungen*, Turnhout 1996

Millar 1977
Oliver Millar, *Rubens´s Landscapes in the Royal Collection: the Evidence of X-ray*, in: The Burlington Magazine 119, 1977, 631-635

Miller & Bisacca 2014
Alan Miller & George Bisacca, *Recent Developments in the Evolution of Spring-Loaded Secondary Supports for Previously Thinned Panel Paintings*, in: AIC Paintings Specialty Group Postprints 26, 2014, 1-5

Muller 1989
Jeffrey M. Muller, *Rubens: The Artist as Collector*, Princeton 1989

Muller 2004
Jeffrey M. Muller, *Rubens's Collection in History*, in: Kristin Lohse Belkin & Fiona Healy (eds.), *A House of Art. Rubens as Collector*, exhib. cat. Antwerp (Rubenshuis & Rubenianum), Antwerp 2004, 11-85

Norgate 1997 (ms. 1627/28 & 1648)
Edward Norgate, *Miniatura or the Art of Limning*, ed. by Jeffrey M. Muller & Jim Murrell, New Haven & London 1997

Oberthaler 1996
Elke Oberthaler, *Zur Geschichte der Restaurierwerkstätte der "k.k. Gemälde-Galerie"*, in: *Restaurierte Gemälde. Die Restaurierwerkstätte der Gemäldegalerie des Kunsthistorischen Museums 1986–1996*, exhib. cat. Vienna (Kunsthistorisches Museum), Mailand 1996, 26-33

Oberthaler 1998
Elke Oberthaler, *Tafelbildbehandlungen im Kunsthistorischen Museum*, in: Restauratorenblätter 19, 1998, 45-54

Oberthaler 1999
Elke Oberthaler, *La campagna di restauro nella galleria Imperiale di Vienna diretta da Joseph Rebell (1824–1828)*, in: Bollettino d'Arte 1999 (Storia del restauro dei dipinti a Napoli e nel Regno nel XIX secolo. Atti del Convegno Internazionale di Studi, Napoli, Museo di Capodimonte, 14-16 ottobre 1999), 209-222

Oberthaler 2015
Elke Oberthaler, *Aus der Sicht der Restauratorin*, in: Gerlinde Gruber & Elke Oberthaler, *Das "Pelzchen" – ein ungewöhnliches Bildnis der Helena Fourment (1614–1673) und seine Genese*, Ansichtssache 13, Kunsthistorisches Museum, Vienna 2015, 23

Oberthaler 2015a
Elke Oberthaler, *Technical Examination of Het Pelsken*, in: Ben van Beneden (ed.), *Rubens in Private. The Master Portrays his Family*, exhib. cat. Antwerp (Rubenshuis), Antwerp 2015, 264-266

Oberthaler 2018
Elke Oberthaler, *Materialien und Techniken. Beobachtungen zum Schaffensprozess Pieter Bruegels anhand der Wiener Gemälde*, in: Elke Oberthaler & Sabine Pénot & Manfred Sellink & Ron Spronk with Alice Hoppe-Harnoncourt, *Bruegel. Die Hand des Meisters*, Vienna 2018, e-book

Oberthaler 2019
Elke Oberthaler, *Materials and Techniques. Observations on Pieter Bruegel's Working Methods as Seen in the Vienna Paintings*, in: Alice Hoppe-Harnoncourt & Elke Oberthaler & Sabine Pénot & Manfred Sellink & Ron Spronk, *Bruegel. The Hand of the Master. The 450th Anniversary Edition. Essays in Context*, Veurne 2019, 414-470

Oberthaler & Prast & Slama 2017
Elke Oberthaler & Georg Prast & Ina Slama, *Rubens' Gewitterlandschaft: Schadensproblematik und Restaurierung*, in: *Rubens. Kraft der Verwandlung*, exhib. cat. Vienna (Kunsthistorisches Museum), Vienna 2017, 111-121

Oliver & Healy & Roy & Billinge 2005
Lois Oliver & Fiona Healy & Ashok Roy & Rachel Billinge, *The Evolution of Rubens´s Judgement of Paris (NG 194)*, in: National Gallery Technical Bulletin 26, 2005, 4-22

Orlando 2020
Anna Orlando, Review of *Peter Paul Rubens e gli arciduci delle Fiandre meridionali [...]* by Cecilia Paolini, in The Burlington Magazine 162, Sept. 2020, 818-819

Paolini 2018
Cecilia Paolini, *Peter Paul Rubens e gli arciduci delle Fiandre meridionali: Storia di un rapporto di committenza attraverso la ricostruzione documentaristica e iconografica delle collezioni di Bruxelles*, Rome 2018

Pijl 1998
Luuk Pijl, *Paintings by Paul Bril in Collaboration with Rottenhammer, Elsheimer and Rubens*, in: The Burlington Magazine 140, no. 1147, Oct. 1998, 660-667

Plauensteiner 1997
Ruth Plauensteiner, *Post diluvium, caeruleum ultramarinum, hic sunt caprae: Handschriftliche Marginalien des 17. Jahrhunderts im Wiener Metamorphosen-Band Sign. ÖNB *35.T.130*, in: Mitteilungen des Instituts für Österreichische Geschichtsforschung 107, 1995, 484-492

Plesters 1983
Joyce Plesters, *"Samson and Delilah": Rubens and the Art and Craft of Painting on Panel*, in: National Gallery Technical Bulletin 7, 1983, 30-50

Poll-Frommel & Schmidt 2001
Veronika Poll-Frommel & Jan Schmidt, *Anstückungen bei Tafelgemälden von Peter Paul Rubens, Technik und Ausführung*, in: Restauro 6, 2001, 432-437

Poll-Frommel & Schmidt & Renger 1993
Veronika Poll-Frommel & Jan Schmidt & Konrad Renger, *Untersuchungen an Rubens-Bildern: Die Anstückungen der Holztafeln*, in: *Jahresbericht: Bayerische Staatsgemäldesammlungen*, Munich 1993, 24-35

Raupp 1994
Hans-Joachim Raupp, *Zeit in Rubens' Landschaften*, in: Wallraf-Richartz-Jahrbuch LV, 1994, 159-170

Raupp 2001
Hans-Joachim Raupp, *Rubens und das Pathos der Landschaft*, in: Ulrich Heinen & Andreas Thielemann (eds.), *Rubens Passioni: Kultur der Leidenschaften im Barock*, Göttingen 2001, 159-179

Reiffenstuell 1702
Ignatius Reiffenstuell (attributed), *Kurtz-Lesens-Würdige Erinnerung Von Herrührung, Erbau- und Benambsung. Auch Vilfältig-anderen, alt- und neuen Seltenheiten, Bemerck- und Andenckungen, sowohl in- als um die Käyserliche Haubt- und Residentz-Stadt Wienn In Oesterreich. Allen, Wissens-Begierigen, Einheimisch- als Frembden zum besten, sambt einer klaren Beschreibung von deroselben letzt-Türckischen Beläger- und frohen Entsätzung, wie auch der Käyserlichen Schatz- und Kunst-Kammer [...], Gedruckt zu Wienn; bey Anna Rosina Sischowitzin, Wittib. Zu finden bey Adam Damer*, Vienna 1702

Renger 1994
Konrad Renger, *Anstückungen bei Rubens*, in: Ekkehard Mai et al., *Die Malerei Antwerpens. Gattungen, Meister, Wirkungen. Studien zur flämischen Kunst des 16. und 17. Jahrhunderts. Internationales Kolloquium, Wien 1993*, Köln 1994, 156-167

Renger 2003
Konrad Renger, *Rubens und Nachfolge*, in: *Die Flämische Landschaft 1520–1700*, exhib. cat. Essen (Kulturstiftung Ruhr) & Vienna (Kunsthistorisches Museum), Vienna 2003, 331-337

Rooses 1886–1892
Max Rooses, *L'Oeuvre de P.P. Rubens. Histoire et description de ses tableaux et dessins*, I–V, Antwerp 1886–1892 (reprint 1977)

Rooses 1903
Max Rooses, *Rubens' Leven en Werken*, Amsterdam & Antwerp 1903

Rosa 1796
Joseph Rosa, *Gemälde der k.k. Galerie. Zweyte Abteilung. Niederländische Schulen*, Vienna 1796

Roy 1999
Ashok Roy, *Rubens´s Peace and War*, in: National Gallery Technical Bulletin 20, 1999, 89-95

Ruelens 1883
Charles Ruelens, *La Vie de Rubens par Roger de Piles*, in: Rubens-Bulletijn 2, 1883, 157-211

Schäfer & Saint-George 2006
Iris Schäfer & Caroline von Saint-George, *Beiträge zur Maltechnik*, in: *Peter Paul Rubens – Juno und Argus*, Wallraf-Richartz Museum, Köln 2006, 26-55

Schäffer 1902
August Schäffer, *Zur Erhaltung von Gemälden in Galerien*, in: Neues Wiener Tagblatt (Feuilleton), 14.10.1902

Scribner 1989
Charles Scribner, *Rubens*, New York 1989

Sellink 2018
Manfred Sellink, *Blickführung und Inszenierung der Komposition. Anmerkungen zu den Kompositionstechniken von Pieter Bruegel d.Ä.*, in: Elke Oberthaler & Sabine Pénot & Manfred Sellink & Ron Spronk with Alice Hoppe-Harnoncourt, *Bruegel. Die Hand des Meisters*, Vienna 2018, e-book, 295-315

Sellink 2019
Manfred Sellink, *Leading the Eye and Staging the Composition. Some Remarks on Pieter Bruegel the Elder's Compositional Techniques*, in: Alice Hoppe-Harnoncourt & Elke Oberthaler & Sabine Pénot & Manfred Sellink & Ron Spronk, *Bruegel. The Hand of the Master. The 450th Anniversary Edition. Essays in Context*, Veurne 2019, 336-352

Seneca 1990
Lucius Annaeus Seneca, *Naturwissenschaftliche Untersuchungen in acht Büchern*, introduced, translated and commented by Otto and Eva Schönberger, Würzburg 1990

Slavíček 2000
Lubomir Slavíček, *Flemish Paintings of the 17th and 18th Centuries. The National Gallery of Prague, Illustrated Summary Catalogue I/2*, Prague 2000

Sohar & Vitas & Läänelaid
Kristina Sohar & Adomas Vitas & Alar Läänelaid, *Sapwood Estimates of Pedunculate Oak (Quercus robur L.) in Eastern Baltic*, in: Dendrochronologia 30/1, 2012, 49-56

Sonnenburg 1979
Hubert von Sonnenburg, *Rubens' Bildaufbau und Technik*, in: Maltechnik Restauro 85, 1979, I: Bildträger, Grundierung und Vorskizzierung, Vol. 2, 77-100, II: Farbe und Auftragstechnik, Vol. 3, 181-203

Sonnenburg 1980
Hubert von Sonnenburg, *Rubens´ Bildaufbau und Technik. Bildträger, Grundierung und Vorskizzierung*, in: Hubert von Sonnenburg & Frank Preußer, *Rubens: Gesammelte Aufsätze und Techik*, 2nd ed., Munich 1980, 3-49

Sonnenburg & Preußer 1979 & 1980
Hubertus von Sonnenburg & Frank Preußer, *Rubens. Gesammelte Aufsätze zur Technik,* Doerner Institut, Mitteilungen 3, Munich 1979, 2nd ed. 1980

Stechow 1941
Wolfgang Stechow, *The Myth of Philemon and Baucis in Art*, in: Journal of the Warburg and Courtauld Institutes 4, January 1941, 103-113

Swoboda 2013
Gudrun Swoboda, *Die kaiserliche Gemäldegalerie in Wien und die Anfänge des öffentlichen Kunstmuseums*, Vienna 2013

Thiéry 1953
Yvonne Thiéry, *Le paysage flamand au XVIIe siècle*, Paris & Brussels 1953 (2nd ed.: Brussels 1987)

Van Damme 1990
Jan Van Damme, *De Antwerpse tafereelmakers en hun merken. Identificatie en betekenis*, in: Jaarboek Koninklijk Museum voor Schone Kunsten, Antwerp 1990, 193-236

Van Der Meulen 1994
Marjon Van Der Meulen, *Rubens. Copies after the Antique* (Corpus Rubeninanum Ludwig Burchard, Vol. XXIII), London 1994

Van Hout 1998
Nico Van Hout, *Meaning and Development of the Ground Layer in Seventeenth Century Painting*, in: Erma Hermens (ed.), *Looking Through Paintings: the Study of Painting Techniques and Materials in Support of Art Historical Research (Leids Kunsthistorisch Jaarboek XI)*, London 1998, 205-210

Van Hout 2000
Nico Van Hout, *A Second Self-Portrait in Rubens's Four Philosophers*, in: The Burlington Magazine 142, no. 1172, 2000, 694-697

Van Hout 2014
Nico Van Hout, *"Rubens Heilige familie met papegaai"*, in: Hildegard Van De Velde & Nico Van Hout & Eva Van Zuien, *Papegaai, 't Cierlijk schoon van haare veeren*, exhib. cat. Antwerp (Museum Snijder & Rockoxhuis), Antwerp 2014

Van Hout 2016
Nico Van Hout, *"Ein so schönes Bild ist nie in der Natur gesehen worden". Peter Paul Rubens und die Landschaft*, in: Uta Neidhardt & Konstanze Krüger, *Das Paradies auf Erden. Flämische Landschaften von Bruegel bis Rubens*, Dresden 2016, 52-57

Van Hout & Balis 2012
Nico Van Hout & Arnout Balis, *Rubens Unveiled. Notes on the Master's Painting Technique. Catalogue of the Rubens Paintings in the Antwerp Museum*, Antwerp 2012

Van Mander 1604
Karel van Mander, *Het Schilder-Boeck*, Haarlem 1604

Van Puyvelde 1964
Leo Van Puyvelde, *Rubens*, 2nd ed., Paris & Brussels 1964

Van Zuien 2014
Eva Van Zuien, *Rubens´s Holy Family with the Parrot: Examination and Restoration*, in: Rubensbulletin 2014, online: https://www.kmska.be/export/sites/kmska/content/Documents/Onderzoek/Rubensbulletin_2014_Van_Zuien_FINALlr.pdf (8.6.2019)

Vergara 1982
Lisa Vergara, *Rubens and the Poetics of Landscape*, New Haven & London 1982

Vergara 2016
Alejandro Vergara, *Splendor, Myth, and Vision: Nudes from the Prado*, exhib. cat. Clark Art Institute & Museo Nacional del Prado, New Haven 2016

Verzeichnis **1991**
Sylvia Ferino-Pagden & Wolfgang Prohaska & Karl Schütz (eds.), *Die Gemäldegalerie des Kunsthistorischen Museums in Wien: Verzeichnis der Gemälde*, Vienna 1991

Vlieghe 2011
Hans Vlieghe, *David Teniers The Younger (1610–1690). A Biography*, Turnhout 2011

Wegner 1973
Wolfgang Wegner, *Katalog der Staatlichen Graphischen Sammlung München. I. Die Niederländischen Handzeichnungen des 15.-18. Jahrhunderts*, Berlin 1973

Weigel 2001
Sigrid Weigel, *Die Richtung des Bildes. Zum Links-Rechts von Bilderzählungen und Bildbeschreibungen in kultur- und mediengeschichtlicher Perspektive*, in: Zeitschrift für Kunstgeschichte 64, Vol. 4, 2001, 449-474

White 2007
Christopher White, *The Later Flemish Pictures in the Collection of Her Majesty The Queen*, London 2007, 179-186

Wood 2011
Jeremy Wood, *Copies and Adaptations from Renaissance and Later Artists: Italian Artists. III. Artists working in Central Italy and France* (Corpus Rubenianum Ludwig Burchard, Vol. XXVI/3), London & Turnhout 2011

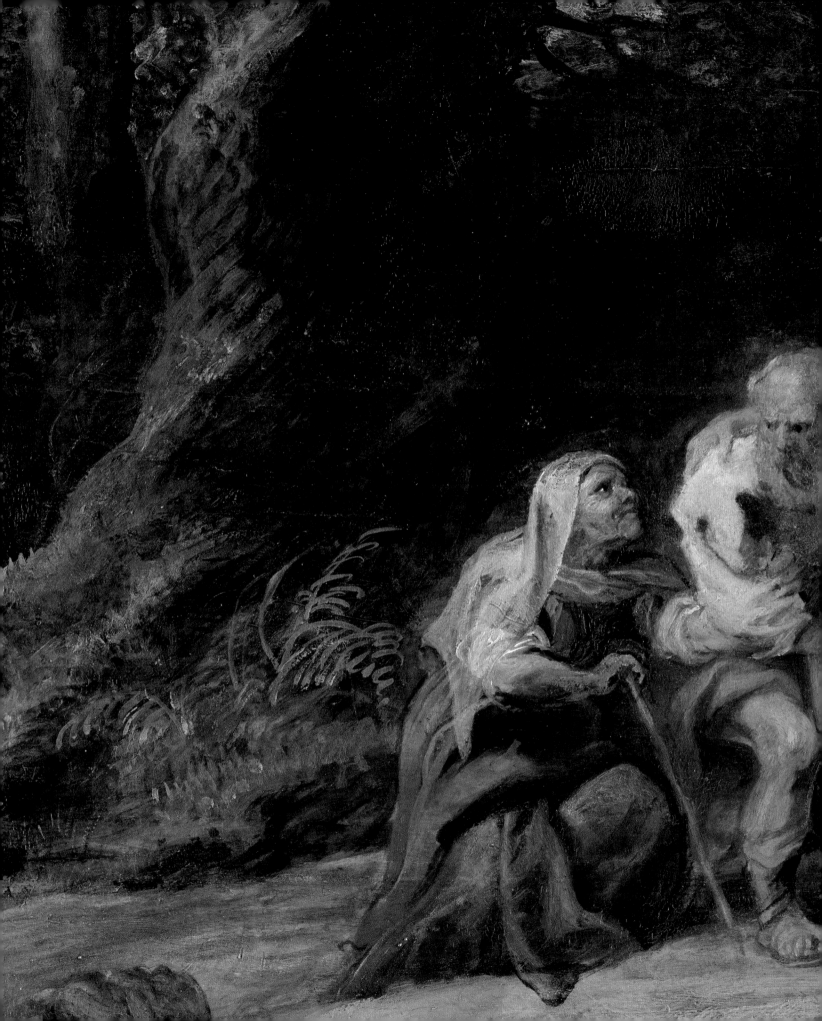

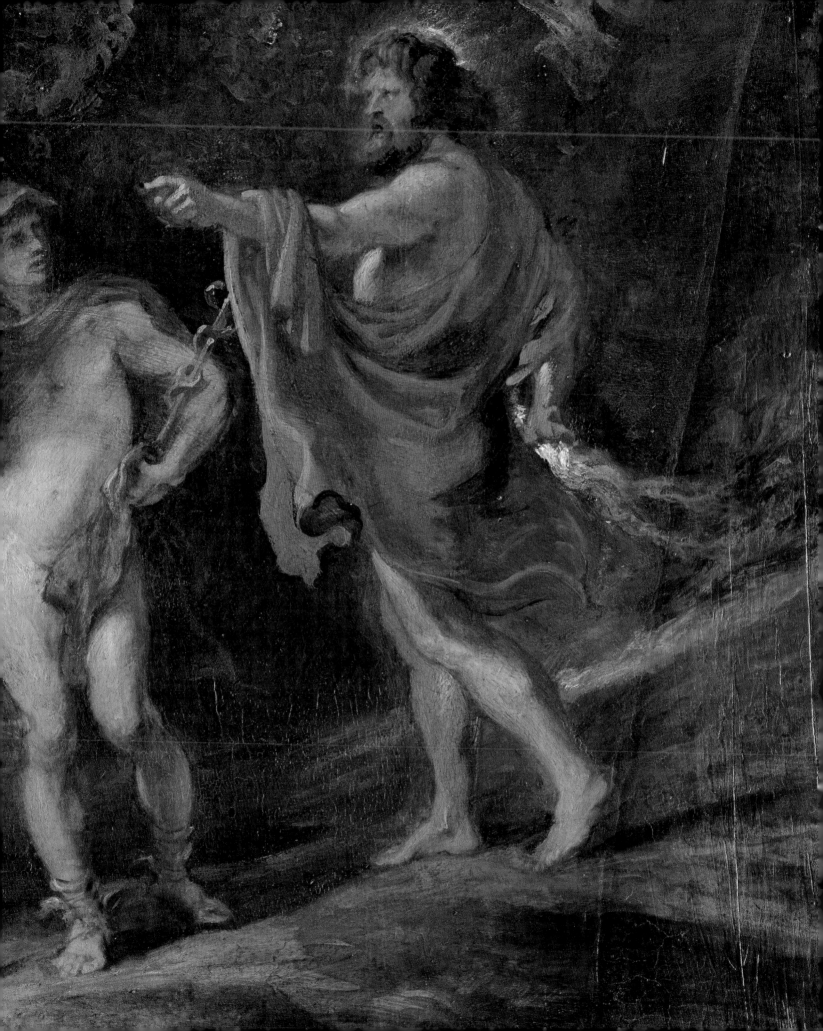

Photograph Credits

mprint

publication of the
HM-Museumsverband
urgring 5
010 Vienna

*ries editor of the Schriften des Kunsthistorischen
useums*
abine Haag

ditors
erlinde Gruber
lke Oberthaler

eneral Manager of Publications
ranz Pichorner

ublication management
tta Allekotte, Hirmer
enjamin Mayr

opy editor
arin Zeleny

ranslation
latt Hayes (essay Oberthaler)
gnes Stillfried (introduction, essay Gruber)
obert Wald (essay Gruber & Slama, essay Slama)

reative Director
tefan Zeisler

raphic design
lemens Wihlidal

ypesetting
arah Horvath

nage editing
lichael Eder
homas Ritter

hotography
ndreas Uldrich

roduction
atja Durchholz, Hirmer

rinted and bound by
rinter Trento, S.r.l., Trient

Papier
GardaMatt Ultra, 150 g/m²

Short Title
Gerlinde Gruber & Elke Oberthaler (eds.)
Rubens's Great Landscape with a Tempest
(Schriften des Kunsthistorischen Museums, vol. 21)
Vienna 2020

Cover
detail: Peter Paul Rubens, *The Stormy Landscape with
Philemon and Baucis*, 1620/25 – c. 1636

French flaps (insides)
front: *The Stormy Landscape* after restauration
back: X-radiograph of *The Stormy Landscape*

Details
pp. 2, 4–5, 6, 8–9, 10, 16, 66, 72, 116–117, 118: *The
Stormy Landscape* in raking light after restauration
pp. 14–15, 34–35, 124–125: *The Stormy Landscape* in
visible light after restauration
pp. 28, 48: *The Stormy Landscape* in raking light
before restauration
p. 94: Restorer's work station in front of *The Stormy
Landscape* during restauration
p. 108: Lucas Van Uden (after P.P. Rubens), *Landscape
with Philemon and Baucis.* Stockholm, National
Museum

ISSN 2521-3210 (Schriften des Kunsthistorischen
Museums)
ISBN 978-3-7774-3176-5 (German edition)
ISBN 978-3-7774-3177-2 (English edition)

*Bibliographic information published by the Deutsche
Nationalbibliothek*
The Deutsche Nationalbibliothek lists this publication
in the Deutsche Nationalbibliographie; detailed biblio-
graphic data are available on the Internet at http://
dnb.dnb.de.

This publication was supported by:

Flanders
State of the Art

The restauration was made possible with support from
the Getty Foundation through its Panel Paintings
Initiative.

Getty
Foundation

Printed in Italy

www.khm.at
www.hirmerpublishers.com